All true art is a form of activism, and the best, most enduring activism rises to the level of art. Here's a thrilling invitation and actionable playbook for anyone willing to retrieve their autonomy, open minds, and fight the power.
— **DOUGLAS RUSHKOFF**, AUTHOR

Effective activism always involves expanding people's imaginations — you need to be able to envision a different world before you can fight to change the status quo. This informative and irreverent guidebook from two revered veterans of creative campaigning, explores the process of opening hearts and minds using images, words, spectacles, and deeds. Read it so we can usher in a society that is more fair, beautiful and free.
— **ASTRA TAYLOR**, AUTHOR AND FILMMAKER

If you are a troublemaker and want advice from professional troublemakers about how to make trouble more effectively, this book is for you. The two Steves have distilled years of their own personal experience working with artists and activists around the globe and combined that with interviews with some of their favorite rebels. Working collectively with others, they've changed AIDS policy in South Africa, gotten out the vote in the 2020 US election, and helped make COVID vaccines more accessible. This book shares their trade secrets so that the Davids of the world can slay many Goliaths.
— **DREAD SCOTT**, ARTIST

Hanging out with Steve and Steve is a whirlwind of stimulating ideas, creative inspiration, practical advice, and a few laughs too. Their book captures exactly that mix.
— **ANDY BICHLBAUM**, THE YES MEN

The Steve's and the C4AA have created a global sandbox for artists, activists and all those passionate about social justice to play in and experiment with strategies for social change. This playbook offers theoretical knowledge, practical experience and much needed inspiration for all those moving towards utopia.
— **ISHTAR LAKHANI**, SOUTH AFRICAN SOCIAL JUSTICE ADVOCATE

THE ART OF ACTIVISM

THE
ART
OF
ACTIVISM

YOUR ALL-PURPOSE GUIDE TO MAKING THE IMPOSSIBLE POSSIBLE

STEVE DUNCOMBE + **STEVE LAMBERT**

O/R

NEW YORK | LONDON

All rights information: rights@orbooks.com
Visit our website at www.orbooks.com

First printing 2021

Published by OR Books, New York and London

Library of Congress Cataloging-in-Publication Data: A catalog record for this book is available from the Library of Congress.

Book design by Andy Outis

paperback ISBN 978-1-68219-269-6 • ebook ISBN 978-1-68219-270-2

This book is dedicated to our children, Kotse, Sebastien, and Sydney. Our dream is that you live in a world where the impossible is made possible.

CONTENTS

MAKE THE IMPOSSIBLE POSSIBLE YOURSELF!

Download the free accompanying *Art of Activism Workbook* at
artofactivismbook.com

ART NEEDS ACTIVISM. ACTIVISM NEEDS ART.

A DECADE AGO, A GROUP of idealistic artists traveled to the countryside of their small Western Balkans nation with the noble objective of bringing art to the people. When they got to one of the towns, however, the people there didn't want to talk about art. They wanted to talk about potholes. Big, gaping, potholes in the main streets of town that were deep enough to break a car's axle and create a small lake when it rained. Potholes that hadn't been fixed by municipal authorities for years and were symbols of the ineptitude and corruption of the current governing regime. Meetings had been held, politicians confronted, and petitions delivered — but the potholes still remained. So instead of bringing art to the people, the group decided to bring artistry to the people's problems.

They borrowed some fishing poles, gathered up some buckets, set up stools around the rain-filled pothole, and cast their lines into the "lake." Local people came out of their homes and gathered around the anglers. Curious, they looked into the buckets where they saw several fish (bought earlier by the artists at a local market). They began to laugh, and told their neighbors. More people arrived, enjoying the absurdity of the spectacle while discussing the problem of the pothole. As the group got bigger, someone contacted the local media, which came and took pictures and recorded the story of the pothole that hadn't been fixed. The artists shot their own video and uploaded it to YouTube. The story made it into the national media that night and the pothole was fixed by municipal authorities within a couple of days.

This is artistic activism.

Make your mark with Exercise 1 in your workbook.

Artistic activism is a hybrid practice that marries the creative force of art to the concrete results of activism. Common definitions of "art" and "activism" are often restrictive. Instead of perpetuating an idea of artists as separate, magical beings, artistic activism allows us to cultivate the creativity we all already have. Even those of us who don't define ourselves as artists have a familiarity and comfort with creativity, arts, and culture that we often don't have with politics. We make playlists of our favorite music, sing songs at church, upload videos we've made to YouTube, assemble scrapbooks with our friends, invent new cuisines from our leftovers, and watch TV dramas or read novels before we go to bed. "I'm not political," is a phrase one hears often; but it's a rare person who doesn't identify with some form of creativity. We are all creative.

Most people would not define themselves as activists either. Yet, in a sense, we all do forms of activism every day: organizing a group of people to go to a movie or picking a restaurant; lobbying parents for extra screen-time or your boss for a raise; talking a friend out of a bad relationship. All being an activist really entails is having an idea of what needs to be changed and doing something about it. Yet capital A Activism can still feel foreign to people, and a bit daunting: it seems to take too much commitment, too much risk, and too much time. (Oscar Wilde once quipped that "the problem with socialism is that it wastes too many evenings on meetings.") And that's why mixing arts and activism is so critical. Because we all have a creative life, using arts and culture in activist work lowers barriers to entry. Culture, as something familiar, can work as an access point through which organizers can approach and engage people who might be alienated from institutional political systems like voting, lobbying, campaigning, and legislation.

Unpack your baggage around "art" and
"activism" in Exercise 2 in your workbook

To create a new world, we need to imagine what that world looks like. To conjure up this vision takes creativity and time to wonder. Visions of success are what get us up and out in the morning and what attract others to do the hard and necessary work with us. We're talking here about utopia — not as a place to arrive at, but as a point on the horizon to move toward. Art gives us the vision; activism helps us make the road.

As we witness the dramatic triumph of right-wing demagogues around the world and the eclipse of truth by performative lies, it is increasingly clear that the simple presentation of facts falls upon deaf ears. If facts are to be heard and heeded, they need to be made into engaging stories and compelling images that capture people's attention and resonate with the ways they make sense of their world. The world today is rife with economic inequality, racial injustice, homophobia, sexism, hatred, and bigotry of all kinds, and we are threatened by the ultimate endgame: environmental catastrophe. If we are going to build a better world, hell, if we are going to survive as a species, we need to change the world, creatively. Art and activism, together, have the superpower to change the world . . . and all of us are artists and activists. This is a book on the art of activism, and it's made for people who want to change the world and designed to help you use your creativity to do just that.

Discover your superpower in Exercise 3 in your workbook

Hello

WE'RE STEPHEN DUNCOMBE AND STEVE LAMBERT, but people usually just call us "the Steves." For the past dozen years, we've worked together on making activism more creative through the arts, and on making the arts more politically effective through activism — in other words, on artistic activism.

We arrived at this mutual destination from different directions.

Steve Lambert is an artist. He learned to draw and paint as a kid by watching lessons on public television. As a young artist, he frequently attended art openings and, because a lot of these took place in the politically charged San Francisco Bay Area during the second Iraq war, much of what he saw was "political art." Some of this art was disappointing, falling into the category of "I'm So Mad and You Should Be Too." But a great deal of it was good: smart, sophisticated, and aesthetically challenging, the type of art that engages the senses and prompts its audience to look at reality in a new way, or to imagine different realities all together.

Most of the time, however, the audiences for this art were made up of people a lot like Lambert: other artists upset with the way things were and wanting a different world, but not knowing how to achieve it. Sequestered in storefront galleries, this potentially powerful art was all sound and fury, signifying nothing to anyone outside the small, politically aligned group in the room. Lambert was depressed by seeing fellow artists put their political passions into pieces of work with little thought to the actual effect their art could have in the outside world.

Steve Duncombe is an activist. He grew up in an activist family and engaged in activism since his late teens. He's picketed with labor unions, protested on the streets of capital cities, volunteered to build houses in Nicaragua during the civil war, organized teach-ins against two Iraq wars, co-founded a local community activist group on the Lower East Side of New York City, and worked in an international direct action organization. He makes his living as an academic, but his heart is in activism, and he's sat in more sit-ins, marched in more marches, and been arrested more times for civil disobedience than he can remember.

Yet too many of the actions he participated in, including the ones he helped plan,

felt formulaic. March, chant, hold up signs, listen to speakers, and then get busted by the police. Repeat next month. The actions were immediately identifiable as "protest," but often ineffectual in bringing about the changes activists demanded. They frequently felt like an obligation, more akin to eating a raw kale salad than bringing into being the just and joyful world activists were after.

When the two of us first met more than a decade ago, Duncombe was desperate to make activism more creative and Lambert was eager to make art more effective, and both of us thought the other might have the answer. Neither of us did. But in talking to one another we started to realize that if we could figure out how to blend our backgrounds, we might find an answer to the problems that had troubled us for so long. Realizing that our interests, frustrations, strengths, and weaknesses complemented one another's, we founded the Center for Artistic Activism in 2009 as a research and training institute. One of the first things we discovered through our research was that we were not alone. Artists and activists were asking the same sorts of questions, and coming up with helpful answers. All over the world, and throughout history, the lines between arts and activism were being blurred in creative and effective ways.

Today, artistic activists in the United States are overturning negative perceptions around immigration by employing the symbol of the monarch butterfly to suggest that it is natural and beautiful.

Twenty years earlier in Chiapas, Mexico, Subcomandante Marcos and the Zapatistas conjured up magical realist imagery and poetry in their struggle against the Mexican military. And decades before this, environmental activist Wangarĩ Maathai rewrote the rules of protest with the creative intervention of a tree-planting procession in Nairobi, Kenya. In the 1980s, ACT-UP founded an art and propaganda wing called Gran Fury to call attention to the AIDS epidemic. In 1955, Rosa Parks made an iconic performance of dignity and resistance by refusing to give up her seat on a segregated bus in Montgomery,

OUR MODERN POLITICAL TERRAIN IS SIGNS AND SYMBOLS, STORY STAGE SUCCESSFUL BATTLES ON THIS TO **OBSERVE, THINK, ANALYZE**

Alabama. A quarter-century before that, Mahatma Gandhi marched 240 miles to the sea in dramatic defiance of the British salt monopoly in India. Peering back further and casting our gaze wider, we encounter the poetry of Muhammad, the pre-figurative performance of Jesus, the spectacles of Moses, and the engaging riddles of the Buddha. The more we look, the more we find examples of artistic activism.

Artistic Activism Works

ARTISTIC ACTIVISM WORKS, and always has. So why does so much political art feel like receiving a lecture from a righteous vegan at a Texas barbeque? And why does so much activism feel like a day spent at the Department of Motor Vehicles? To find another way, your authors needed a lot of help, and in writing this book we've drawn upon the wisdom of many. At the Center for Artistic Activism we've been fortunate enough to study artistic activism from around the world, cataloging the different approaches people use, and researching what works. We use what we learn to run training workshops around the world, teaching and learning from activists and artists around the world. We've worked with Muslim American activists in New York, Iraq and Afghanistan War Veterans in Chicago, migrant rights activists in San Antonio, and mothers of incarcerated youth in Houston. We've

A HIGHLY MEDIATED LANDSCAPE OF AND SPECTACLE. FOR US TO CULTURAL TOPOGRAPHY WE NEED AND RESPOND CREATIVELY.

trained transgender artists and activists across eastern and western Europe, democracy advocates in Scotland, sex workers in South Africa and Ireland, public health organizers in Kenya, queer and Roma activists in North Macedonia, and anti-corruption advocates across West Africa and the Western Balkans. And we've coached dissident artists from Russia, Pakistan, and China and art students in public high schools in New York City.

One of the things we've learned from all these people in all these places is that artistic activism is not the preserve of the privileged. Artistic expression and cultural creativity flourish among communities who are marginalized within formal spheres of politics, law, and education. We've also learned that artistic activism works particularly well in repressive regimes where overt political protest is prohibited, yet artistic practices are tolerated or even celebrated. And finally, we've learned that while culture is something we all share, we don't all share the same culture. The building blocks, the symbols and stories that give art its content and form, differ among different people and places. At the time of writing, we've trained over one thousand activists and artists from four continents, fifteen countries, and scores of locales across the U.S. In every case, we've seen how learning to think creatively about activism inspires and energizes people, bringing a sense of discovery and play

to the serious business of social change. We've seen how innovative and creative approaches bring concrete wins in activist campaigns. We've seen it work.

The first rule of guerilla warfare is to know the terrain and use it to your advantage. We may not be huddled up with Che Guevara in the mountains of the Sierra Maestra or fighting in the jungles of Vietnam with Ho Chi Minh, but the lesson still holds. Our modern political terrain is a highly mediated landscape of signs and symbols, story and spectacle. For us to stage successful battles on this cultural topography we need to observe, think, analyze, and respond creatively. We need to become artistic activists.

This is what *The Art of Activism* is for. While there is theory in this book, it is not a theoretical book. Nor is it a history book, though it contains many illustrative historical examples. And although it includes cutting-edge creative work, this is definitely not an art book. This book is about changing the world through *doing*, not just analyzing and criticizing. As Marx wrote, "Philosophers have hitherto only interpreted the world in various ways; the point is to change it." *The Art of Activism* is not a book *about* artistic activism, with the practice as its subject matter, meant to be read and considered and then returned to a shelf in a library — it is a book *of* artistic activism. It's meant to be acted upon, and actively used as a guide for your own artistic activism.

However, this is not a recipe book full of instructions for creative actions. The problem with such books is that they promote a "best practices" approach to artistic activism where we reproduce what's been done well in the past. We don't think this is very creative. Nor is it very effective. Artistic activism only works when it takes into account local talents, cultures, and contexts. This book seeks to impart the history and philosophy that goes into developing artistic actions, and to nurture your expertise and creativity so you don't need recipes; you can make them up yourself.

Everything we've learned from all the amazing activists and artists we've worked with has been put into this book right here. We want to see it work for you too. Artistic activism is more than just an

innovative tactic, it is an entire approach: a perspective, a practice, a philosophy. And the artistic activist practice we hope to promote is not about copying what others have already done. Rather, we want this book to help *you* to generate new ideas; to formulate concepts that give you clarity in what you want to do; to do your art and activism more effectively; to change the world. Above all, this book is about *you* creating *yourself* as an artistic activist.

CHAPTER

1

THE ART OF ACTIVISM

"Right now, I could name at least ten ideas I would have found intolerable or incomprehensible and frightening, except as they came after dreams and poems.

— AUDRE LORDE, POET AND ESSAYIST

Stepping off the Curb

WHEN WE FIRST gather participants together in our workshops at the Center for Artistic Activism, we always start with introductions. First, we ask everyone to share the usual things — their names, the causes they are working on, the organizations they are part of — and then we ask them: "What made you step off the curb?"

When used by activists, the phrase "stepping off the curb" refers to the moment that one leaves the sidewalk and enters the street to join a protest, but in a broader sense it means making the step from passive indifference into active engagement. In our workshops, we are interested in finding out about the moment that people decided to become activists or socially-engaged artists, or just to give a damn. We ask them to recall the first time they realized that the world needed changing, and felt stirrings within themselves to be part of that change.

It may have happened long ago, and they may not have realized the importance of it until much later. And it may be that there was never a singular, defining, "aha" moment. We then do a quick poll, asking participants to raise their hand if any of the following activities is what got them to step off the curb:

- Signing a petition
- Reading a flyer
- Studying a policy report
- Sitting in a political meeting
- Listening to a public speech
- Watching a public service announcement on TV
- Being approached by an earnest young person holding a clipboard
- Writing a check to a cause
- Reading a Facebook posting
- Retweeting a tweet

As no hands are raised, it begins to dawn upon everyone that many of the typical methods that activists use to get others involved are not how they got involved themselves. Running this exercise with hundreds of artists and activists, of all ages and ethnicities and from all over the world, we've found that very few people become politically engaged through encounters like those listed above. Yes, they'd all heard a great lecture and been outraged by a set of facts, or may vividly recall their first political meeting. But what brought them to their work was usually far more personal and emotional.

For example, one participant named Ahmed* recalled walking into a fast-food restaurant as a young child with his mother. Dark-skinned and wearing a hijab, his mother was first ignored and then treated disrespectfully by the people behind the counter. As a child, Ahmed didn't understand the politics of racism and Islamophobia, but he was hurt, ashamed, angry, and knew this treatment was wrong. This experience set him on the journey to where he is today: the leader of a Muslim American human rights organization. Jackie, a community

* All of these examples, and many others in the book, are based on real people we have met and worked with. We've changed their names, and sometimes genders and locales, to protect their anonymity.

organizer in New York City, remembered riding the subway with her parents as a young girl and noticing who was getting on and off. Some groups of people wore suits and skirts, while at other stops people were dressed in clothes made for manual labor. Dark-skinned people like Jackie would get on at one stop, and white people would get off at another. Spanish-speaking folks got on, Asian folks got off. She remembered asking her parents why, and received her first painful lesson in race and class segregation.

For some, stepping off the curb may be like an epiphany, a blinding moment of clarity in which the injustices of the world are dramatically revealed, while for others it may be a slow awakening, learned indirectly. Maria recalled listening to the many stories of her grandfather, who had come to the United States from Mexico to work in agricultural fields. He told her stories of the discrimination he faced, but also of how he organized with other workers to demand better wages and conditions and restore his sense of pride. It was these stories that led Maria to become an immigrant rights activist. Jonathan, a young human rights organizer, remembered how he, as a privileged white European university student, was assigned an internship in a camp for recent migrants from Syria. Working with families who had been uprooted from their homes through war and hardship impressed upon Jonathan the precarious realities of lives so different to his own. Rachel, who grew up in South Africa as a poor Black lesbian, could never recall a moment when she was not political; being active just seemed the natural response to the conditions of her life.

You will have your own unique story of what led you to step off the curb. Whatever it was, it was likely a powerful experience. You can probably feel this experience even better than you can explain it, and words (or even images) may feel inadequate for capturing it. That's because its effect upon you was felt more than considered, sensed more than reasoned. It's what might be called an *affective experience*. While we each have our own individual story, what we share is a transformative process that began with something deeply personal, emotional, and experiential.

Now, think again for a moment about how most activists often build membership in their movements. How do they convince newcomers to step off the curb of indifference and join in our struggle for a new world? Activists ambush people on the street, clipboard in hand, asking people to sign petitions and donate money. We stuff fact-filled flyers and pamphlets into people's hands. We build websites where people can access information. We organize public forums at which people can hear the truth from experts, and fantasize about having the media reach of a cable news station. We dump overwhelming amounts of often depressing information about the world on people, and then expect them to be energized and excited about joining us.

This is routine activist practice. And it doesn't make sense. If the tactics we use to raise attention about the causes we care about are not what attracted us to politically engaged art and activist work, why do we expect them to work for anyone else?

Recall your own origin story in
Exercise 4 in your workbook

We Hold These Truths to Be Self Evident

WE ARE BEHOLDEN to a powerful story, and imagine ourselves to be part of it: it is the story of *The Power of The Truth*. One such variation is "The Emperor's New Clothes," Hans Christian Anderson's nineteenth-century fairy tale. The story, as you may recall, is about an emperor who is tricked into buying a spectacular suit of nonexistent clothing. Eager to show off his new duds, the emperor parades through town in the buff. The crowd, eager to share in the fantasy, exclaims how marvelous the Emperor's imaginary attire is. Then, from the sidelines, a young child exclaims "But he has nothing on!" Upon hearing this undeniable fact, the people whisper it mouth to ear, awaken from their illusion, and the Emperor scurries off in shame while everyone else, of course, lives happily ever after.

We've likely all imagined ourselves as the courageous child in this kind of story. We will be the ones to find and reveal The Truth to others. The People will listen: the scales will fall from their eyes and they will finally see the world as it really is (which, of course, means seeing the world as we see it). Once the truth has been told, everything will change and we will all live happily ever after.

The truth shall set you free.

MORE The truth shall set you free.

ALL The truth shall set you free.

access to?
The truth shall set you free.

in the correct form
The truth shall set you free.

The truth shall set you free.

"The Emperor's New Clothes" is a fairy tale, but like many popular stories this one taps into our deep-rooted beliefs, fears, and desires. The myth that there's power in simply knowing The Truth is older

than Hans Christian Anderson. The Bible says, "And ye shall know the truth, and the truth shall make you free." And how many times have you heard (or said) the maxim: "Knowledge Is Power"? At one time this might have been true. Throughout history, powers-that-be have stayed in power by having a monopoly on knowledge. The European Medieval church, for example, kept a firm grip on the handbook for proper thinking, doing, and being in the Christian world by allowing access to the Bible only to sanctioned users, priests, and educated readers of an arcane language: Latin. In China, during the same period, access to literacy was only allowed to an elite Mandarin class. Even today, totalitarian governments restrict access to information, ban books and artworks, and repress intellectuals, activists, and artists, fearful of any ideas that might challenge their official Truth. When the economy of information is one of scarcity, knowledge *does* equal power.

But that's not the world in which most of us live in today, quite the opposite: we have a surplus of information. The internet contains terabytes of knowledge that we access with unprecedented ease. In our classrooms, on our blog pages, and in our discussions with friends or arguments with relatives, we freely ponder, consider, and rant. We are retrieving, discussing, forwarding, and retweeting ideas all the time. WikiLeaks provides us with secret governmental information, and the fact checkers of CNN and the *New York Times* daily refute the lies of right-wing demagogues. We are awash with information. If knowledge is power, and knowledge is now so freely available, then why does power still remain firmly in the hands of a few? Something is wrong with the equation.

Much of our faith in the liberatory potential of facts and truth has to do with how we've been taught to think about politics. According to political theorists, the model for modern democracy is the seventeenth-century European coffee house. In this public place, men of relative privilege and leisure sat around reading newspapers, discussing and deciding upon the important political topics of the day (like how to carve up Africa, Asia, and the Americas). They were reasonable, educated men making rational decisions with full and open

access to all the facts. This is, at least, the shape that the democratic ideal often takes in popular imagination.

"Good daye fellow rational act'rs! Alloweth us to break with ideas in pursuit of a noble truth!"

Coffee house denizens and democratic theorists were on to something. Making rational decisions based upon informed and reasoned discussions is a worthy ideal. This is something we should aspire to, not only as artists and activists but throughout our societies. It is also naïve. A nation of considered thinkers or a republic of rationality may be our political ideal, but the practice of effective politics resembles little of this. From our own stories of stepping off the curb we know that politics is not a purely rational affair, yet we consistently present others with black-and-white arguments and documented facts. Somewhere, right now, a door-to-door canvasser is mechanically repeating a reasoned argument for why the person in front of them should sign their petition. And they are being ignored.

We make sense of our world through symbols and stories at least as much as we do through facts and figures. We are often motivated more by emotional attachments to issues, perspectives, and politicians than

by reasoned political positions. Social movement scholar Marshall Ganz argues that experiences and feelings of urgency, hope, love, anger, dignity, and solidarity are at the core of people's politicization. As you probably noticed when recalling your own artistic activist origin story, what *moves* us to engagement is often less a reasoned evaluation of all possible options that brings us to a rational decision, and more a *felt* response: it just seems like the right thing to do given what we see, hear, and experience.

There are rational reasons for why people often make sense of the world like this (to be further discussed in chapter 5 on cognition), but what matters here is this idea that we are often moved to become involved with politics for non-rational, emotional, and personal reasons, and that we make sense of our world through symbols and stories as much as words and logical arguments. Accepting this idea means accepting that we need to do activism in a way that acknowledges the power of the sensual and the emotional.

The irrational is used politically by some pretty unsavory characters; it's the stock-in-trade for fascists, bigots, and demagogues. It's dynamite, and we need to be careful how we use it. That's why we devote a whole chapter to ethics later on. But if we don't learn how to tap into people's feelings and experiences we leave an important dimension of politics to the other side. Just because the irrational has been abused, doesn't mean it can't be used in a different way.

We should always remember the first rule of guerrilla warfare: know your terrain and use it to your advantage. If we are going to be effective as artistic activists, we need to operate on *real* terrain, not on the basis of the democratic fantasy of the European coffee house. This means rationally understanding that politics are not only rational. The truth about politics is that it is not about truth. Politics is about people's *perceptions* of the truth, their *feelings* about facts, and their visceral *experiences* of the world. None of this is to say that people's rationality should be ignored, that facts don't matter, or that the truth is relative and malleable. Facts are important, and truth should be the foundation of our analysis, our actions, and the worlds we create. But

facts and truth don't speak for themselves. They need to be made into symbols and incorporated into stories that people can make sense of and care about. *They need our help.*

Discover why the truth is not always enough
in Exercise 5 in your workbook

The Power of Art

ANIMATING FACTS, TRUTH, and our causes in ways that resonate with people is critical to changing the world, yet traditional political theory and standard activist training don't provide much assistance here. There is, however, one field that has made the connection between issues and emotions for millennia: the arts. From the Indonesian cave paintings of 45,000 years ago to the most cutting edge conceptual work produced in art institutions today, artists use signs and symbols, stories and spectacles to *move* us. Art is highly effective at translating events, facts, and ideologies into stories, images, and performances, making objective things into subjective forms we can experience, feel, and, importantly, remember. As the writer Jorge Luis Borges summarized at the end of his life: "The task of art is to transform what is continuously happening to us, to transform all these things into symbols, into music, into something which can last in man's memory."

Art allows us to say things that can't be said, to give form to abstract feelings and ideas and present them in such ways that they can be communicated with others. "Poetry is the way we help give name to the nameless so it can be thought," writes Audre Lorde, the feminist writer

and civil rights activist quoted at the beginning of this chapter. Art allows us to imagine things that are otherwise unimaginable, and then to live them. As Lorde continues: "Poetry is not only dream and vision, it is the skeleton architecture of our lives. It lays the foundation for a future of change, a bridge across our fears of what has never been before."

Art of course does a lot more than this, too. To detail all the intricacies of exactly how art works would take hundreds of pages, and even then we couldn't ever offer a complete explanation. But that's kind of the point: despite tens of thousands of years of art practice, thousands of years of philosophical discussion, hundreds of years of art criticism, and, most recently, brain studies of the neurological effects of exposure to art, the power of art is largely beyond rational explanation. And this is art's power.

It's hard to think about art because the power of art lies beyond thinking. In the past, philosophers and critics called this the "sublime" quality of art. The sublime can be beautiful or it can be horrific; in either case it is beyond direct description, beyond measurement, beyond even comprehension. As mystical as the sublime power of art is, or perhaps because it is so mystical, it can be a powerful force in the real world. The ancient Greek philosopher Longinus believed that the power of the sublime lay not only in its capacity to provoke awe, but in its ability to persuade. That's why when we are affected by a piece of art we often say it *moves* us.

This sublime power of art to circumvent our rational minds and affect our emotions, bodies, and even spirit, has been recognized for millennia. And it has been feared for just as long. The Bible and the Quran are filled with strictures against visual depictions of all manner of things holy and profane. Witness the God of Exodus when

he commands Moses: "Thou shalt not make unto thee any graven image, or any likeness of any thing that is in heaven above, or that is in the earth beneath, or that is in the water under the earth." Why is God so set against creative representation? Yes, because of the dangers of misrepresentation, but also perhaps because God realizes that one of the greatest powers is the power of creation, and if people can create then they too will have godlike powers (including the power to create the concept of God in the first place).

The Christian God and Plato devoted a chapter in *The Republic* to explaining why art should be banished from his ideal society. Plato's objections against art are many, but his criticisms culminate in fears concerning the power of art to move its audience. Watching a play or listening to a poem, the audience experiences the pleasure and pain of the characters in the drama. Rationally, the audience knows that these are merely fictive creations of the artist, but emotionally they feel as if the struggles and victories of these fictions are their own.

God and Plato are absolutely right about the power of art. But where they saw this as a threat, we see it as an opportunity. We like that art can represent the world, that people are attracted to and can identify with these representations, and that art has the power to move us emotionally. The problem with art, from an artistic activist perspective, is that this power is often wasted. A painting hangs on the wall of a museum. It moves us. And then, all too often, we move on. We leave that experience, and its power, behind when we leave the museum. We're also taught that art is something "special," something separated from our everyday world. Except, of course, that it isn't. The power of art is used to command high ticket prices or boost the status of particular institutions. In our world, the sublime is in the service of capitalism and hierarchy. But what if we could harness the power of art and apply it to the world-changing potential of activism?

Explore how art works through
Exercise 6 in your workbook

Affect, Effect, and Æffect

ART CAN DO ALL SORTS OF amazing things: it can inspire, horrify, alter our perspectives, and allow us to imagine things that seemed unimaginable. But it's not enough. In order for the emotional *affect* of art to have political *effect*, art needs to be combined with activism.

Activism, as the name implies, is the activity of challenging and changing power relations. Activism does not necessarily mean a mass protest outside a government building to demand more resources; it can just as easily mean organizing a small childcare collective among parents in your neighborhood, thereby empowering the community to create new resources for itself. There are many ways of doing activism and being an activist, but the common element is an activity targeted toward demonstrable outcomes: changing a policy, mobilizing a population, overthrowing a dictator, or organizing a childcare collective. The goal of activism is *action* to generate an *effect*.

Art, on the other hand, doesn't often have such a clear target. It's hard to say what art is for or against; its value often lies in demonstrating or provoking new perspectives. Its impact can vary from person to person, is often subtle and hard to measure, and its meaning is not necessarily unitary, with sometimes contradictory messages

'TIS PRONOUNCED "*EYE*-FECT"

layered into an artwork. As we suggested above, good art, in our opinion, always contains a surplus of meaning: something we can't quite describe or put our finger on, but which moves us nonetheless. Its goal, if we can even use that word, is to stimulate a feeling, move us emotionally, or alter our perception. As our favorite art critic, Lucy Lippard, puts it, "Art is suggestive. The motion it inspires are usually e-motions." In short: Art is an *expression* that generates *affect*. Stripped down to the essentials, the relationships might look like this:

<div align="center">

Activism → Effect

and

Art → Affect

</div>

At first glance, these aims seem at odds with one another. Activism moves the material world, while art moves the heart, body, and soul. But effect and affect can be complementary. We're moved by affective experiences to take physical actions that result in concrete effects: affect produces effect. And concrete effects have affective impact, generating personal emotion: effect produces affect.

At the Center for Artistic Activism, we used to call this complementary combination "affective effect," or sometimes "effective affect," until we developed a more elegant solution: "**Æffect**." (If you are wondering how to pronounce this word, we did too at first. But we decided in addition to taking liberties with the language, we'd make up our own pronunciation too: Aye-ffect. Like a pirate might say it.)

As artistic activists, we are always trying to generate, creating experiences that generate feelings that have demonstrable impact in the world. This is the brass ring of artistic activism. We always reach toward it, sometimes we grab it and sometimes we miss. But balancing affect and effect in an æffective piece is what makes this practice an art.

**Stir emotions into actions in
Exercise 7 in your workbook**

What Is Artistic Activism?

AT THIS POINT YOU MAY BE THINKING, "OK, all this theorizing is really interesting (or not), but what is artistic activism?" Artistic activism is hard to define. Sometimes it looks more like art, and sometimes more like activism. There are so many great examples that cover such a wide range of media and issues that we could never come up with a list of the "best practices," but here are some case studies from the past twenty years or so that inspire us.

UNDOCUBUS

In 2012 a group of undocumented immigrant activists bought an old bus, painted "No Fear" across its side, and decorated it with images of brightly colored monarch butterflies. The "Undocubus" was then taken on a road trip through the Southern United States to protest local anti-immigration laws that had created a climate of xenophobia and fear. Following in the footsteps of civil rights "freedom riders" who made a similar journey to register African American voters half a century previously, the Undocubus activists drew upon the now-sanctified mythos of that movement. But in addition to adopting and adapting the symbols of previous social movements, they made one of their own: the monarch butterfly, a beautiful creature that annually migrates across North America, from Canada through the United States to Mexico and back again. Artist Favianna Rodriguez, and others in the group Culture Strike, then ran with the idea and developed designs that fed back into the movement. Donning butterfly wings at their events, and with butterfly designs covering their bus and emblazoned on their shirts, the Undocubus activists forged an association between human immigration and a natural and majestic migration, reframing the image of a population unjustly feared and routinely degraded. Who, after all, can be enraged at a butterfly?

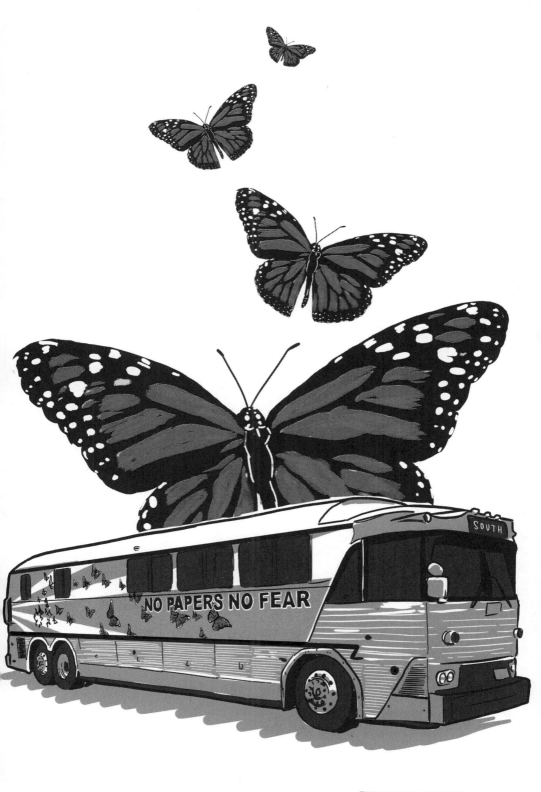

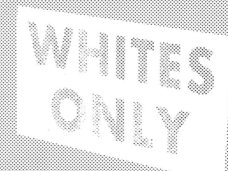
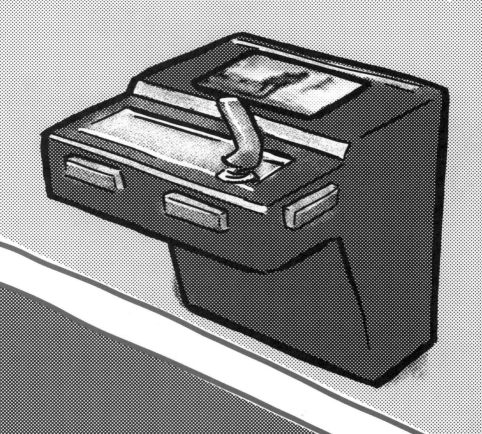

A DALLAS DRINKING FOUNTAIN

In 2003 a sign above a drinking fountain in the County Records Building in Dallas, Texas, fell down. Underneath the modern sign were the remnants of an older one. It read "Whites Only." Once discovered, a public debate began about what to do: should the sign be left alone as a visual reminder of the history of the racially segregated South? Should it be covered up again to reflect that the South had moved on? The artist Lauren Woods had another idea: instead of tearing down or covering up signs of institutionalized racism, she wanted to draw attention to this history and to how history changes. So Woods designed a new drinking fountain. It looks like any modern stainless steel fountain except that it has a video screen set into it right beyond the water bowl. When the button on the fountain is pushed no water comes out immediately. Instead the video screen lights up and scenes from civil rights protests from the 1960s are played. Only after the visitor has spent time meditating on the struggle it took in order for all people to be able to drink from the same fountain, does the water come on for them to take a drink. In the public debate leading up to the installation, a particularly telling exchange occurred between two county commissioners, one white and one Black. "If somebody is interested and wants to see the history of it, that's fine," County Commissioner Mike Cantrell said. "But, to force people to wait forty-five seconds to get a drink, you basically make that water fountain inoperable." "I think it's OK to wait forty-five seconds for water," fellow Commissioner John Wiley Price said. "Some of us have waited forty-five years and longer." After nearly a decade of governmental wrangling, the drinking fountain was installed in 2013.

JOURNAL RAPPÉ

Inspired by the Y'en a Marre ("Fed Up") rap-infused youth movement that started in Senegal in 2011, rappers Cheikh "Keyti" Sene and Makhtar "Xuman" Fall decided to create a news program to provide youth with the information they needed in order to be effective and aware political citizens. In Senegal, however, like in many places, political language is associated with corruption and the abuse of power and is ignored or rejected by many, particularly by the young people who make up 60 percent of the population. So Keyti and Xuman decided that they needed to use a different approach than a straightforward news broadcast. Drawing on their talent and experience, they created Journal Rappé, a regular video show where the two artists provide a long-form investigative report in the form of a hip-hop mixtape, rapping the current news in French and Wolof (Senegal's dominant local language). In doing so, they provide political information for young people in a language and through a culture young people feel is their own. The show was so successful that it has been replicated in countries across West Africa, in East Africa, and as far as Jamaica and Vietnam.

WAR ON SMOG

Chinese cities are notorious for their smog. Chinese authorities, wary of a repeat of the Tiananmen Square protests, are equally notorious for being hostile toward street demonstrations. Cleverly responding to this challenging political terrain, artistic activists in Chongqing city in Southwest China, staged a public performance piece in 2014 called War on Smog (the name borrowed from a public proclamation by the Chinese premier of the necessity of staging a "War on Smog"). The "war," which aimed to bring attention to air quality in the city, was fought by a couple being wed in formal marriage attire and gas masks, a parade of tutu-clad women, likewise in gas masks, and other artistic performers. Mixing a street protest with an art piece was a stroke of brilliance. Since it didn't look like a political protest to the authorities, no activists were arrested. But the style and creativity of the War on Smog provided arresting images for local and world media. By riding the line between political expression, which is often repressed in China, and art, which is tolerated and even celebrated, these artistic activists carved a space to safely protest within an authoritarian regime.

OPERATION FIRST CASUALTY

Troops in desert combat fatigues move purposefully through an urban landscape. Their eyes scan up and down, side to side, looking for danger. Watching them are civilians, standing on the sidewalks and looking out of windows and doorways. The tension is palpable. Suddenly the squad leader shouts, gesturing with his hands to the corner ahead. The soldiers spring into action, closing the distance in a few seconds and grabbing a man dressed in street clothes. They throw him to the ground, slip plastic ties around his wrists and a bag over his head. Piercing shrieks ring out and the crowd surges. The soldiers form a ring around the body on the ground, screaming at people: "move it, get back, get away!" Some of the bystanders yell back at the soldiers, others move quickly to get out of their way, still others gaze on, seemingly unable to process what's going on before their eyes. A child stands watching, transfixed, wiping tears from his eyes. The street has erupted into fear and chaos in a matter of minutes.

This is not a scene from the streets of Iraq, Afghanistan, or Syria, but a creative protest staged by the Iraq Veterans Against the War in the streets of U.S. cities like Chicago, New York, Washington, D.C., Denver, and Los Angeles in 2007. "Just walking around talking and marching wasn't getting the point across," explained Garett Reppenhagen, former U.S. Army sniper and chairman of the IVAW. "We wanted a demonstration that depicted what we wanted to show people. . . . I don't have to talk to them, I don't have to show them a piece of literature. They can see what we are doing, and see that the soldiers in Iraq are going through a hell of a time and the occupation is just really oppressive and violent." Through a fictional performance, the artistic activists of IVAW brought the war home to the United States and made it "real."

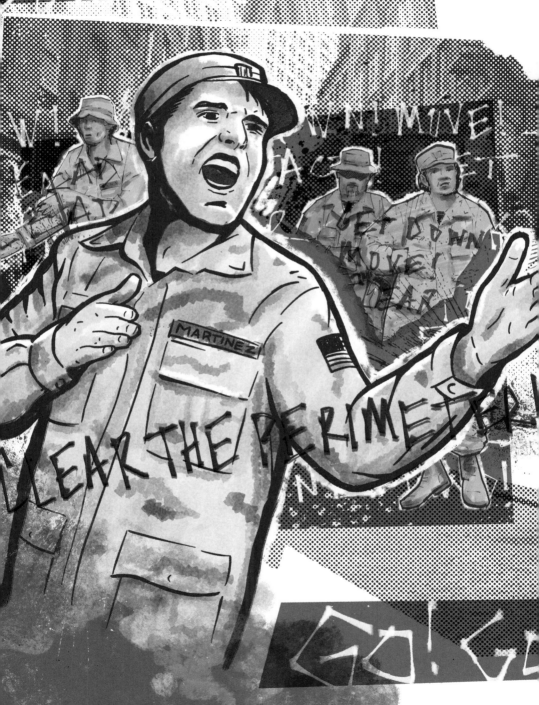

UNITED VICTORIAN WORKERS!

Troy is a town in upstate New York whose best days are long gone. A century and a half ago it was a booming industrial town, but today its downtown is deserted and its factories are boarded up or torn down. Troy can often be a depressing place to live, but once a year the remaining residents of the city dress up in Victorian-era costumes and parade up and down the city's main street. In 2005 artistic activist Dara Greenwald noticed something odd about the annual "Victorian Stroll": everyone was dressed up as *rich* Victorians, and the poor factory workers who comprised the majority of the historic population of Troy were nowhere to be seen. So Greenwald resurrected them. Dressed in period working-class clothes and holding placards with radical slogans from the previous century, Greenwald and a band of local artists and activists joined the parade. The United Victorian Workers, as they called themselves, printed a radical newspaper and held a "period-inspired" strike for higher wages. The organizer of the official event, dressed in proper bourgeois Victorian attire, was not amused. She even tried to get the police (also in Victorian outfits) to intervene to stop the workers from "ruining everything," unwittingly adding the critical element of class conflict to the festivities. Instead of sitting by the sidelines and decrying the revisionist history of Troy, Greenwald and her friends "corrected" history by joining the parade and turning the spectacle to their advantage.

TRAFFIC MIMES

Antanas Mockus faced many serious challenges when he became mayor of Bogotá, Colombia, in 1995. The city, one of the most violent in the western hemisphere, also had a seemingly intractable problem with traffic congestion. Cars and people alike ignored signs and laws, and the result was chaos, with frequent gridlock and fatal accidents. Rather than imposing heavier fines, which he knew would be resented, or displaying more traffic signs, which he knew would be ignored, the mayor did something very creative: he hired 420 mimes to direct traffic. These traffic mimes roamed the streets of the capital in brightly-colored clothes and painted faces, mocking and shaming pedestrians and drivers using the centuries-old art of pantomime. The shock value of the mimes' presence, along with their appeal to citizens' sense of humor (and their fear of ridicule) was impressively æffective. Due to the mimes, and other creative tactics, traffic fatalities dropped in Bogotá by over 50 percent. The mimes were so successful that other Latin American cities followed suit, using humor and ridicule to solve their traffic problems.

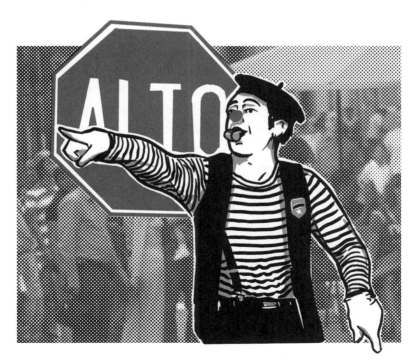

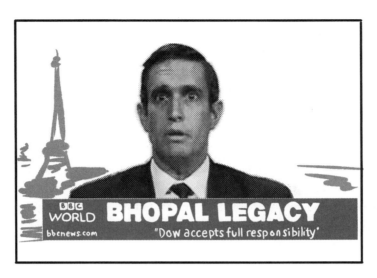

DOW CARES

The Yes Men are imposters. In real life Andy Bichlbaum and Mike Bonanno (not even their real names) are activists; as the Yes Men they act as corporate and governmental spokesmen. A famous example: working in conjunction with Greenpeace, but parading as representatives of Dow Chemical, the Yes Men were invited to appear on television by the BBC. It was the twentieth anniversary of the Bhopal disaster, in which a leak at an Indian chemical plant killed thousands of people and maimed nearly half a million. The topic of the day: the chemical giant's "corporate responsibility." In front of millions of viewers, "Jude Fenestera," aka Bichlbaum, calmly explained that since Dow was making billions of dollars in profit, they, as good corporate citizens, were taking full responsibility for the disaster by finally making full financial restitution to the victims. On news that Dow was accepting responsibility for the disaster, the company's stocks plunged, vividly demonstrating the financial, not social, values that corporations are held to. The Yes Men were then asked back onto the BBC to explain their "stunt," which they turned into another opportunity to highlight the gap between corporate crisis management and genuine corporate responsibility.

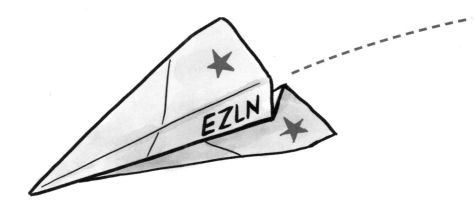

ZAPATISTA AIR FORCE

New Year's Day 1994 was the day the North American Free Trade Agreement went into effect. Out of the mountains of Southern Mexico walked three thousand indigenous peasants wearing black ski masks — some carrying rifles and machetes, others long sticks — declaring war on the Mexican oligarchy. They were the Zapatista Army of National Liberation (EZLN). Within days, images of this ragtag rebel army, and the words of its resident poet-in-arms Subcomandante Marcos, spread across the globe. Six years, dozens of campaigns, and hundreds of communiqués later, the Zapatistas unveiled their "air force" against a Mexican Army encampment. EZLN guerrillas wrote notes to soldiers asking them to put down their weapons, folded these notes into hundreds of paper airplanes, and then flew them over the razor wire encircling the army camp. Pitted in a battle of military strength they had no chance, but with humor and imagination they captured public sympathy and support, creating a potent political force.

24HR MUSEUM

Alfredo Jaar is a Chilean-born artist trained in architecture. Well known in the art world, he was invited to Skoghall, Sweden, to do an art installation. Skoghall is a company town, where the local paper industry, working with the benign Social Democratic government, provides jobs, housing, and municipal services for everyone. The people of Skoghall were content with their library, gym, grocery store, and park. Jaar noticed, however, that the one thing that was not provided for the citizens was a museum. So he built one, constructing it from the heavy waxed paper manufactured by the town's mill and the long wooden poles it used as paper spindles. When the museum was complete the people of the town were invited to bring and exhibit their own art work. There was a big celebratory opening, a brass band played, and the people of Skoghall were happy. Then, twenty-four hours later, Jaar removed the art and burned his museum to the ground.

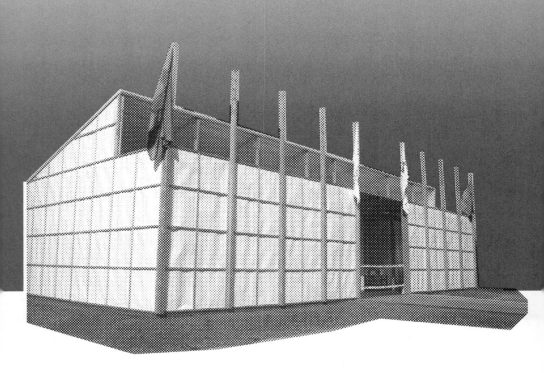

MUSEUM— SKOGALL, SWEDEN
WOOD + PAPER CONSTRUCTION

Jarr's actions could seem incredibly disempowering and cruel to the people of Skoghall. And they would be if his artistic activism ended here. But a few weeks after he left town Jaar received a telephone call from the mayor of Skoghall. The mayor told him that the citizens of the town, *for the first time ever*, had petitioned the town government to request something themselves: that a permanent museum be built, and they wanted Jarr to be the architect. Having experienced their museum for a day, the people longed for what they hadn't even known they wanted, and they mobilized themselves to get it.

These are just a few case studies of artistic activism. Some projects are tied tightly to campaigns, while others skirt the edges of what we traditionally think of as politics: raising questions, opening spaces, and providing perspectives. Some are more affective, some more effective, some are delightfully æffective. What they all have in common is a blending of arts and activism.

Search Actipedia.org, our totally free, user-generated, digital database of case studies for thousands more examples from around the world

POLITICAL ART TENDS CONCERNED AND TENDS TO BE SOCIAL

When considering these or any examples of artistic activism, it's important to know three things:

1. *These won't work for you.* Simply repeating these projects won't achieve the same outcomes in a different place and time because...

2. *Context matters.* Each of these pieces was designed for a particular cultural context and political purpose. When taken out of that context and used for another purpose, the result is diminished, or often a failure. But these examples still have value because . . .

3. *Creativity comes through combination.* We can learn from what others have done, borrowing bits and pieces — a style here, an approach there — and putting them together in new ways, in new places, and for new uses. Through this process we create something new.

While our example actions can be inspiring and exciting, because of the reasons above (and others) we don't advocate arson, armed occupations of cities, or stepping into traffic wearing face paint.

TO BE SOCIALLY 'ACTIVIST' ART LY INVOLVED.

What Isn't Artistic Activism?

ARTISTIC ACTIVISM ENCOMPASSES many practices, but it is also *not* a lot of the things people frequently think of when imagining art combined with activism; for instance, political art. Political art has an important place in the art world, and no global biennale would be complete without it. But most "political art" shown in museums, sold in galleries, or celebrated in art textbooks is usually art with political or social injustice as its subject matter or muse; a means to express the artist's opinion or feelings about social problems or injustices. As the critic Lucy Lippard explains, "political art tends to be socially *concerned* and 'activist' art tends to be socially *involved*." The actual political effect of most political art is an afterthought, if it is thought of at all. In brief, it is art *about* politics, not art that *works* politically. We call this "political expressionism" (discussed further in chapter 7), and it is not artistic activism.

Conversely, artistic activism is not simply activism that adds art as a window dressing. This is too often how art is used by organizations and advocacy groups, who may ask an artist to design a poster or banner, or donate their talents and prestige to raise money or awareness for

a shared cause. Artistic techniques may help to make a protest more palatable, or profit a cause, but without using creativity in designing tactics, strategies, or goals from square one, these organizations are squandering a valuable resource. We call this "faux-finish politics," and it is not artistic activism.

Artistic activism is neither wholly art nor activism, but is somewhere in between. Working with our colleagues Risë Wilson, founder of theart-gallery-cum-community-space the Laundromat Project, George Perlov, a researcher on creative impact, and the artistic activist Brett Cook, we came up with a series of simple scales that can help us think about artistic activism as a point on a spectrum between arts and activism.

ART ACTIVISM

Expressive ⟵⟶ Instrumental
Tactical ⟵⟶ Strategic
Cultural Change ⟵⟶ Material Change
Relationships ⟵⟶ Outcomes
Individual ⟵⟶ Collective
Timeless ⟵⟶ Timely
Esoteric ⟵⟶ Accessible
Affect ⟵⟶ Effect

Artistic activism is a dynamic hybrid of art and activism, a shifting point on a line between these two poles. It is this in-between space where the practice resides.

This is a space of tension.

This is a space of contradiction.

This is a space of experimentation.

This is a space of generation.

Creativity comes through combination.

Artistic Activism Is Not Enough

ARTISTIC ACTIVISM IS NOT MEANT to supersede other forms of activism, whether legal, electoral, or community based. No matter how artistic our activism, there will always be a need for old-fashioned, boots-on-the-ground activism: digging for facts, knocking on doors, organizing community meetings, badgering politicians, and submitting legal challenges. Nor is artistic activism meant to take the place of other art practices. There's a time and place for all sorts of artistic expression, whether this be exploring a new creative medium, experimenting with color, capturing a moment of beauty in a song, or writing a poem about someone you fell in love with.

Traditional forms of activism work. Traditional artistic practices work. Artistic activism makes them both work better for specific purposes. We all know that having limited ideas limits our possibilities, and a limited tool set limits our ability to act. A good activist or artist, like a good carpenter, has a big toolbox and is able to select the right tool for the right job at the right time. One of these tools ought to be artistic activism. And as with all new tools, using this one will help you to see the job you are doing differently and prompt you to imagine other tasks that can now be done. Artistic activism is not merely a tactic that helps you to be a better activist or more effective political artist, but a new way of seeing, working, and thinking that transforms both art and activism.

Find artistic activism in your favorite social
movement with Exercise 8 in your workbook

CHAPTER

2

PROCESS

First forget inspiration. Habit is more dependable. Habit will sustain you whether you're inspired or not. . . . Habit is persistence in practice.

— OCTAVIA E. BUTLER, SCIENCE FICTION AUTHOR

The Creative Process

IN ARTS AND ACTIVISM the product gets all the glory.
In the art world, an artist's talent is judged by what she
has created: the painting that hangs on the wall of a
museum or is sold in a gallery, or the dramatic perfor-
mance staged in a theater and watched by an audience.
In the activist world, it is the demonstration or rally that
one organizes that attracts people, gets media coverage,
and influences politics. The same applies when the two
worlds are merged in artistic activism. What was fore-
grounded in the examples we showcased in the last
chapter? The products that artistic activists produced.

An obsession with the product is not unique to arts and activism, it is at the core of capitalism. Capitalism is based upon *things*: producing *things* and consuming *things*. What's overlooked when we focus on things is an understanding and appreciation of how things are made and who makes them; that is, the *process* of creation. Too much emphasis on things — what we'll discuss later as a sort of "tactical myopia" — can lead to an artistic activist practice that is only interested in replicating successful pieces: employing "best practices," in cookie-cutter fashion, anyplace and at any time. This isn't very creative.

Creativity isn't a product, it's a process. It's a process that helps us to notice new objects and events, make new connections, and see the world in different ways. It's a process that helps us think of, sketch, experiment, and build innovative things. A process that helps us act in a different manner and imagine new horizons within which to act. Most important, creativity is a process that *all of us* can use to become artistic activists.

The creative process is something that every artist develops and masters over the course of many years, and there is no one-size-fits-all approach. We would, however, like to share some shortcuts that we've learned through our experience, and a lot of trial and error. Of course, while these lessons worked for us, they may not work for everyone. Take what you can from them, all the while experimenting with other ways of developing your own creative process.

Create a sketchbook for your creative
process in Exercise 9 in your workbook

Creative Habitats

TO BE AN ARTISTIC ACTIVIST, it helps to have a creative habitat. This habitat is a place where we can cultivate, grow, and replenish our creativity for the rest of our lives. Here's a list of things to think

about when making a creative habitat. Some may work, some may not. What's important is understanding the concept and adapting it for your needs. In the end, do what works.

FIND A SPACE

Physical and mental space is key for creativity. A space away from the ordinary routines, obligations, and distractions of daily life. What the author Virginia Woolf called "A Room of One's Own." Have you ever had a great idea in the shower, or when you're lying in bed drifting off to sleep? What makes these spaces so conducive to creative thinking? Our mind is constantly working away. It's making plans and alternate plans, playing out conversations both real and imagined, and revisiting and analyzing the past. For most of our lives, our mind runs like a personal tabloid television news show in the waiting room of our consciousness: giving reports, speculating on events, gossiping, and hyperbolizing our past and future. Our creativity thrives when it can escape the chatter of our mind, or the chatter of other people. This can happen when we're going out of town, or relaxing in the shower. When we can turn off the distractions and quiet our minds, it's like a

new channel opens up for creative thought. This is why some artists like to go on retreats. When we can, we schedule our artistic activism workshops out of town in antiquated religious centers and off-season summer camps so participants can put miles between themselves and the pressing concerns of everyday life. But while this can make it easier, we don't have to leave town to be creative.

Lambert works best from his studio, surrounded by all his tools and materials. Sometimes, when he can't get there, he works from home. But since being creative for him looks a lot like spacing out to others, he puts on a special, bright-yellow "I'm-being-creative-don't-bother-me" hat to ward off well-meaning incursions and conversations from his partner. You don't need to do this (and Lambert's partner sometimes wishes he wouldn't). Having a space to be creative, more practically, also means preparing a physical space to work. It needs to be clear of clutter so that we don't have to search for the tools and materials we need. With ample space to spread out to write and draw, and with everything we need visible and accessible, we create a space that fosters creativity.

If this kind of space doesn't exist in your home or workplace, find another location. In fact, leaving your normal surroundings can help promote the kind of break from habitual thinking necessary for new ideas. When he was working on his last book, Duncombe found that cafés provided the best environment for him to think, write, and be creative. But only certain cafés: those that had no internet access so he wouldn't check his e-mail; that were far enough away from home and school so he wouldn't run into anyone he knew; and that played music he didn't like so he wouldn't hum along and get distracted. Then he could write.

Discovering your own creative space will take time, and a lot of trial and error. Experiment with different environments and be attuned to what feels right for you.

Finding a new space can be a good idea when planning creative meetings with a group as well. Next time a meeting is called, instead

of having it in your organization's office or a meeting room, suggest having it somewhere you normally wouldn't:

- A community garden
- A rooftop
- A gallery
- A children's playground
- On a hike

Sometimes just shifting the context from "the place where we work" to a place where we play, or can watch others play, is enough to loosen up thinking so that we can be creative in our planning. Most of your authors' early organizing work was done in the back rooms of local bars.

CARVE OUT TIME

Our creativity won't thrive if the only time we make for it is an occasional weekend, or between phone calls, emails, and "important" meetings. We need to set aside blocks of time. Put it in your calendar if you need to, but give yourself a period of time for creative work.

Even once the necessary time and space has been created, there's more we can do to clear our heads for creative work. Try this: write down everything that is pulling at your attention: the running list of groceries you need to pick up, the list of possible vacation plans, the phone call you need to make, and every miscellaneous to-do item that's banging around in your head. Don't be surprised if you can fill several pages. All of

these items are taking up mental energy that draws from your creativity. Writing them down allows you to temporarily let go of them, to create the space you need for new material. Put the list aside; these tasks and reminders are not for now. This is your time to create.

CREATE A ROUTINE

When Lambert was in art school in the 1990s, the experimental film-maker Larry Jordan visited his film class and said that the most important guidance he could give was to keep a regular schedule. "Artists have to train like Olympic athletes," he said. "An Olympic high-jumper needs to train every day. If she doesn't do the high-jump for four days, what's going to happen? She's not going to be successful." Jordan kept a strict five-day-a-week schedule for his art practice and approached his creative work like he was training for the Olympics.

We all have our creative routines. Duncombe can only do creative work in the morning, from the time he drops his kids off at school at 7:30 AM until about 10:30 AM when his mind starts buzzing with all the pressing demands of the day. And he has to have *one* cigarette on the sidewalk outside his café, before he starts writing. Lambert will only drink coffee at his studio — a reward he gives himself for arriving. He then enables the SelfControl app that locks out the internet on his computer, and he's ready to be creative. A creative routine also has other benefits: it provides our minds with little visual and tactile cues that "the creative work is about to begin." You might want to add other prompts as well. Enter a specific room or sit in a special chair. Change sweaters like Mister Rogers. Drink a cup of coffee from a specific cup. These become triggers for the start of our creative routines.

Experiment with what times of the day or week you feel most creative. Maybe working a couple of hours each day or night works for you. Maybe you need to build up lots of ideas before devoting long stretches of time every weekend. Play around with the rituals you need to get yourself going, or the rewards you give yourself once you've done your creative work. You'll find the routine that works for you. At first it may be uncomfortable and may not yield much, but a routine will help to train your mind to prepare for creative work. When you show up at the gym in your sneakers at the same time every day, your mind and body come to expect a workout. The routine makes it easier to start the work. You develop a creative habit.

TURN DOWN THE PRESSURE

Once you've made a habit of showing up for your creative work, don't expect to make masterpieces. If someone handed you a guitar and some sheet music and demanded you to play a composition perfectly the first time, could you do it? Of course not. It's too much pressure. We need to practice, mess around, and make mistakes. George Bernard Shaw once said, "A man learns to skate by staggering about and making

a fool of himself. Indeed, he progresses in all things by resolutely making a fool of himself." In order for our creativity to progress, we need to allow ourselves the freedom to make fools of ourselves.

We are often our own worst enemies when it comes to being creative. As artists and activists we frequently self-censor our ideas because they aren't clever or creative enough. Instead of striving to create masterpieces, we need to give ourselves permission to experiment in disasters: to muck about and test the ridiculous, absurd, silly, and, above all, stupid things. Unfundable things. Ultraviolent things. Insane things. Things that will make our bosses, boards, funders, or the police very nervous. We don't need to act on these ideas, but we need to be able to think them.

Working collaboratively presents new challenges to be perfect. Sometimes we succeed in turning down the pressure on ourselves, only to work with others who ramp it right back up. If you're working in a group, make a concerted effort to develop an atmosphere of creative acceptance. This isn't always easy, and it takes a lot of trust, but it is worth the struggle. We *all* need to be able to have silly thoughts and say stupid things and not feel judged.

The poet Jack Gilbert wrote: "We must have the stubbornness to accept our gladness in the ruthless furnace of this world. To make injustice the only measure of our attention is to praise the Devil." This is good advice. If our process is rooted in vengeance, fury, hopelessness, or despair, our efforts will likely fail. If we only act when we are outraged, then that outrage is either going to consume us alive and burn us out, or ebb over time and leave us without motivation. Either way we won't be artistic activists for long. Over the long-term, our creative process needs to be imbued with a sense of hope and optimism. In order to have this sense of equanimity, we need to treat ourselves well by living full and complete lives, taking breaks, eating well, going on vacations, and doing whatever makes us happy and joyful. Our work needs to come out of love.

[handwritten margin note: similar to bell hooks idea on love]

Discover how to create your creative habitat
in Exercise 10 in your workbook

The Artistic Activist Process Model

NOW THAT WE'VE FOUND A PLACE, cleared the time, developed a routine, and are in the right frame of mind, we are ready to be creative. Fortunately, to help us navigate this terrifying creative abyss there are guides. Large design groups like IDEO and the British Design Council, "creativity experts" like Roger Von Oech, the design-thinking team of Jakob Schneider and Marc Stickdorn, and artists like Anna and Lawrence Halprin have created models for creativity with wonkish names like Service Design Thinking (SDT), RSVP Cycles, 3-I, 4D, or Double Diamond. Each has its own terms and structure, but all propose that there are similar stages we move through when doing creative work. At the Center for Artistic Activism's underground research laboratory, we took these models apart and ran them through our flux capacitor. We named the product the Artistic Activist Process

Model, or AAPM. The four stages of the AAPM are:

1. Research
2. Sketch
3. Evaluate
4. Act

These stages correspond with four roles an artistic activist needs to play:

1. Observer
2. Inventor
3. Critic
4. Worker Bee

To employ the AAPM means moving through each of these stages and taking on each of these roles as follows:

1. OBSERVER: RESEARCH!

Nothing comes from nowhere. Whenever "new" forms of music emerge, upon closer listening they are soon found to be *new combinations* of preexisting music. Rock 'n' roll, for instance, came from combining elements of Black blues, jazz, and gospel with white country and western-swing genres. Creativity does not appear, fully formed, as a gift from the gods, nor does it result from inborn talent or luck, it's a process of making new combinations from old stuff. In order to make new combinations, we need to seek out inspiration and borrow various elements from diverse sources.

Creative people are observers. Observing simply means moving through the world with wonder, using our senses, taking notice of and capturing anything and everything that strikes us, without judgment. Imagine yourself as an explorer on a strange planet collecting photographs, samples, and observations. Or a masterful detective, just arriving at the scene of a crime. The more research you collect, the more you have to work with. We all do this collection process all the time. In fact, you possess a lifetime of research you've already done.

Our advice is only to do this more consciously and deliberately, and to recognize it as part of your creative process.

Watching documentaries, going to art museums, and reading policy white papers are important forms of research, but they can also be narrow in scope. With research sources like these, it's too easy to replicate combinations that have already been made, and so it's important to look further afield. Research and observation can be done anywhere, from noticing the colors and forms around you to reading a celebrity gossip magazine. Because research provides content for our work, we can find insights and inspiration in everything: history, economics, philosophy, popular culture, subcultures, current events, or simply people-watching. Research might be looking at art supplies, construction resources, and the physical landscape. Research can also be learning to tie knots or taking a trip through the dollar store, reading up on metal fabrication, registering for a

class on screen printing, observing how paint moves on a surface, or learning the ins and outs of all the buttons on your video camera. You might also try:

- Staring at the clouds
- Watching fifteen minutes of a cooking show
- Visiting a niche museum (say, of the history of dentistry)
- Playing a game of table tennis with a six year old
- Wandering through a plumbing supply store
- Striking up a conversation with a stranger
- Walking a new way home

This is all research. Explore!

2. INVENTOR: SKETCH!

After collecting the raw material, we start making new connections. When we combine elements, they react with one another in new ways, but we don't know how they will react until we do it. We can think of these experiments as rough sketches we will develop into finished work. Remember, sketches are not complete masterworks, only the initial steps we make as we work out an idea; the early drafts, the underpainting, the pencil sketch on the back of an envelope, or the bits of phrases and metaphorical connections a poet jots down in a notebook.

The inventor is always trying to find new ways to solve problems by experimenting without judgment. Sketching out ideas is the simple means of taking our observations and putting them together in a rough form so we can step back and see if they work. If it helps, imagine yourself as mad inventor in a laboratory, taking the parts you have collected and wildly bolting them together to see what happens.

These two things are both blue, let's put them together!

These words sound the same, let's swap them!

What happens when we flip this upside down? Turn it inside out?

Of course, every sketch doesn't turn into an artwork, every note jotted down doesn't become a poem. But every great artwork has a

sketch or notes that came before it. Many of these experiments don't work, but the surplus is required for innovation. Duncombe keeps stacks of legal pads in his office where he jots down ideas; Lambert's studio walls and notebooks are filled with sketches. We have friends who swear by "mood boards" — collages they create from images and words cut out of magazines. Most of these ideas and images and influences go nowhere, but some do. In this phase of the AAPM, we are creating a wealth of experiments and possibilities.

It is easy to imagine ideas like fruit in a field and, as we wander through the orchard of our mind, we pick and choose the sweetest and ripest fruit, while leaving the unripe and rotten behind. Unfortunately, it doesn't work this way. We don't get to pick only our good ideas. Rather than wandering in a field, it's more like we're back in the barn, inspecting *all* the harvested crops as they flow down a conveyor belt. Our ideas come in a singular stream, good mixed with the bad, bruised with pristine.

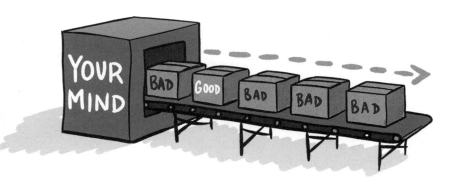

Once we can see our ideas on paper, we can better evaluate them. This is why it is important not only to write your ideas down but to sketch them, make drawings of them, however crude. We need distance from our ideas before we can truly understand them, and getting them out of our head and into a rough visual form allows us to step back and truly see them for what they are. We are used to expressing

ideas in words, but words often force us into traditional patterns and clichés. We're trying to break our habits of thinking; drawing helps us do that. And it truly doesn't matter how well you draw. In fact, the worse you are as an artist the better the process might be, as you won't fall into well-worn artistic ruts.

3. CRITIC: EVALUATE!

So far, we have collected our research and made our sketches without judgment. In this stage of the AAPM we adopt a critical perspective and decide whether the sketch is a plan worth moving forward with, or whether it needs more work. Here we imagine ourselves as a judge whose sole duty is to look at what's been made so far and ask: Will it work for what we want to do?

We are all experienced evaluators already. We make judgments about all sorts of things throughout the day: this coffee tastes better with milk, this is the fastest route to work, these pants make my butt

look fat, and *those* pants make *his* butt look fat . . . In this context, however, we're going to give our judgments a new purpose: directing this critical gaze toward our own creative work. This critic works for *you*. Looking over our sketches, we should be asking:

Do we need more research?

Do we need more ideas? A different combination?

Is this plan practical enough? Ambitious enough?

Is it legible to our audience? Will the connections being made in the sketch phase be understood by others? Or is it speaking too much to only our perspective, experience, and ego?

To what end are we working here? Are we still on track? Does this work in moving us toward our goal? Will it be affective? Will it be effective? Will it be æffective?

It may be helpful to bring in a friend or two here and have them also critique what you are doing, as they'll be able to see things you may not. This evaluation phase is the most difficult phase to master and we'll return to it many times in this book.

4. WORKER BEE: ACT!

We have done our research, developed sketches, and critically pushed and probed them until we are pretty sure they will work. Now it's time to act. We call this the "worker bee" stage because this is not the time to explore, create, or judge — it's time to get busy! We all know someone who talks big and never follows through. They have great ideas, make big plans, and then . . . it just never happens. That's not you.

The production phase is the time that we do whatever it takes

to get the job done: long days, late hours, calling in friends, breaking open your piggy bank, perhaps bending some laws . . . In this phase we are the dedicated friend, the loyal soldier, the trusted partner, or the "fixer" who does the job, no questions asked, with no supervision needed. We just do it.

To get ourselves psyched up for this final stage we sometimes play inspirational music. Loud. Our current favorite is from the early '70s anarchist-psychedelic band, the Pink Fairies. The song goes like this:

> Don't think about it
> Well, all you've got to do is do it
> Well, don't talk about it
> All you do is do it!
>
> Don't sing about it
> If you ain't gonna do it
> Don't write about it man
> If you ain't gonna do it
>
> Yeah, do do do do do do do do do do do it
> Do it, do it, do it, do it, do it, do it, do it, do it
> Aw, just do it
>
> It's Rock n Roll
> And the message is: Do It!

The song is called, appropriately, "Do It."

The Artistic Activist Process Model is just *one* way to organize your creative process. We've found the structure is both clarifying and motivating in an undertaking that can become disorienting and even paralyzing at times. For the AAPM, we borrowed useful ideas from others and made them our own. And again, you will find what is useful for *you* and make it *your* own. That's part of the creative process.

Try out the steps of the AAPM and make it your own in Exercise 11 in your workbook

Common Mistakes

MOVING THROUGH THE ABOVE STAGES of the Artistic Activist Process Model is not always easy in practice. This is where creative *practice* comes in. Since we've employed the model a lot, we can share some common mistakes made by our workshop participants, our students, and, most frequently, ourselves.

UNDER-EMPHASIZING RESEARCH *(or, "We know this already!)*
Research sometimes feels like a formality. Many of us have been working as artists and activists for years, and we have a pretty good idea of what's at stake and what can be done. We know what we know. But we don't know what we don't know. Think about it this way: most of us know our own neighborhoods pretty well, but what do we *really* know? The neighbors we're friendly with, the places we like to go, the paths we usually take. There's a lot, however, we miss. What about the new family down the block? The auto body shop in the alley? The utility tunnels under the sidewalks? When we operate solely from our own experiences, interests, perspectives, and comforts, we miss a lot. It takes self-awareness and humility to admit that we don't know it all and have to seek out more information.

OVER-EMPHASIZING RESEARCH
(or, "Wait, you haven't read this book!")
Research can draw you in like a warm blanket. It's a cozy place. The stages in the AAPM that come after research bring us closer to action, which entails a lot more risk, so collecting more (and more) information can feel safer than moving forward. And since it's hard to know when we've done enough research, the temptation is always to do more. There's always more community members to reach out to, more books in the library, and more tools and techniques to experiment with, but

at some point enough is enough and it's time to move on. If, later, we realize we haven't done enough research, we can always come back.

UNDER-EMPHASIZING SKETCHES *(or, "We already know what we're going to do, so why are we wasting time?")*
Sketching requires experimentation and exploration, but sometimes, in our hurry to move on and "Do It!" we rush through the sketch process by grasping at the first sign of success. One workable idea is enough, so why bother with more, especially when so many of them are bad? Because more ideas give us more to choose from, to combine, and to work with. As the pacifist philosopher Émile Chartier once said, "Nothing is more dangerous than an idea, when it's the only one we have."

OVER-EMPHASIZING SKETCHES *(or "Look at how this ink spreads across the paper . . .")*
Like over-emphasizing research, over-emphasizing sketches can feel very comfortable. An endless refrain of "what if we did *this*?" can be both fun and safe. Among activists, this tendency shows itself when, after the reports and data are in, we hold an almost endless series of strategy meetings. In an art context, it happens when the artist falls madly in love with the act of creating: pushing clay

OOOOH, LOOK AT THIS INK...

30 MINUTES LATER...

OOOOH, LOOK AT THIS INK...

around but never finishing a sculpture. There's a time to stop futzing around and move on.

UNDER-EMPHASIZING EVALUATION (or, "It's cool.")

Lack of evaluation happens when we're sick and tired of working on the project and just want to get it done. It can happen when we are too excited and can't wait to make it happen. Or sometimes we are so invested in one outcome, or so buried in the process, that we lose perspective. But without an honest, thorough evaluation, plans can fall apart. Sometimes we're afraid to be critical because we don't want to hurt others we are working with. If someone is excited about an idea from the sketch phase, offering criticism can be awkward. It's even worse when this conflict isn't between you and someone else, but you and yourself. But criticism is necessary to give *and* receive. Remind yourself that evaluation is what makes the project stronger.

OVER-EMPHASIZING EVALUATION (or, "That will never work.")

We've all been in situations where a new member of a group makes a smart suggestion only to have it quickly shot down before it gets off the ground, often by someone jumping in with comments like, "Yeah, we tried that once back in 2004 and I can tell you, it is *not* going to work." The person giving this kind of criticism often thinks they are being helpful: offering a reminder of complex realities, or protecting the project from being released into the world before it's ready, but it also stunts creativity. We all fear the embarrassment of letting an idea into the world before it is ready, and this makes us more likely to be excessively critical and allow few ideas, if any, through the evaluation stage. Giving criticism that is productive, generative, and keeps people motivated may be the trickiest skill to master, even for the most experienced creative people, but with practice it becomes easier.

UNDER-EMPHASIZING ACTION (or, "We'll have plenty of time...")

The point of the process is an outcome. Developing a project is a lot of fun, but seeing it through to completion takes hard work. It demands

late nights and long hours, and heavy lifting of all kinds. The work usually doesn't go as planned: materials are hard to find, things break, people get sick, target locations shift, and police presence increases. These changes and setbacks happen in every project. Not accounting for the amount of work needed and the delays that inevitably occur can be depressing and debilitating. Producing good work takes a lot of work: we need to know and expect this.

OVER-EMPHASIZING ACTION *(or, "Enough talk, we just have to do this!")* Often, pieces are pressured by political deadlines. Or, participants may be frustrated with a lack of results and press the group toward

action. There are many reasons to push production at the expense of other stages. But all the elements of the creative process need to be well balanced for the final product to be any good. Creativity needs time and space; rushing the process to the final project is a recipe for an uncreative action.

And finally,

WRONG ORDER (or, "Whoops!")

Besides placing the wrong emphasis on a certain stage, another common mistake in the creative process is putting stages in the wrong order. We often see folks take on the Critic role too early, evaluating while they are still researching. Or they contaminate their artistic sketches with critical comments, like "This is terrible", or "I have no talent." Others don't evaluate until after they have pushed through the production stage: putting days of hard work into a project, only to stand back for the first time once it is done to see how they could have improved it.

When the stages are done out of order, we risk truncating the creative brainstorming necessary for innovative ideas, or putting half-baked ideas out into the world where they are bound to fail. We can move back and forth between the stages: a sketch that failed the evaluation stage needs to go back to research and sketching, before moving forward again. But even as we move back and forth, the stages of the process are meant to be followed in their sequential order. Walt Disney, with no shortage of money, created multiple rooms for each stage of his creative practice. As he and his team moved from one stage to the next, they would literally move into another room designed and decorated for that purpose. Building three additional rooms onto your apartment or studio may not be an option for you, but finding ways to silo each stage and giving it a distinct and clear time and place certainly is.

Working in a group can make the problem of sequence either better or worse. Different people have different strengths and

weaknesses. There's the person who loves to think up wacky ideas but never follows through on them. Or the overly critical member who finds fault in everything. If we let our critical comrade play too large a role in the research and sketch process, or put our friend with the fecund imagination in charge of production, we are asking for trouble. But as a collective we can recognize each other's skills and arrange the expertise of our group so our talents can complement instead of undermine one another's.

Perfection Is the Enemy of Completion.

WE ALREADY MENTIONED the need to "turn down the pressure" on yourself when discussing the creative habitat, but we also want to discuss a related problem that is so pervasive and so crippling to the creative process that it warrants its own section. This is the problem of perfection.

Perfection is the voice that creeps up while you're working on a project and whispers over your shoulder, "that could be a little bit better." It sounds like the voice of a friendly coach, so you listen. You keep reworking and polishing, and your piece does get a little bit better, in smaller and smaller increments. There's some movement toward this quest for an ideal, and it feels important — until you realize hours, days, or weeks have passed and you haven't actually completed anything. Sure, we owe it to the causes we are working on to always strive to do our best, but we also have to ask ourselves: What best serves the cause? And what cause are we actually serving? Within the world of art there's all kinds of myths and distortions around perfection and craft. In our idealized perceptions of artists, we often position them as magical people who make things perfectly the first time, or if not the first time, inevitably through their relentless pursuit of perfection. These myths of perfection and commitment are lauded, way past the point when they are helpful or even healthy.

Such was the case with Jay DeFeo, a Beat-era painter in San Francisco. DeFeo started working on a painting called *The Rose* in 1958. When she started, the painting was nine feet tall; it eventually grew

to eleven-and-a-half feet tall and seven-and-a-half feet wide. DeFeo worked on it in her apartment, adding layers of paint and reworking it, for *eight years*. In 1966, the painting weighed close to two thousand pounds and had eleven inches of paint on its surface. She was made to call it quits—for the time being—when she was evicted from her apartment, and her painting was so large and so heavy that movers had to carve out a two foot section of the wall below her window so that it could be removed with a crane. *The Rose* was moved to the Pasadena Museum that year, but DeFeo was still not done. She got a key to the museum so she could continue working on the painting adding "final touches" at all hours. The story of *The Rose* was told with reverence to art students when Lambert was a student at the San Francisco Art Institute as an exemplar of an artist with incredible commitment to her work; an artist in search of perfection. What wasn't mentioned in the aspirational tale of Jay DeFeo was that, at the end of that eight years of painting, her career had lost its momentum, her health and marriage were in poor shape, and she was depressed and drinking. Yes, DeFeo was committed to *The Rose*, but the commitment was mis-allocated. She had lost perspective.

Let's look at a counter example: the Kingsmen. Even if you don't know the band you've probably heard their early-1960s recording of

the rock classic, "Louie Louie." It won a Grammy Hall of Fame Award and *Rolling Stone* listed it as the fourth most influential recording of all time. It's still played regularly on the radio, in movies, and on TV shows. The song is so popular because it is intense and lazy at the same time, there's an undeniable drive to the rhythm, a casual ease to the playing, and exuberant shouts in the background. It's a good time. It's a great song. And it's not perfect.

There's a mistake on the recording—an obvious one. Following the guitar solo, singer Jack Ely comes in two measures early. After two halting words, Ely quickly realizes his mistake and stops short. The drummer also notices and adds an extra fill to lead the band back into the verse. If you listen closely you can even hear someone yell "fuck!" in reaction to the mistake. Today, this kind of mistake would be relatively simple to correct using sound studio software. "Louie Louie," however, was recorded in just one take in 1963. We like to imagine the conversation that happened after the tape stopped: "Jack screwed up. Do we do it again?" Maybe it was the constraint of the fifty-dollar fee they had scraped up to pay for the recording. Maybe they felt they couldn't get a better take. Or maybe it was something else. But we're betting someone responded, "Nah, it's good enough." And, it *was* good enough. "Louie Louie" is *transcendent*. When you hear it, you're not noticing individual instruments or technical musicianship, much less a blown bridge into the verse. You probably never noticed someone yell an obscenity. Why? Because you're feeling the song, probably dancing or singing along.

When working on a creative project, you can make *endless* progress toward perfection. Think instead of the Kingsmen: look for the point of diminishing returns and move on, because that point is often also the point of transcendence, where the imperfection makes it better than perfect. This point isn't always clear, but we can train ourselves to step back and recognize when what we've done is *good enough*. The Kingsmen didn't get caught up in perfection. And they reached a different kind of greatness through being "close enough for rock 'n' roll."

Abandoning the search for perfection doesn't mean being satisfied

with the first take. (We can't all be the Kingsmen.) Multiple sketches are critical for working out our ideas. But just as each sketch is necessarily imperfect, so will be the culmination of our creative process: our final piece. We need to work on it and work on it, but at a certain moment we need to let go. Picasso made forty-five sketches before he went to the canvas to paint his political masterpiece *Guernica* — but he didn't make 450. He researched, sketched, evaluated, but he also knew when it was time to produce. In order to have maximum political impact, his painting had to be done in time to be shown at the World's Fair in Paris in 1937. In the last draft of his painting Picasso changed its composition, raising the head of the horse that had lain in a heap on the ground so that it screams up into the sky, creating one of the most iconic details of the painting. Picasso knew it was good enough, and the result was transcendent.

Practice until it's *imperfect* in
Exercise 12 in your workbook

Double Standards

IN OUR WORK WITH ARTISTIC ACTIVISTS around the world, we've noticed the quest for perfection isn't contained to the work people do, but bleeds into how they live out their lives. There is often an expectation for people who take any political stance to have the

"right" position on everything: to be a master-in-all-things, an angel without wings. This criterion haunts the field. We sometimes force this unreal standard upon ourselves; other times it is enforced by critics and pundits with the charge "hypocrite!" With expectations like this, any inconsistency found in the work or behavior of the artistic activist is seen to undermine all their efforts.

Here's another way to consider this problem of perfection. It prevents us from experimenting, taking chances, taking breaks, failing, or, tragically, ever beginning. In the end, it justifies taking no action, for when we set impossible standards of purity and consistency that no human being can meet, then nothing we do will ever pass muster. Better than being imperfect, the perverse logic goes, is to do nothing . . . but then, of course, nothing changes.

We stand with Walt Whitman when he wrote:

Do I contradict myself?

Very well then I contradict myself,

(I am large, I contain multitudes.)

Double standards get a bad rap, but we can make them work for us. We should set a high standard; establishing ambitious goals for ourselves. This gives us direction and focus. But the reality is that if our goals are suitably ambitious, we'll always fall short. We must keep a second standard; what we'll settle for. And we need to be compassionate with ourselves when we land somewhere in between. We can

set out to permanently improve the dynamic of our neighborhood in concrete ways, and be happy when we are able to do it for an afternoon. We can aspire to never fly in jet planes because they destroy the environment, yet allow ourselves an exception in order to visit our elderly mother. We can hold one strict standard for what we strive for, and a more forgiving one for what we'd be happy to achieve.

No single action or artwork will cause a revolution or topple a government. If we hold ourselves to that standard, then everything is a failure. Living by a double standard, to us, means allowing ourselves a spectrum of success instead of a single point. It means having high standards that we aspire to, and understanding that we will usually fall short. This isn't failure, it simply means we are human.

Freedom of Constraint

PARADOXICALLY, LIMITATIONS AND CONSTRAINTS can stimulate creativity. Yet when we talk about constraints with artists and activists, they seem to get nervous and irritated. This is totally understandable, particularly for people who have committed themselves to artistic and political freedom. But too much freedom is as stultifying as too many constraints. Imagine making a piece for which you are given an endless amount of time, all the space you could possibly need, and the freedom to work in any medium. A bit stifling, isn't it? While total creative freedom sounds nice, in practice we all work within the limitations of certain physical places, the creative mediums we know or can learn, and the relatively brief period of time in which we are alive. It is because we have these few and relatively broad boundaries that we can be creative without being paralyzed by the infinite.

When we create we are always operating under real constraints: labor, budget, location, and timeline, as well as the purpose and message of our piece. These confine our creativity, but they can also enable it. Once the rules are known and defined, we can decide how to play within them. The rules of baseball are very specific, yet broad enough that games are played every day with different outcomes; personalities emerge, boring moments happen, and there are distinct

triumphs, controversies, joys, and so on. A blues song with a verse/chorus structure may seem simple and strict — only twelve notes, and four chords that change on a set rhythm — but that structure is what allows Jimi Hendrix to play a mind-bending solo in the second chorus. Fluxus artist Dick Higgins wrote about conceptual art *as* rules to a game. Higgins pointed out that when rules are well defined, they allow for all kinds of drama, excitement, and results.

Within all constraints there is flexibility. When we begin an artistic activism piece, the first thing to do is explore the edges and see if we can push against them: Can the piece happen sooner or later? With more or less time and money? Can we renegotiate the expectations? Can we expand what's possible or shift the terrain? Once we know the edges of the field we're operating in, we can create the rules for our game; expectations and potential strategies can become clearer. This also makes it easier for others to find a role in which to participate. With clear boundaries and rules we can all start playing.

Apply constraints creatively in
Exercise 13 in your workbook

The Slump

THERE IS ANOTHER IMPORTANT, and frustrating, stage of the creative process. It's called *the Slump*. No matter how great a project idea is, at some point in the process of making it happen, an invisible authority will make itself heard, often in your own voice, telling you "This will never work!" or making innumerable other utterances falling within the category of Reasons to Quit. Ask any creative person and, if they're honest, they'll tell you this happens at some point in *every* project.

The slump often looks something like this:

You start up real high, with a great plan, full of confidence, and then, as you seek to bring things to fruition, the inevitable decline

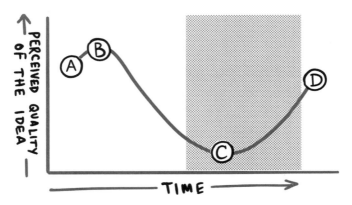

A: "I JUST HAD AN IDEA"
B: "THIS IS THE GREATEST IDEA"
C: "THIS IS A STUPID IDEA"
D: "THIS TURNED OUT PRETTY GOOD"
▨ : THE HARD PART.

begins: you don't have the budget you need, the materials you wanted are not available, it's not looking like you thought it would ... until you hit the point where you contemplate quitting. But if you don't quit and you work your way through the slump, you will start to climb back up: a friend comes through with a donation, the limitations in materials force you to make interesting changes — it looks different, but in a good way. The place you reach may never be as high as where you began, as reality never meets expectations, but it'll be *good enough.* And remember: the Slump will try to trick you into thinking it's the Critic. The voice can sound like the smartest, most rational voice you've ever heard. It's wrong.

Confront your slump (and overcome it)
with Exercise 14 in your workbook

Risk and Failure

A FINAL THOUGHT ON THE CREATIVE PROCESS. All creative work involves risks, the most daunting of which is the risk of failure.

To open your eyes to new things, to try new combinations, means leaving the tried and true, safe and sure. Sometimes your creativity will result in something great, and sometimes in epic failure, and if you practice really hard, it will most often result in something *good enough*.

Experimenting with new forms of creativity might make you feel uncomfortable at times, and that's good. Your current work methods are familiar and generally work for you (even if not as well as you'd like). When we move away from what's comfortable onto a new pathway, our footing is unsure, we can stumble and fall. This discomfort is part of growth. You will make mistakes. We all make mistakes. These are not the kind of mistakes one makes every week or so, more like every few minutes, and even the most experienced creative people still make them. But stick with it and you'll learn how to identify missteps as they begin to happen and correct them more quickly. It is all part of the process.

Process and Progress

ARTISTS DEVELOP THEIR CREATIVE PROCESSES throughout their entire career. Artistic activists are no different. This is a life-long journey we are on. Once you understand the concepts and begin to practice them, you will adapt them to your particular work in a way that makes sense for you. You will discover *your* creative process.

A good creative process is what's behind any successful artistic activist piece. But it's important to remember that process is just that: a process, and the point of a process is *progression toward a goal*. Among activists and artists there are those who will say "It's all about the process." But it's just as easy to fetishize process as it is to fetishize the product. There are real outcomes we're striving for—ultimately, we want to change the world. This means we need to step off the curb and take action.

Track your progress through
Exercise 15 in your workbook

CHAPTER

3

HISTORY

"History is a gallery of pictures in which there are few originals and many copies.

—ALEXIS DE TOCQUEVILLE

"Most of my heroes don't appear on no stamps.

—CHUCK D, PUBLIC ENEMY

All Successful Activism Has Been Artistic Activism

IT'S A CLICHÉ TO SAY that we learn from history. But, like with many clichés, there's a truth behind it. We learn from past successes and past failures, from people of the past whose struggles we identify with, and from those whose actions we oppose. And one lesson the past can teach us is that artistic activism is not anything new. Given the mass mediated, spectacle obsessed, hyper-aestheticized world of today, it makes sense that artistic forms of activism are currently being embraced by an increasing number of activists. But activists throughout history have used creativity and culture to wage their struggles for social change. And from the activists and organizers who came before us we can learn principles of artistic activism to employ today.

The history of artistic activism told in this chapter is not comprehensive. Not even close. Aside from the fact that one could fill several volumes writing this history, many of those whose stories are told in this chapter would not necessarily call themselves artistic, and some might not even describe themselves as activists. What we've tried to offer here is a creative perspective on a history of social change, looking at moments of political transformation through an aesthetic lens. Most of our examples are based in the United States because this is the context we know best, but once you know how to look for them, historical examples of artistic activism are not hard to find. You'll see them in the histories you know best. All great activism is artistic activism, and it always has been.

Another warning: as with the contemporary examples of artistic activism in chapter 1, the examples here *won't work for you*. Everything we are about to describe was created in and for a particular time and place. We should not seek to replicate the examples of history but

to learn from them. And we can, because each of the specific examples in this chapter embodies general principles that are applicable to artistic activism at any time and any place. Creativity comes from combination.

Jesus

IN OUR WORKSHOPS, when we reach the history section we like to start with the example of Jesus (we have lessons on Moses and Muhammad too).

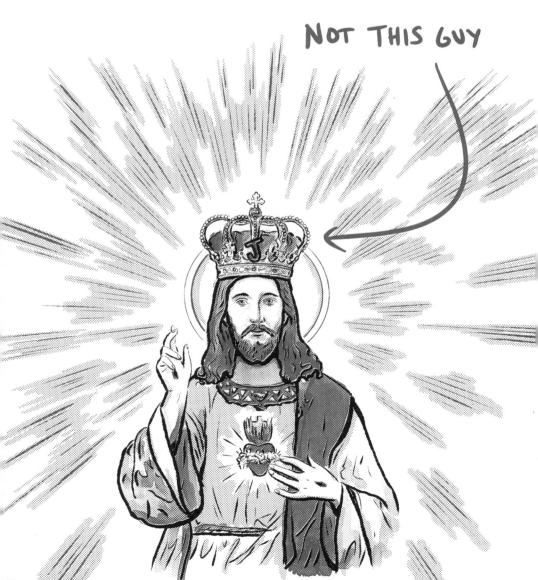

NOT THIS GUY

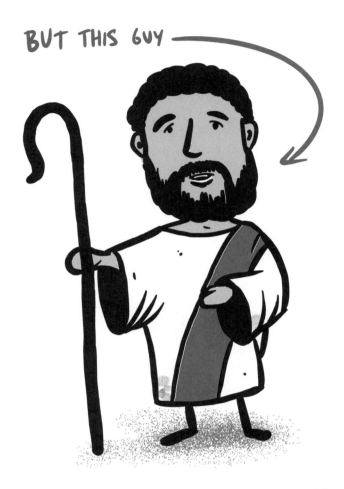

BUT THIS GUY

This is the historical Jesus: the Mediterranean Jewish peasant taking on religious authorities and the Roman Empire and building a revolutionary movement two millennia ago. Not Jesus Christ, but Jesus of Nazareth. We are interested not in the divine figure but in the on-the-ground militant. Jesus was, among other things, an activist and an organizer, and, judging by the two thousand-year lifespan and global spread of his message and movement, a pretty good one. Like other great religious leaders — Moses, Mohammed, the Buddha — Jesus was successful, in part, because he approached activism and organizing

artistically. Jesus understood the fundamentals of using story and spectacle, signs and symbols as means to criticize the status quo and offer up an alternative vision. The proselytizing we are interested in doing is political not religious.

Jesus knew how to kick off a protest. When he entered the main temple of Jerusalem and saw people changing money and selling ritual objects, Jesus was pissed. He could have stood outside and harangued the passersby with his opinions on keeping sacred places sacred, the ancient equivalent of the activist on the soapbox, but instead he demonstrated his politics through a spectacular act of civil disobedience. He physically threw out the money changers and kicked over their tables, using his body and his actions to convey his message. It was an æffective political performance so provocative that news of his deed, and therefore his message, traveled throughout the city.

The principle: demonstrate your politics.

In the United States we use the words "demonstrate" and "protest" synonymously. It's a meaningful slippage, and one we don't think about enough. When we protest we are also *demonstrating* to the world who we are, what we believe in, and how we'd like the world to be. (The Spanish word for protest, *manifestación*, works much the same way.) Jesus, like most good artistic activists, understood the power of demonstrating his politics.

———

CONSIDER NEXT JESUS'S method of communicating his message. He didn't deliver laws, he didn't hand down commandments; rather, he told stories . . . often stories that don't seem to make much sense. One of his most famous parables involves likening the Kingdom of Heaven to a mustard seed. We don't really understand the analogy, and we're not convinced anyone else really does either. This confusion was intentional. Using parables like these, Jesus created an opening for his audience to make the message their own. Unlike a list of grievances or demands, easily understood and just as easily ignored, the parables asked listeners to puzzle through their mysteries and meanings. One can imagine the scene following one of Jesus's impromptu teachings: people walking away, debating among themselves what exactly this wacky holy man meant. And with every argument and counter-argument they made, Jesus's words ceased to be his alone. Through interpretation, his teachings became the common property of his audience and cemented their belief.

The principle: don't preach, teach.

As any good teacher can attest, rote learning lasts only about as long as the next test. If you want your students to remember the lesson, and to integrate it into their lives, they need to puzzle through it, process it, and make it their own.

———

JESUS WAS FAMOUS for his miracles, but he was not the only one of his time to be well-versed in the arts of spectacle. Faith-healing and magic tricks were stock-in-trade for the many wandering holy men and prophets (The Amazing Jacob! Disappearing Jebediah!) who used public demonstrations of their supernatural power as a means to fame and fortune. These miracles, implausible by our standards, were the popular entertainment of the time. Jesus, by all accounts, was an adept performer within this common culture. Learning to work within the popular cultural medium is a good lesson for any activist to learn, but what is truly inspiring are the creative ways in which Jesus used, and didn't use, this medium. When asked by the Devil, and later by Roman imperial authority, to perform miracles to benefit himself, Jesus refused. Instead he healed the physically and mentally ill, calmed the seas for simple fisherman, and conjured up food and wine for the multitude.

It matters little whether these miracles happened or not; what matters is the message his spectacles communicated: an ideal of power not used selfishly to privilege oneself, as it often is, but as a gift for helping

others, caring for and sharing with those on the bottom of society. In brief, he used popular culture to articulate a message that ran counter to its traditional practice. Jesus was a master of "ethical spectacle."

The principle: use the spectacular vernacular.
Artists and activists are always operating within a cultural context. In order to be heard and understood, an activist needs to learn how to use popular culture, but they also need to know how to transform it so that it speaks to and for their own cause.

JESUS AGAIN EMPLOYED popular culture creatively when he entered Jerusalem during Passover riding a donkey. He knew, as did his audience, that biblical passages foretold that the savior would arrive riding upon a simple beast. Jesus borrowed the old story and turned it to his own use. But, beyond this, he was acting out his vision of a better world tomorrow though employing creative tactics in the present. By entering Jerusalem on a donkey—the titular "Son of God" seated upon a lowly ass—he performed his ideal of a world turned upside down in which "the last shall be first, and the first last." This spectacle was even more powerful because it happened on the same

day as the official entrance to Jerusalem—with all their pomp and circumstance—of the religious and political elite. Jesus prefigured the future in more everyday ways as well; for instance, through his dinner parties. By sitting down to the meaningful ritual of dinner with women, tax collectors, sinners, and the ill, Jesus enacted in the present the egalitarian community he envisaged for the future.

The principle: prefigure the future.

When we act in order to bring about social change, it's important not only to "demonstrate" what we are against in the here and now, but also to create a vision of the world we would like to bring into being in the future. It is not enough to merely criticize the way things are. This, perversely, can actually reinforce the status quo by recentering what is. What's also needed are new models for the way things might be.

———

THERE IS A STIRRING SCENE in the Gospels in which Jesus is asked by religious officials whether it is proper to pay taxes to the Roman imperial authority. It's a trick question. If Jesus answers "yes," then he undermines his message of rebellion, but if he answers "no," he can be arrested for treason. So this is what Jesus does: he asks those confronting him to take out a coin and tell him whose image is stamped upon it. As the coin is Roman, the visage is Caesar's. Jesus then replies: "Render unto Caesar the things that are Caesar's and to God the things that are God's." Jesus's typically cryptic answer has been discussed and debated for millennia. The most common interpretation is that Jesus is preaching an apolitical stance: Church and State, religion and politics, shouldn't mix. Maybe. But here's a more radical interpretation: Jesus is arguing for a deeply political reframing of reality. The Roman Empire is to be rejected, sure, but not on its

own terms whereby we either pay or do not pay the prescribed taxes. To play that game means accepting the Empire's rules: pay or not, we are still in the position of reacting to the Romans. Instead, Jesus is saying that if we are going to be truly liberated from the Empire, we need to create, embrace, and enact an entirely different way of seeing and being that refuses to acknowledge its authority.

The principle: shift the terrain.
We need to learn to fight on the terrain of our enemy. But there are also times when we can shift the terrain to one more advantageous to ourselves. While it's often impossible to change the physical realities of our situation, we can change the ways in which people make sense of that reality. There will always be death and taxes, but in shifting the terrain of the debate Jesus figured out how to escape both.

FINALLY, BY ACCEPTING and even embracing his own execution, Jesus refused to do for his followers what they needed to do for themselves. By removing himself from the scene at the very moment both his friends and enemies demanded him to lead, Jesus put responsibility back upon his followers. He let the people know that if the world was to be changed, then they would have to be the ones to change it.

Alas, this is not the interpretation of Jesus's crucifixion that has persevered. The Christian Church, in its effort to stabilize his radical message and institutionalize his authority, transformed Jesus's decentering sacrifice into an act of self-aggrandizement meant to inspire guilt in people. There's a good lesson here for activists about the elasticity of symbols and the dangers of co-option, but we think Jesus was trying to impart an even more valuable one. His message was not "I do this all for you," as we've been taught, but instead "I am *not* your savior; you need to do it yourself." For those of us interested in building a truly democratic society, one in which all people have the capacity to lead, this may be his most important lesson of all.

"ALL PART OF MY PLAN."

The principle: empower the people.

We are taught that history is made, and changed, by leaders. This is partly true: leaders often provide the skills, perspectives, examples, and charisma that are necessary for social movements. But it is people who make up those movements, and if change is to be far-reaching and sustainable, then all of us must be the movement. The mark of a good leader is to train others to lead, give them the tools to succeed on their own, and then get out of the way.

In addition to teaching us that artistic activism is not only a modern strategy for social change, Jesus, and the movement he spawned, holds another important lesson that is relevant here.

> Though I am free and belong to no one, I have made myself a slave to everyone, to win as many as possible. To the Jews I became like a Jew, to win the Jews. . . . To the weak I became weak, to win the weak. I have become all things to all people so that by all possible means I might save some.

These are the words of one of Jesus's later followers, Paul, who was to become the crackerjack organizer for the early Christian Church. His moral: that an effective activist, if they want to reach anyone with their message, needs to adapt to who, what, and where people already are—to "become all things to all people."

To be honest, we have mixed feelings about Paul. He was a great organizer, but what he organized the Jesus movement into is not really to our liking. Paul's words here, too, are in equal parts offensive and inspiring. Offensive because Paul presents himself as a rank opportunist, a shape-shifter, willing to "become all things to all people" just so that he can get his message across. Inspiring, because Paul understands the power of empathy and how human beings can use commonalities to connect with others unlike themselves.

Jesus is an example of an influential figure that Christians, including many who hold conservative politics that we might not agree with, can relate to and thus learn from. In Jewish communities, this figure might be Moses; among Muslims, the Prophet Muhammad; for Buddhists, Siddhartha Gautama; and for Hindus, stories from the Upanishads. All are treasuries of creative techniques for winning hearts and minds that can provide lessons and inspiration. Of course, religion isn't the only influential force in people's lives. Secular societies often find their salvation through mass culture, their messiahs taking the form of pop stars, athletes, and celebrities. Here, too, it matters little whether we personally share these passions and beliefs. If we want to reach out to people beyond our own small circles then we need to speak in a language that is widely understood, finding inspiration in the figures

that inspire others. To be an æffective artistic activist in today's world might just mean asking yourself "What Would Jesus or Mohammed or Krishna, or even Kim and Kanye, Do?"

<u>The principle: talk the talk.</u>

The cultural symbols, stories, characters, and images that already exist in the world can inspire and be mobilized in the service of artistic activism in order to change that world.

The American Revolution

LET US NOW SKIP AHEAD nearly 1800 years, to a revolution both secular and closer to your authors' home: the American Revolution. The American Revolution was many things. It was a war between different factions of the economic and racial elite of America and Britain, and it was a radical people's war against a colonial oppressor. One of the first political actions of the American Revolution was the Boston Tea Party. On the night of December 16, 1773, white activists dressed up as Mohawk Indians, climbed aboard ships in the Boston harbor, and dumped crates of tea into the harbor to keep it from being unloaded and sold. It was staged to protest the British Tea Act by which the British Government, which did not represent the American colonists, levied taxes on them and thereby violated their "rights as Englishmen."

The Tea Party worked on both symbolic and practical levels. Not

only did the dumping of the tea demonstrate visually the colonists' protest against the Tea Act, but, by destroying the tea, they were denying profits to the quasi-governmental East India Company and the ability of the British Government to tax the imports. The activists also understood the power of politics as performance. By dressing up as Mohawk Indians, the colonists were able to act out things that they would likely have been reluctant to do as law-abiding citizens and "civilized" white men. This red-face pantomime was despicably racist, yet it was also a brilliant spectacle. Dressing up and dumping tea in the harbor was tailor-made for the colonial American popular imagination. The Tea Party occurred on a cold evening in December, with no lights and probably very few spectators — but that's not how it has been memorialized. The colonists understood that with effective staging they could create an image to be remembered.

The principle: stage a spectacle.

We frequently present others with "the facts," expecting these to speak for themselves. They rarely do. People like to visualize ideas. Pictures help give a form to abstract theories, causes, and grievances. Spectacles are a public way to draw a picture.

"ONE IF BY LAND, two if by sea." Every school child in the United States learns of "the midnight ride of Paul Revere" to warn colonists of an impending attack by British troops. Here's what they don't teach you: Paul Revere's ride was relatively unknown at the time of the Revolution. It wasn't until nearly a hundred years later, when the famous poet Henry Wadsworth Longfellow wrote Paul Revere's Ride, that the ride became part of American popular history. The creative action here is not Revere's ride, it's Longfellow's retelling. Published on the eve of the U.S. Civil War in 1861, the poem was making an appeal to a unified American identity by creating a national hero of Revere.

The principle: tell a story.

We often act as if people are encyclopedias in the making, waiting to be filled up with facts and figures. They aren't. People need to make meaning out of ideas, and one of the ways they do this is through stories. Narratives are a way to string together facts and figures, characters and motivations. They give ideas emotional resonance by placing them within a human drama. In short: stories help us to "make sense" of our politics. (We'll discuss how this works further in chapter 5 on cognition.)

THE U.S. CONSTITUTION, opening with the epic words, "We the People of the United States," created the legal and political framework for the government of a newly independent country. But the document had a cultural role as well: in a nation composed of semi-autonomous states, and inhabited by people of multiple national origins and ethnicities, who were not all in agreement, the Constitution constituted and cemented in the public mind a new, and questionable, idea of a democratic nation. In other words, there was no "We the People," nor even a "United States" at the time of the drafting of the Constitution. The Constitution created them. "The People" were white male property-owners, but the concept did also serve to create an ideal of "the people" that would later be drawn upon by others — women as part of the feminist movements, African Americans as part of the civil rights movement, and, today, right-wing populists — to make their own claims to be counted as the people of the United States.

<u>The principle: act as if.</u>

A great deal of activism and political art is directed toward criticizing what we don't like. Occasionally it suggests the steps we might need to take to change things. But sometimes the best way to bring the world we want into being is to act "as if" it is already here. This takes "prefiguring the future" (see above) a step further, where we are not only suggesting that this is how things ought to be, but insisting that the future has already arrived. In doing this, we bring the future into our present and normalize as reality a state that still only exists in our imaginations.

The U.S. Civil Rights Movement

OUR NEXT EXAMPLE took place almost two hundred years after the American Revolution. Through the 1950s and 1960s, the civil rights movement involved tens of thousands of people and won rights for millions. The struggle of African Americans for civil rights was one of the most successful activist campaigns in U.S. history. It was also a consciously creative campaign.

This is how we often remember that movement: masses of people led by the shining star of courage and righteousness, the Reverend Martin Luther King Jr. There is no doubt that King was a courageous and righteous leader, but his power, and that of the broader movement, was collective and cultural.

The civil rights movement would have been inconceivable without its foundation within Black churches. This network of institutions supplied organization and leadership for the movement, as is well known. But it also provided something equally important: culture. The Black church provided the creative material, the images and narratives, with

which to imagine a successful struggle against great odds. The story of Moses and the Jewish slaves fleeing bondage under the Pharaoh to freedom in the promised land provided a template for imagining an alternative future. The churches also fostered solidarity through the communal experience of singing spirituals like "Let My People Go," and provided songs that served as the soundtrack to the civil rights movement. Finally, the Black churches provided a place to collectively perform acts of creation and imagination. Each Sunday, a different society, one not controlled by whites, was celebrated.

The principle: build upon cultural foundations.

We never start at zero, and it's a mistake to think we create something from nothing. We are always drawing from repositories of words, images, and meanings that already exist. This is what makes changing society so hard: we are working within the very culture we are trying to change. But within even the most oppressive of societies there are pockets of counter-culture and of resistance that provide a cultural foundation — stories, songs, and institutions — upon which we can build.

———

THE CIVIL RIGHTS MOVEMENT didn't just draw upon pre-existing songs, stories, and imagery, it created culture anew. This is seen in the example of Rosa Parks, a tired seamstress who in 1955 refused to give up her seat to a white man to sit in the back of a segregated bus in Montgomery, Alabama.

Parks's action is well known, with many attributing it to have propelled the civil rights movement into the public eye, but the story behind it is lesser known: it was a planned performance by an accomplished political actor. Parks was an experienced activist and political organizer who trained at the Highlander Center, a progressive politics and cultural training center in Tennessee, and was the secretary of the local chapter of the National Association for the Advancement of Colored People (NAACP). When she refused to move from her seat, she was well aware of the power of her action and what the ramifications would be.

Rosa Parks also wasn't the first Black woman to be arrested for refusing to give up her bus seat in Montgomery. Claudette Colvin, a fifteen-year-old girl, had done the same thing nine months earlier. But Parks was a seasoned political operative and provided a more mature and sympathetic face for the press. And the iconic photograph of Parks seated on the bus? It was staged on an empty bus one year after her action. The white man pictured sitting behind her is

not the racist who demanded her seat, but a United Press reporter whose placement was intended to create racial contrast. This is the real Rosa Parks story.

That this was a staged performance doesn't mean that Parks's act of civil disobedience wasn't "real." When she refused to give up her seat that day she was, no doubt, tired from her long day of work as a

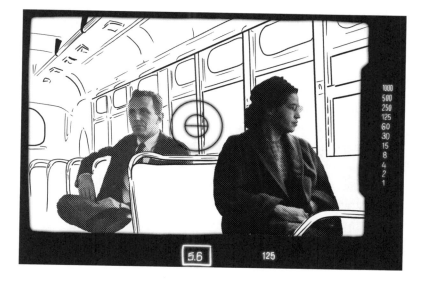

PARKS'S ACT WAS ALSO A **PLANNED PER** INTENDED TO **DRAMATIZE** THE **REALITY** INEQUALITY TO A LARGER WORLD THAT EITHER OR **DIDN'T CARE.**

seamstress, and it is true that she could not sit in the front of the bus in the segregated South. But, beyond this, her act was also a planned performance intended to dramatize the reality of racial inequality to a larger world that either didn't know or didn't care. And it worked.

The principle: perform reality.

We often think of performance as something that manifests a fiction. Here, it usefully allows us to visualize and to act out our dreams, to "demonstrate" our convictions or prefigure our ideals. In addition to this, however, performance is useful for dramatizing what already exists. Sometimes reality needs help.

NOWHERE, PERHAPS, WAS the civil rights movement's "performance of reality" better demonstrated than in the 1963 Southern Christian Leadership Conference (SCLC) campaign to desegregate Birmingham, Alabama. So many famous images of the dignity of the civil rights movement, and the brutality of Southern racism, come from that demonstration: unarmed men being attacked by police dogs, firemen turning their hoses on peaceful protesters, and school children being marched off to jail. Like the image and story of Rosa Parks, we know these well.

FORMANCE OF RACIAL DIDN'T KNOW

What's less well known is that the SCLC's desegregation campaign was also staged. In fact, it was staged twice. Prior to the Birmingham events, a similar protest had been attempted by the SCLC in Albany, Georgia, but it failed. It failed in part because the police simply, and relatively non-violently, arrested everyone and held them in isolated jails across the state. No conflict, no images, no story. The SCLC treated this experience as a test run.

It planned its next protest to take place in Birmingham, a city with a long history of labor and civil rights organizing, and an equally long history of virulent racism (a Black church had just recently been bombed, killing four young girls). Another key factor in the civil rights activists' decision upon Birmingham was one man: Theophilus Eugene "Bull" Connor.

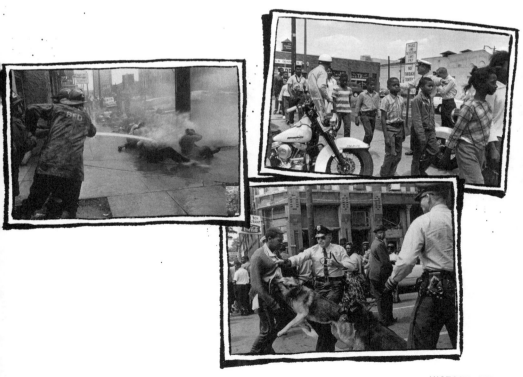

Bull Connor was the acting Commissioner of Public Safety in Birmingham. He was also an open bigot, an ex-member of the Ku Klux Klan, and known for his brutal policing methods. Given his history, the SCLC figured that Connor would overreact, and instead of quietly arresting protesters and hiding them out of sight, he would unleash the full fury of the police and fire departments on the protesters for the assembled media to witness and record. Which is exactly what happened. The result produced images of the struggle for civil rights that assisted with the SCLC's campaign: images of Black decency and courage, and of the violence and racism of white officials. King cast Connor in the role of villain and he played it perfectly. One year after the desegregation campaign in Birmingham, the Civil Rights Act was passed in the U.S. Congress and signed into law by the president, guaranteeing voting rights and ending racial segregation.

<u>The principle: make the invisible visible.</u>

Problems are often hard to see. Racist violence frequently happens in back alleys and after the sun goes down. Economic inequality is often the result of abstract forces. Ecological degradation takes place over long periods of time. And most people would simply rather look away from things that make them uncomfortable. By dramatizing those aspects of reality that are hard to see, or that we are reluctant to look at, we can make the invisible visible. As King himself wrote from his Birmingham jail cell: "Like a boil that can never be cured so long as it is covered up but must be opened with all its ugliness to the natural medicines of air and light, injustice must be exposed, with all the tension its exposure creates, to the light of human conscience and the air of national opinion before it can be cured."

Black Power!

THE CIVIL RIGHTS MOVEMENT taught a generation of activists about the power of image and performance, and these lessons were passed on — most immediately to the Black Power movement and groups like the Black Panther Party.

The Black Panthers formed in Oakland, California, in 1965 in response to police violence against African Americans. Distancing themselves from the suits and ties and reformist politics of the civil rights movement, they dressed and acted the part of militant revolutionaries: wearing berets and black leather jackets, sporting Afros and dark sunglasses, raising their fists in the air, and, where they could, openly carrying guns. They were, quite simply, the coolest, baddest, hippest looking people around.

The principle: style matters. People associate the message with the messenger, and how we appear in public communicates a message that is often more powerful than the words on the pamphlets we hand out. This is why early civil rights activists dressed in coats and ties

Black Beret

Big Gun

Leather Coat

Bandolier

Not Pictured:
Free Breakfast for
Children Program,
community health
programs, news
service, education
programs, conferences,
ambulance service,
drug and alcohol
treatment, clothing
distribution, campaigns
for office...

and the Black Panthers wore leather and berets: both communicate
a message, to different audiences and in different contexts. Perhaps
more important, people associate the very idea of activism with how
we present ourselves. But style is not just about, or even primarily
about, what we wear: it's about the overall image we project. If we
look joyful and confident, then this is what we are saying activism
assures. If we look dour and defeated, then the promise we make is
the opposite. We, as artistic activists, are part of the art of activism.

The militant message and style of the Black Panthers resonated with younger activists and spread from the African American community to other groups like the Chicano Brown Berets, Puerto Rican Young Lords Party, Asian American Political Alliance, and the American Indian Movement. These groups were all masters at artistic activism.

A particularly powerful piece of artistic activism was staged in 1968 by a group of Native American activists who invaded and occupied Alcatraz Island in the San Francisco Bay. They militantly claimed the former prison complex as sovereign Indian land. But they didn't forget to bring their sense of humor. In front of assembled news cameras they made their case:

> We, the native Americans, re-claim the land known as Alcatraz Island in the name of all American Indians by right of discovery.
>
> We wish to be fair and honorable in our dealings with the Caucasian inhabitants of this land, and hereby offer the following treaty: We will purchase said Alcatraz Island for twenty-four dollars ($24) in glass beads and red cloth, a precedent set by the white man's purchase of a similar island about 300 years ago. We know that $24 in trade goods for these 16 acres is more than was paid when Manhattan Island was sold, but we know that land values have risen over the years.
>
> 1. We feel that this so-called Alcatraz Island is more than suitable for an Indian Reservation, as determined by the white man's own standards. By this we mean that this place resembles most Indian reservations, in that:
> 2. It is isolated from modern facilities, and without adequate means of transportation.
> 3. It has no fresh running water.
> 4. It has inadequate sanitation facilities.
> 5. There are no oil or mineral rights.
> 6. There is no industry so unemployment is great.
> 7. There are no health care facilities.
> 8. The soil is rocky and non-productive; and the land does not support game.
> 9. There are no educational facilities.
> 10. The population has always exceeded the land base.
> 11. The population has always been held as prisoners and kept dependent upon others.

The message the activists sought to communicate was a gravely serious one, but they also understood that using humor in its delivery meant that it had a better chance of being heard.

The principle: be seriously funny.

Humor is a key element in successful artistic activism. Where polemics and assertions put people on guard, and ask them to either agree or disagree, humor works more obliquely and doesn't demand that a person take a stand, at least not immediately. As such, humor allows us to reach people who would otherwise shut us and our message out.

HUMOR IS ALSO important for activism in another way: it creates connections. It takes at least two people for a joke to work. This is something the stand-up comic is painfully aware of when faced with a silent audience. When a joke bombs, the failure is palpable. But when a joke works, it builds an emotive bond between the joker and the people laughing. This is particularly true for satire and irony, where in order to "get" the joke and understand the message, the audience has to fill in the reverse of what the comic is saying. And because laughter is a way we connect with others, we're more likely to share something we find funny. When humor is done well, it is a powerful political weapon.

While style and humor were at times important components, Native American and Black Power activism was often expressed through militancy. At the time of the civil rights movement, the assertive image of groups like the Black Panther Party was a potent symbol for young people of color who saw the limits of legal reforms and were impatient with the movement's progress. But this powerful symbol was double-edged. The militancy that for young activists of color was a symbol of power and pride was perceived as threatening and dangerous by the majority of the white population, who were terrified by images of Black people carrying guns and calling for revolution.

The Black Panther Party understood the political liabilities of such representations early on and began expanding in other directions, launching campaigns that replaced direct confrontation with their enemies with programs that made a positive impact on their own communities, like the BPP Free Breakfast for School Children. But the image of violent Black militancy was hard to shake — particularly when it was manipulated by the Federal Bureau of Investigation's COINTELPRO program, which engaged its own form of "artistic activism" by producing hate literature (including a comic book) that it ascribed it to the Black Panthers.

Exploiting negative rhetoric and images associated with militancy in order to justify their actions, the FBI and local police forces launched operations to harass, arrest, and murder members of the Black Panther Party, American Indian Movement, and many other

THE ONLY GOOD PIG, IS A DEAD PIG

militant groups. There were protests against this, most notably when Black Panther organizer Fred Hampton was assassinated by the Chicago police in his bed. But the public outcry that had erupted in response to the images of Bull Connor attacking school children in Birmingham was largely absent. Too many whites—the infamous "silent majority"—were willing to believe that such groups posed a violent threat and (whether explicitly or not) supported the incarceration or assassination of their members.

The principle: symbols are slippery.

We need symbols, they are a way of making groups, causes, messages, and ideals less abstract, more visible, and easier to convey. But symbols are slippery: they can and will be interpreted differently by different audiences. We need to be aware of how the words we use, the images we employ, and the performances we stage will be made sense of in various contexts. Our opponents can consciously manipulate our symbols for their own ends, and we need to operate with the assumption that they will.

United Farm Workers

YOU DON'T NEED TO AGREE with Marx and Engels that "The history of all hitherto existing society is the history of class struggles" to acknowledge that the struggle between labor and capital is an essential part of the history of social movements. The labor movement pioneered the use of many activist tactics we take for granted: the march, the rally, the picket, the strike, and the sit-in. Some of these tactics may now seem tired and overused—to emblematize exactly what we, as artistic activists, are trying to challenge and change—but at one time they were the cutting edge of creative innovation.

The United Farm Workers union was one of the great innovators of the labor movement in the United States. The UFW grew out of a community rights organization founded in California in 1962 by Chicano activists César Chávez and Dolores Huerta, among others. It became a labor union three years later when it joined with the Filipino led labor group, the Agricultural Workers Organizing Committee. From the beginning, the UFW realized that organizing farm workers posed a unique set of challenges. The workers were not protected by existing

labor law and health regulations. They were poor, marginalized immigrants who often did not speak English, and nor did they share a single language among themselves. And then there was this problem:

Unions had traditionally organized in factories. When factory workers held an action, like a strike or a picket, it usually took place in or near big cities, and within sight of reporters, photographers, politicians, and passersby. But farm workers worked in the middle of nowhere, far from cities, towns, or even roads. The workers were largely invisible, not only to broader society, but to each other. Unlike industrial workers who worked together in big factories, farm workers were scattered over thousands of fields on hundreds of farms.

Like the civil rights movement, the UFW needed to make the invisible visible. What needed to be seen, however, were less acts of individual injustice than the collective struggle for justice itself. To do this, the UFW used cultural tactics. Mashing up the traditions of the protest parade with the religious procession, and drawing upon the familiarity and authority of a powerful symbol of Mexican Catholicism, they marched with images of the Virgin of Guadalupe in their protests. They mobilized traditional art forms, like colorful public murals that drew upon their rich political history, and protest songs that adapted the conventional *corrido* to a new history-in-the-making. The UFW also forged artistic alliances with theater groups like Teatro Campesino (founded by a member of the famed San Francisco Mime Troupe) and poster makers coming out of the burgeoning Chicano poster movement. Using culture and the arts as a form of communication, the UFW was able to represent its struggle both to other farm workers in the rural fields, and to potential supporters in big cities.

The principle: culture is communication.

When we think of communications we often think of written words: reports, fact sheets, emails, text messages, and the like. These are all important. But there are other forms of communication we can utilize that are sometimes more effective. Important political messages can be communicated through

performance, song, images, and symbols, appealing to different senses. The UFW understood that art moves people and needs to be part of all aspects of the movement.

EMPLOYING CULTURAL SYMBOLS in its marches was not the only way the UFW organized artistically — it also approached the nuts and bolts of labor organizing creatively. The UFW knew that the traditional tactic of union organizing, the strike, wouldn't work in the middle of a field. Who would see it? Prairie dogs? The UFW had to bring its struggle to the places where people lived, and involve more people than the farm workers themselves. Its solution: the boycott. The UFW asked consumers to boycott agricultural goods produced by farms that wouldn't allow its workers to organize. The boycott brought the struggle out of the fields and into the streets and stores. It was a way for the UFW to extend to consumers an invitation to *participate* in the

workers' struggle, thereby dramatically expanding its field of engagement. Families around the dinner table who, in terms of ethnicity, geography, and class, were worlds away from the farm workers of the UFW, could become part of the struggle. And this lesson of solidarity wasn't taught at an infrequent rally or faraway protest, but through the domestic and everyday habits of ordinary people. This was the genius of the UFW boycott.

The principle: think artistically about all activism.

Thinking creatively about tactics doesn't simply mean "adding" the arts to our actions and campaigns — using symbols, making images, staging spectacles, and telling stories — it also means thinking creatively about the seemingly non-cultural aspects: tactics, strategies, objectives, goals, and organizational structure. The United Farm Workers thought creatively about the relationship between labor tactics and their own unique material and cultural context and came up with something innovative, and most important, æffective. As artistic activists, we need to do the same.

Feminism(s)

OVER THE PAST ONE HUNDRED YEARS, feminist movements have transformed the political, legal, and social status of women in many parts of the world. Feminism also succeeded in radically redefining what we mean by "politics" itself. The range of accomplishments that can be attributed to feminism are impressive, but it is important to note that this is not a singular movement proper to any one place or time, but multiple different movements that continue to evolve.

In the United States, the "first wave" of feminism began nearly a century ago with (largely white) women demanding the right to vote. The suffragettes were portrayed in the mass media either as irrational women who could not be trusted with the vote, or as pants-wearing, masculine brutes, and thus not really women at all. Early feminist activists recognized that in order to convince the patriarchal establishment to give women the vote, they needed to create a different image of both their cause and themselves.

In 1913, over five thousand suffragettes wearing long white dresses, pushing baby carriages, and led by a woman astride a white horse, staged a march on the Capitol in Washington DC for their right to vote.

They countered negative stereotypes, not by directly refuting them, but instead by appropriating "positive" symbols and associating these with their movement. Their march on the Capitol drew on symbols of white feminine purity and respectability and on Victorian middle-class ideals of "true womanhood." Using traditional cultural myths and symbols about women and femininity, they legitimized their decidedly non-traditional agenda. Through creative tactics like these, first-wave feminists succeeded in creating a social context in which women's suffrage could be perceived as both possible and positive, rather than outlandish and menacing. And it worked. The march was viewed by the *New York Times*, no great friend of feminism, as "one of the most impressively beautiful spectacles ever staged in this country." Seven years later, the Nineteenth Amendment to the Constitution was passed by Congress and signed by the president, giving women the right to vote.

The principle: don't just create, appropriate.

The dominant myths and symbols of society have real power, both intellectual and emotional. Sometimes these dominant myths and symbols have to be challenged outright—the myth that women are inferior to men, for example—but they can also be appropriated and used for other purposes. One needs to be careful, however, that the symbols you mobilize today don't return to haunt you tomorrow.

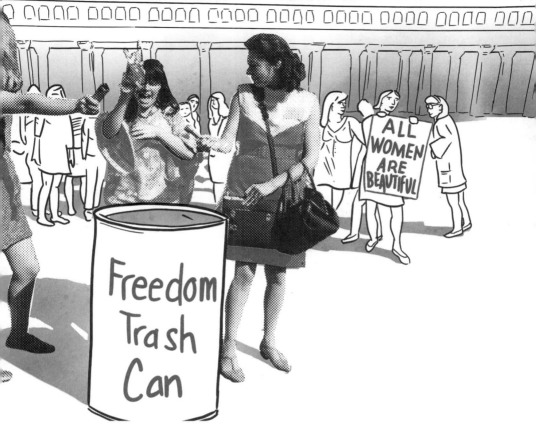

IN 1968, FEMINISTS now associated with the "second wave" gathered in Atlantic City, New Jersey, to hold a demonstration outside the Miss America pageant. Protesting the sexual objectification of women, they tossed bras and girdles into a "Freedom Trash Can," creating a counter-spectacle to challenge normative societal ideals of women's fashion and beauty. These new feminists were of course trashing some of the same symbols of traditional womanhood mobilized by their sisters half a century before.

While the Miss America protest made national news, perhaps the most profound performance by second-wave feminists happened not in public squares, but in private spaces, through face-to-face meetings called "consciousness raising circles." In these intimate get-togethers, women discussed and defined their experiences of being women. They shared personal stories of oppression and injustice at home, in the workplace and on the street, as well as lessons in political education. They blurred the traditional boundaries between what was understood as the public and the private, the political and the personal. In

doing this, feminists fundamentally challenged notions of what was defined as political, making the case that the "personal is political," which meant, among other things, that equity within the home was as important as (and interconnected with) equality at a voting booth. This radically redefined the terrain of politics and activism.

The principle: redefine the political.

The powerful maintain their power by deciding who or what can act and be acted upon, and defining who and what counts as "political." As artistic activists, our job is to not only to fight battles within the legitimate or prescribed arenas of politics, but to expand the very idea of the political and define new terrains of struggle and change.

———

INTRODUCING THE IDEA that the personal is political raised critical questions for second wave feminists; chiefly, whose personal experiences were being discussed, contested, and represented? In the 1970s, women of color, working-class women, lesbians, and radical feminists challenged the universalism of the "women's experience" spoken of by the mainly white middle-class feminists of the second

wave. In a 1974 statement by the Combahee River Collective, a group of Black, lesbian, radical feminists pointed out that different women had different personal lives, and therefore different understandings of the political:

> In our consciousness-raising sessions . . . we have in many ways gone beyond white women's revelations because we are dealing with the implications of race and class as well as sex. Even our Black women's style of talking/testifying in Black language about what we have experienced has a resonance that is both cultural and political. We have spent a great deal of energy delving into the cultural and experiential nature of our oppression out of necessity because none of these matters has ever been looked at before.

Taking "the personal is political" seriously, these feminists challenged a definition of feminism that was, by and large, born from the culture, concerns, and experiences of straight middle-class white women, and expanded and advanced feminism by bringing to it a range of different voices and experiences.

Feminism is continually evolving. One of its more recent expressions was the punk movement Riot Grrrl that developed out of Olympia, Washington, and the greater Pacific Northwest from the early 1990s. Like the first wave feminists of a century earlier, these third wave feminists drew upon traditional markers of femininity and innocence, adopting short skirts, pigtails, and hair barrettes — some of the very things rejected by the second wave. But their adoption of these markers is subversive: they wear thrift store dresses and ripped tights (and, in Pussy Riot's case, balaclavas) and adopt assertive stances. Their bands perform songs about their lives and experiences, elbowing their way into the conventionally male domain of rock music. They draw upon the symbolic power of girlhood while at the same time challenging it.

The principle: transform tradition. We sometimes get hung up on what we think activists and artists, protests and movements, are supposed to look like — this often being based on how things have looked in the past, or in other places. The feminist insight that the personal is political asks us to question this, and suggests that our subject positions reflect the varied nature of our life experiences and social and historical contexts. In other words, there is no universal revolutionary subject, no single model of the "proletariat," "feminist," or even "artist" or "activist."

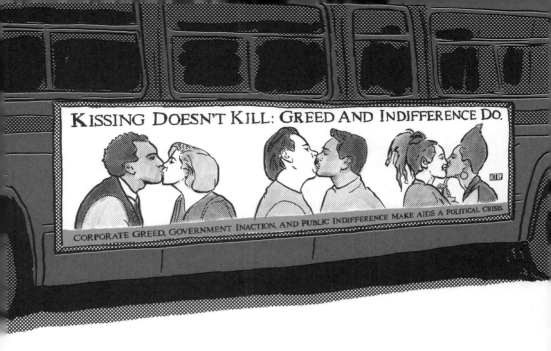

ACT-UP!

THE AIDS COALITION TO UNLEASH POWER, or ACT-UP, was formed in New York in the late 1980s in response to the silence and inaction of the government and medical establishment to the AIDS epidemic. It was creative from its inception. Not only was ACT-UP founded by a playwright, Larry Kramer, but the demographic from which the movement initially drew — gay, urban, professional — meant that aesthetic skills and sensibilities honed in worlds of art, design, advertising, and marketing were part of the movement from the beginning.

Facing widespread social indifference and ignorance about AIDS, one of the strategies of ACT-UP and their propaganda wing Gran Fury (artfully named after the model of undercover police cars used in New York City) was creating images and posters to capture public attention and deliver much-needed information. All social movements do this, but ACT-UP did it differently. Instead of using the amateurish, but "authentic," hand-drawn style favored by many protest groups at the time, or creating an "avant-garde" artistic style unique to themselves, ACT-UP and Gran Fury co-opted the aesthetics of advertising and marketing. Their posters, stickers, and t-shirts would not have been out

of place among ads for fashionable clothing stores. But then they did something fabulous with this mainstream style: they queered it.

One of the best examples of this tactic of appropriation and transformation was their "Benetton" poster. Gran Fury copied one of the clothing chain's well-known advertisements almost verbatim, using the same layout, colors, font, and multi-cultural themes, and then queered it by substituting the ad's heterosexual couples with homosexual ones. Benetton's consumerist message was changed to a provocative political one with the slogan "Kissing Doesn't Kill: Greed and Indifference Do." By using popular aesthetics, ACT-UP was able to introduce an unpopular message to the wider public. ACT-UP even went so far as to queer the pink triangle symbol forced upon homosexuals by the Nazis, turning its message of hate into one of remembrance and defiance.

NAZIs
1930s

ACT- UP
1980s

The principle: queer the culture.

As progressive activists, we often have an adversarial relationship to mainstream, commercial culture. And for good reason: this culture is driven by the profit imperative of capitalism, promotes waste, and is often unbearably idiotic. Against this, we create our own forms of culture — our own lingo, style, ways of thinking about and doing things — building subcultures that we feel comfortable within. This is understandable, and much of value is born from subculture, but it can also isolate us. Many are invested in the culture of Hollywood and Madison Avenue, and we need to engage with this, but on our own terms. We can "queer" mass culture by making it say things it was never designed to say, and act in ways it was never meant to act.

ON SEPTEMBER 5, 1991, ACT-UP activists drove to the house of homophobic senator Jesse Helms. They didn't picket or chant, and nor did they hold a candlelight vigil for the friends they'd lost to AIDS; instead, they wrapped his two-story home in a giant condom. This was a media stunt designed to communicate the message that the AIDS epidemic was as much a political crisis as a health one. And it also put politicians on notice that their actions (or inactions) regarding AIDS would be made public. As one of the activists involved warned: "You mess with us and one day you are going to wake up one morning with a condom on your house."

ACT-UP's condom action highlights another feature of artistic activism: the importance of play. ACT-UP understood that playfulness is important, not just to appeal to a wider audience or provide an engaging news story, but, perhaps most important, as an essential ingredient of activist life. Objectively, there was little for an ACT-UP activist to be light-hearted about in the '80s and '90s: your friends were dying, and no one outside your small community cared. ACT-UP was founded out of grief and anger, but its activists knew that to continue their work, and their lives, they needed pleasure and play.

IN ORDER FOR HISTORY TO BE USEFUL, WE NEED TO USE IT — TO LEARN FROM IT AND PUT THESE LESSONS INTO ACTION

The principle: make politics playful.

The work that many of us do as activists can be grueling, and the world we open our eyes to is depressing. We lose a lot more often than we win, and even when we win, we have to fight again the very next day to hold on to the little we gained. It's easy to get dispirited as an activist. Because of this it is important to bring creativity, joy, pleasure, and play into activism. Not only because it is a more effective way to get our messages across and entice others to join us, but, equally as important, because it'll keep us doing the work that needs to be done, not as a chore or burden, but as invigorating, energizing, creative play.

———

AGAIN, THE EXAMPLES above are familiar to those of us who've grown up in the United States, but there are so many others from different times and places that we can learn from. You have grown up with different experiences and within different histories that can provide creative lessons and inspiration. All you have to do is look for them.

Explore your own history of artistic activism
in Exercise 16 in your workbook

History Is Not Destiny

HISTORY MAKES US, whether we like it or not. Where we have been shapes who we are now, as well as what we can imagine for the future. But when we know our past, we are no longer captive to mysterious forces. We can understand that things happen for a reason. We see how certain actions, by certain actors, lead to certain results, and how other actions, by other actors, lead to other results. Knowing this, we begin to recognize our place, and our potential power, within history. Knowing our history is the first step in taking control of our destiny.

But knowing is not enough. We may know that historical institutions of slavery have generated societies in which racism is deeply structurally and psychologically rooted, but that doesn't make us any more free. Similarly, we may study the history of the civil rights movement in a classroom, but that knowledge doesn't guarantee that we'll fight for our own freedom, or that of others. As we've said before, the truth will not set us free. In fact, historical knowledge can at times have the opposite effect, convincing us that the present is the inevitable result of the past, or assuring us that the battles that need to be fought have already been won.

In order for history to be useful, we need to *use* it — to learn from it and then put these lessons into *action*. This chapter has sought to draw out some of the creative lessons to be learned from successful social movements. And we hope, too, that it has encouraged you to discover some new lessons from your own histories. This is a process that is as expansive and inspirational as human history itself. The past will always hold more for us to learn from, and there will always be more lessons to apply to the present.

Use history to make history with
Exercise 17 in your workbook

CHAPTER

4

CULTURE

"We seldom realize, for example, that our most private thoughts and emotions are not actually our own. For we think in terms of languages and images which we did not invent, but which were given to us by our society.

— ALAN WATTS, ZEN PHILOSOPHER

Culture Is Our Operating System

CULTURE IS ALL AROUND US. It's the system of meanings that allows us to understand our world and to communicate this understanding to others. Culture is necessary for our very survival. Without it we wouldn't know who or what we are, nor how to function beyond rudimentary biological life. Think of it this way: culture is to us as an operating system is to a computer. You can power up a computer with electricity, but without an operating system the machine just whirrs away, never booting up. The same goes for us. With just food and water we might be able to live, but without culture we'd be little more than a meat machine whirring away without ever being able to do anything meaningful. Culture is the operating system of humanity, and if we are going to change the way humanity operates, we need to be able to hack the culture.

Culture is the raw material of artistic activism. If you are a legal activist, then law is the material with which you work; if you are a sculptor, your medium might be stone, wood, metal, or plastic. As artistic activists, culture is the stuff we mine and the resource with which we build. Culture is also what we create — through our actions, performances, protests, and other demonstrations — in order to communicate our messages and meanings to others. But culture is complicated. It's a word so commonly used that it's hard to nail down exactly what it is. This slipperiness is not a problem in day-to-day use, but because it is a fundamental building block of artistic activist practice, here we need to be more rigorous and to define what we mean when we use the word culture.

An initial definition might be this: culture is what a society creates

in order to represent itself or express its ideals. This is the definition of culture that might be given by an art historian, a museum curator, a governmental culture minister, or the uptight TV sitcom character Mr. Belvedere. Culture as art.

WESLEY MY BOY,
YOU NEED CULTURE.

But there's another way of understanding culture, a definition that is broader and more inclusive. This is culture as the patterns and byproducts of everyday life: the languages we use, the rituals we perform, and the unspoken rules we abide by. It's what is created and recreated through work, play, conversations, and everyday inter-actions in our homes, schools, jobs, and places of worship. Culture surrounds us: it's the material from which we create our lives and

make sense of our world. It's this definition that people like anthro-pologists, sociologists, and marketers use.

Stuart Hall, a founder of the academic field of cultural studies, usefully distinguishes between these two primary definitions by referring to Culture as art with a big C, and culture as life with a small c. Culture and culture are interrelated. Think, for example, of ancient Greek marble sculptures. These nude forms are stone expressions of the religious myths and human ideals, moral and physical, of the Greeks who created them. But where exactly did these ideals come from? While Plato thought an encyclopedia of ideals existed in some netherworld that only the artist or philosopher could access and bring down to earth, today that seems a bit far-fetched (and egotistical). In truth, the spirit that guided the sculptor's chisel did not come down from the heavens, but rose up out of the ground. The ideals expressed in the artwork were shaped by the everyday concerns of the people who created, appreciated, and financed it. Greek culture gave rise to Greek Culture.

It also works the other way. Statues created from the ideals of society in turn become the standards to which society compares itself. Having created these representations of muscular gods, the Greeks no doubt compared their flabby, earthbound selves to the sculptures to see how they measured up, perhaps walking away with a bounce in

their step, or a personal pledge to cut back on the olive oil and wine over the coming moon. In this way, Greek Culture helped to shape Greek culture.

Considered together, the relationship is something like this: Culture works as a representation and reinforcement of culture, and culture shapes and is shaped by Culture. This cyclical relationship might be pictured like this:

As artistic activists we create Culture: creative forms we think best represent and communicate the ideas and ideals we would like others to share. For example, we might make a community mural that projects an ideal of how the local neighborhood could be. We do this in the hopes that people will see the mural and be inspired to change their community so twhat it is closer to the painted ideal. Or we might design a performance piece that warns of the evils of gentrification. Either way, we are producing Culture in order to influence culture.

At the same time, the Culture we produce necessarily arises from the everyday culture in which we live. This is why it's so important to be self-aware of our own cultures that influence our creations, and why our murals and performances will be more æffective when the ideals and imagery they depict are generated by the community itself, using signs, symbols, stories, and values that are true to the people that comprise it.

The relationship between Culture and culture is not straightforward, and neither can be said to wholly determine the other. The process is more complex because of us: people. Culture and culture are human creations, and we can consciously and creatively intervene in the relationship between the two, shaping the C/culture around us. This means that all Culture is local. What an artistic activist produces in Nairobi will be different to what her counterpart in Liverpool creates. Since local cultures are diverse, Culture is diverse too. This is why exporting an artistic activist tactic from one part of the world to another simply doesn't work.

Take a field trip to explore the culture in Culture in Exercise 19 in your workbook

Big C Culture

WE'LL START WITH CULTURE, or what we usually call "art."

Art is powerful. It's a way we can express our understandings of the world as it is, and articulate our visions for how it could be. In this way, all art is political, whether the artist intends it to be or not. And a great deal of art is politically conservative, reflecting and expressing the worldviews of those who are best placed, politically and economically, to patronize the arts and determine standards of competence and beauty. This is true for the European landscape painting that represented and reinforced values of private property for the landowners of early capitalism, and it is true for the contemporary art that represents and celebrates neoliberal ideals of unrestrained individualism. Through art, the ways of seeing of the rich and powerful are presented as the way of seeing for everyone; the elite set the standards to which we all feel we must conform. As Marx and Engels once wrote: "The ideas of the ruling class are in every epoch the ruling ideas."

But art is also used to challenge authority and privilege, often precisely by challenging how those in power see the world. That privileged perspective is confronted when artists represent reality in different lights, showing the world from different perspectives. In the early 1800s, Spanish artist Francisco Goya created a series of works called *The Disasters of War*. These sketches and paintings were based on his experiences of the Spanish people's uprising against the French occupation. They showed war as Goya saw it: not as a noble enterprise of commanding generals astride bold steeds leading their brave troops into battle, but as the horror of women being raped by soldiers, or prisoners executed before a firing squad. Through this work, Goya held a mirror up to the unsavory realities of war known by its victims and perpetrators, but often hidden from the general public. Goya revealed this truth, not with measured words, but through graphic depictions meant to shock and move his audience.

Pablo Picasso's famous *Guernica* is a reflection of reality. The mural-size painting reflects the chaos and fear, and the dismemberment of bodies and buildings in the Basque town of Guernica when it was bombed by Nazi warplanes during the Spanish Civil War. *Guernica* was painted by Picasso at the request of the left-wing Republican government of Spain, which hoped that the graphic images of the civilian bombing would persuade the people and rulers of the world to come to its aid.

But Picasso is doing something else in *Guernica*. Take a look at the painting. What do you see? Chaos, fear, and the dismemberment of bodies and buildings? And *how* do you see them? The style is very different to that of Goya or Gainsborough. Compared with those others, there are more angles and geometric shapes, and then there's Picasso's characteristic placement of two eyes on one side of the head. If he is holding up a mirror to reality, why is it so distorted? What sort of reality looks like this? Picasso's vision of reality — or rather *realities*, for Picasso is depicting the scene from multiple perspectives simultaneously. As a modern artist, he was not interested in capturing reality as it appeared to the eye; painters had already mastered that skill, and photography had rendered realist painting redundant. Instead, Picasso, like many other artists at the time, was trying to show the world as he interpreted it. Freed from having to imitate material reality, artists could explore things like perspective, the subconscious, color, emotion, or the materiality of the medium itself.

When Picasso painted the bombing of Guernica, he was not only holding a mirror to the world, confronting the public with a reality that must be changed, he was also encouraging people to understand reality itself differently. And this was political. Where fascism insists that there is only one way to understand the world, democracy, on the other hand, seeks to honor a multiplicity of perspectives. Picasso's painting, therefore, also exemplified an alternative to fascist Spain *aesthetically*.

French philosopher Jacques Rancière argues that power works by delineating certain behaviors and desires as "sensible" while

marginalizing others as "non-sense." Rancière calls this "the distribution of the sensible." The "sensible" of course has multiple meanings, referring at once to what "makes sense," or the "common sense" assumptions that stabilize society, and also to what we physically sense through our eyes, ears, nose, mouth, and hands. It's not just that we reject unorthodox things because we don't understand, relate to, or agree with them, but also because, beyond this, we're not culturally equipped to recognize, hear, or see them: dissident speech sounds like noise, marginalized people escape our field of vision, and so on. As Rancière puts it: "Politics revolves around what is seen and what

can be said about it, around who has the ability to see and the talent to speak, around the properties of space and the possibilities of time." Art as an aesthetic weapon aims for a redistribution of the sensible, figuratively and literally making a new world make sense. It is a means to recalibrate what we experience as reality.

Here's another art example that might make these abstract musings more concrete. It's Kazimir Malevich's *Black Square*, painted in 1915 at the beginnings of the Russian Revolution. Malevich was a supporter of the revolution, and he thought of his art as a weapon in the struggle.

Part of the political meaning of *Black Square* is straightforward and
concerned the particular culture within which Malevich worked. In
pre-revolutionary Russia, the Orthodox Church had immense political
power and was aligned with the Czars and the aristocracy. One of the
ways the Church reinforced its power was through art, and specif-
ically the paintings of Saints. These were icons of individuals who
lived aspirational lives of humility, obedience, and faithfulness — traits
which, conveniently, supported subservience to authority. These icons
were hung in Russian homes in the top corner of a room, enabling
the Saint to gaze out and bestow their blessings — and behavioral
example — upon those below. When Malevich first displayed *Black
Square,* he hung it in the very place usually reserved for the Saint. His
art worked politically because, like all good artistic activism, it spoke
from and to the dominant local culture of Russia. As a big fuck you
to the established church, *Black Square* was pretty punk rock (as was
Pussy Riot's performance in the main Orthodox Church in Moscow
almost a hundred years later), but the profound politics of the painting
go beyond its blatant oppositional positioning. Malevich's painting

prompts a series of questions that asks his audience to rethink traditional ways of making sense:

Why a black square?
Maybe it's blank slate? Or a space open for creation? Isn't this what a revolution promises us: the chance to start anew?
Couldn't anybody paint this?
Perhaps, but isn't the revolution about challenging the division of labor? What sorts of new skills will the revolution call for?
What does it mean?
Anything? Nothing? Does it even have a singular meaning or interpretation? Shouldn't the revolution encompass all the different voices and opinions of the masses?
Is it even art?
What is art? And who decides?

These are the kinds of questions provoked by *Black Square*. In answer to the last one: Malevich's painting was certainly not art as it had been understood for hundreds of years. Art was supposed to be about saints, or famous people, or monuments to power. It was supposed to look like something real, or something holy. This was the tradition of art that *made sense* to the people of Russia in the early twentieth century.

But what also made sense were the traditions of feudalism, patriarchy, hierarchy, and private property. The communist transformation of Russia demanded that all old traditions, all usual ways of doing things — everything that "made sense" — needed to be discarded and, in its place, something new and better created. This was a *revolution*; as with society, so with art. Malevich, like many of the Russian avant-garde, wanted his painting to pave the way for the radical cultural and political rethinking that the revolution would necessitate. Malevich was not interested in depicting the world as it was, but in getting people to look at the world in an entirely new way; his *Black*

Square was part of a broader movement that functioned to redistribute the sensible.

Another example of this approach from the Russian revolutionary avant-garde is Vladimir Tatlin's *Monument to the Third International*.

Tatlin's tower was commissioned soon after the revolution, in 1919,

by the Department of Artistic Work of the People's Commissariat for Enlightenment (sounds better in Russian). It was to stand four hundred meters tall, almost one hundred meters higher than the Eiffel Tower, and straddle the main river in central Saint Petersburg. Tilting at the same angle as the Earth, and taking the idea of "revolution" quite literally, the tower was constructed of three internal revolving levels. At the bottom was a massive glass and steel cube to house the Soviet legislative assemblies, rotating once per year. Above this was a pyramid, where the executive committees would meet, revolving once a month. And on top was a cylinder to hold a radio station and newspapers, which spun each day.

Monument to the Third International was never built. Beyond the vast amounts of steel that would be required to construct it, it is unclear whether the design could be made architecturally stable. The technology necessary for the tower's revolutions and communications systems did not yet exist. The closest Tatlin ever came to realizing his dream monument was a five-meter model built of wood, tin, paper, nails, and glue.

Leon Trotsky, one of the founders of the Russian Revolution, had these words to say about Tatlin's monument: "I remember seeing once, when a child, a wooden temple built in a beer bottle. This fired my imagination, but I did not ask myself at that time what it was for.... But for the moment, I cannot refrain from the question: What is it for?" Trotsky unknowingly answered his own question, for what is the purpose of Tatlin's monument if not to fire the imagination? *Monument to the Third International* worked to redistribute the sensible for a population whose sense of possibility had for generations been circumscribed by the regimes of feudalism, capitalism, and the orthodox church. Tatlin's tower was a monument to the impossible.

There is power in the impossible.

Approach activism as an artist through
Exercise 18 in your workbook

The Impossible Possible

OUR SENSE OF possibility is limited by what we can imagine, and our imaginations are bound by the culture within which we imagine. This is why it is so hard to imagine anything *entirely* new. We're taught to believe that artists create things that are new, unique, and absolutely their own. This is not true. Even sitting by themselves, isolated in their garret, the individual artist is never alone: they are surrounded by culture. Every person grows up within a society that instills, to borrow a phrase from art critic John Berger, certain "ways of seeing." This social perspective shapes what the artist sees and chooses to create, just as it shapes how others will see and make sense of their creations. In *Art as Experience,* philosopher and educator John Dewey wrote that the first thing to consider about art is that "life goes on in an environment; not merely *in* it but because of it, through interaction with it."

One of the biggest mistakes an artist can make is to fool themselves into thinking they can create outside of culture. They can expand it, turn it inside out, and refute it, but the one thing an artist cannot do is create outside of it. If they could, the products of their labors would not only be meaningless to their audience, but also to themselves. Malevich's *Black Square* could only be seen to make any sense at all in the context of revolution, a time and place in which people — at least some of them — were open to cultural experimentation.

While we are all trapped within the prison house of culture, we have also developed tricks to help us escape: travel and exploring other cultures, putting together new combinations of old things, tapping into dreams and the unconscious, meditating, and taking drugs. Some techniques are healthier than others, but in each case, artists are trying to get around the very patterns of meaning that structure our society and constrain our imagination. They can never be wholly successful, but in every case, what we think of as reality is stretched, questioned, and unsettled. Tatlin's trick was to create something he knew to be impossible to build at the time.

If we try and approach the exercise of imagining the unimaginable directly, we are bound to fail. It is much easier to imagine something

completely absurd, ridiculous, or out of place; something that would never work because of limits on money, time, or basic physical laws. Time travel! Free flying cars! Talking alien fish! A pocket sized shrink-ray! All of a sudden, the ideas start rushing into our minds. While we can't imagine outside of our culture, we can flip the "distribution of the sensible" on its head and imagine what our culture tells us is absurd. In doing this, we expand our imaginations. Tatlin's monument is impossible to build, but its very impossibility is what allows him to pose the question of "What if?," to be followed by the critical query "Why not?," and then, if truly we want to make the impossible possible, the revolutionary ask: "What is to be done?"

In terms of our endeavor to become better artistic activists, the lesson so far is that depending on the context we are working in, and what we want to do, we might think about our pieces as reflecting reality, or opening up new realities — or both. As artistic activists, we can choose tactics that hold up a mirror to things that people either cannot or do not want to see: lives locked away behind prison walls, wars in distant countries, or abstract forces like endemic poverty or structural racism. Here, our task is to make the invisible visible, drawing attention to the world as it is and demanding that people first notice reality, and then (hopefully) change it. As we saw in chapter 3, creative activists have used this "mimetic" technique throughout history. Rosa Parks and Martin Luther King Jr., for example, were masters at mimesis: holding up a public mirror to the reality of racial segregation. A more contemporary example might be Iraq Veterans Against the War's 2007 performance of combat missions on the streets of U.S. cities as a way to demonstrate what war and occupation are really like to people who give their tacit support to a reality they never see (see chapter 1).

We can also create actions that propose radically new ways of making sense of reality. Instead of revealing the world at is, we here demonstrate the world as it should be, prefiguring the reality we desire. This approach might entail using new forms of language, imagery, or sound, which might not ordinarily be thought of as political, in the

service of expanding the very definitions of what and who is political. This is what second-wave feminists (see chapter 3) did when they redefined the personal as political in order to expand the terrain for debate and struggle, and it is what the Undocubus immigration activists (see chapter 1) did by employing the symbol of the monarch butterfly to change people's "sense" of migration, transforming it from something illegal and ugly into a process both natural and beautiful.

There are strengths and weaknesses to both approaches. The mimetic approach, in its attempt to reflect often unseen aspects of reality, seeks to make the unfamiliar familiar. If we do it well, our message is legible to a wide audience because it simply "makes sense." One reason that the above mentioned tactics of Parks and King were so successful is that they revealed the *nonsense* of making people of a certain ethnicity sit in the back of a bus, or the absurdity of turning fire hoses on peaceful demonstrators. These events didn't make sense in a culture that purportedly guaranteed all citizens the right to peaceably assemble, and held that "All Men Are Created Equal..." These actions were so æffective because they spoke to and within a commonly shared reality.

In another sense, of course, it is precisely the shared reality that is often the problem. And even if we are critical of certain ideas or events, actions that hold a mirror up to reality may be interpreted as reinforcing that reality as it is. In reflecting reality, we tacitly agree that the dominant way of understanding the world is legitimate. Through his paintings, Goya may have criticized war, but he also helped to cement the centrality of war in our culture.

When the civil rights movement moved from the South to the North, it realized the limits of representing reality. The struggle in the South was to make the rhetoric of universal civil rights a reality. By this measure, Northern Blacks were not so oppressed: they could ride in

the front of a bus and vote in elections. Yet it was also clear that they were second class citizens. To recognize and address this difference in the application of racial oppression, a different perspective on reality was necessary. The Black Power movement was in part created, we argue, to recalibrate what was sensed as reality through the aesthetic representation of a new ideal of militant Blackness. The aesthetic approach, in its effort to recalibrate reality, does not seek to make complete sense; rather, it embraces the unfamiliar — and sometimes reframes the familiar so that it seems unfamiliar — in order to force a change in popular perspective.

In embracing this approach, we do however run the risk of being too far removed from common sense, so removed that our pieces make no sense to anyone but ourselves. When this happens, our message is either ignored or misunderstood — and not just because people are hostile to it, or because it challenges their power and privilege, but because they simply can't understand it. Our actions are dismissed as nonsense — at least in the short run. Feminist perseverance resulted in the non-sense of the "personal is political" prevailing as common sense within a generation. But groups with a smaller constituency that "gets it," and less time to communicate their entirely new perspective to outsiders, can find themselves easily misunderstood or misrepresented, marginalized, or purposely demonized. This was often the case with the Black Power movement — and with the artistic avant-garde.

A disconnect with popular understanding might be acceptable for those avant-garde artists who wish to live their bohemian lives in isolation and take pleasure in the fact that "no one understands," but for those of us interested in popular social change this lack of comprehension is political suicide. Luckily, a good artistic activism

strategy demands multiple tactics, so you have room to experiment with both representing reality and rearranging it, or, as Picasso did, figure out ways to combine them.

Learning to Love Las Vegas

SO FAR WE'VE BEEN DISCUSSING Culture in its most rarefied, "high" forms: paintings, sculptures, plays, symphonies, literature, philosophy, or poetry, and as much as we may pride ourselves for having a membership to the Friends of the Museum Society, buying season tickets for the local symphony, devoutly attending local poetry readings, or not having owned a television since 1989, we need to acknowledge that what most people — including your authors — do after a hard day at work is turn on the TV, browse social media, watch a blockbuster, or groove along to top-ten pop hits; that is, we indulge in *popular* culture. And it's always been like this. While what cultural elites remember and cherish about Ancient Greece is its philosophy, theater, and art, what ancient Greeks most enjoyed was likely their own popular culture: a dram of wine, a game of dice, and listening to a story or song. As artistic activists we need to be attuned to pop culture as well as "high" Culture.

Popular culture is fantasy stories, not literary fiction; it's pop lyrics, not poetry readings. It's *Batman* movies, home makeover shows on TV, *Minecraft, Fortnight,* and *Call of Duty* video games, *People* and *OK* magazines, and, of course, videos featuring cats doing all sorts of cute things. It's entertainment, not art. But pop culture serves the same function as high Culture: it is a representation of society as it is or aspires to be. And like high Culture, it in turn becomes a model for how society thinks and behaves. What differentiates high Culture from popular culture mainly comes down to this: pop culture is popular.

We work with a lot of activists who bristle at working with pop culture — and for good reason. It is entirely true that a lot of pop culture is pretty trashy. Much of it celebrates the rich and the privileged, the sensational and the violent, and it only exists to make money. Among activist and artistic circles, we often hear people decrying pop culture as base, corrupt, and part of the problem, and advising that the best thing to do is simply ignore it. As individuals, we might agree. But as artistic activists we need to understand pop culture, why people are drawn to it, and figure out what we can do with it. We can't afford to just trash it.

In thinking about what we can do with pop culture, we've found the ideas of an American philosopher and early psychologist named William James very useful. In 1906, James delivered a talk to pacifist students in California, helping them strategize ways to get their anti-war message to resonate with more people. His advice was pretty surprising. He told the students that instead of just telling people how bad war is, they needed to understand what's *good* about it. Yes, war is bloody and brutal, but good people support bad wars for all sorts of understandable, and even noble, reasons: self-sacrifice, camaraderie, solidarity, honor, bravery, and patriotism. Today, we might add: a job, technical training, and a way out of the shithole you grew up in.

James argued that if pacifists wanted their message to have a broader appeal, they needed to move past simple condemnation and "enter more deeply into the aesthetical and ethical point of view of their opponents." His plea was for a pacifism through empathy with

the other side. Too often, James warned, we don't respect that people believe what they believe and do what they do for good reasons. The first step in converting war-mongers into peace lovers was to understand and respect them.

But James didn't stop with empathy. After we acknowledge the complicated and sometimes contradictory justifications and rationalizations of those we disagree with, our job is to create a "moral equivalent": an activity, or institution, that fulfills the same needs for people that war does, minus the killing. It's not enough to merely condemn the views we don't agree with; we need to understand popular needs and desires and then re-route them — to "move the point," as James put it.

So what might a "moral equivalent" to war look like? James's idea was to create an army — with discipline, fellowship, and a sense of purpose — but instead of being targeted toward killing, its objective would be the betterment of society. This idea was later enacted in U.S. governmental programs like the Civilian Conservation Corps during the 1930s, the Peace Corp in the 1960s and, in AmeriCorps today. Alas, none with nearly the scale and funding of the U.S. military.

Learning from James, we start with the assumption that people are getting something they need — something rewarding and meaningful — from the things in which they invest their time and money; for instance, popular culture. In our workshops, we incorporate James's century-old wisdom into contemporary practice when we take everyone out for a "cultural event" on Saturday night. When we announce this, most people suggest we partake in some sort of culture that's familiar, supportive, or maybe inspiring — things that activists are expected to do with their free time, like going to a poetry reading in support of domestic workers, or watch a hard-hitting documentary on strip mining.

This is not what we do. Instead, we find out what everybody else in the area, those who are *not* activists and artists, are doing on a Saturday night and go and do that. This has meant going to a rural sports bar in North Carolina to watch college basketball finals with desegregation

activists, or tuning in to a Turkish soap opera with Macedonian LGBTQ and Roma rights organizers. We've hung out at roadside *choma* restauraunt in Nairobi with HIV-AIDS and maternal health care advocates, crept through a house of horrors with immigration activists in San Antonio, attended a Cubs game with anti-war veterans in Chicago, and sat through a screening of *Fifty Shades of Grey* with South African sex workers. This is our idea of a cultural outing.

We once worked with a group of American Muslim activists who were fighting police surveillance and harassment in their community. We were at a retreat center in rural New York State and when Saturday night rolled around the cultural options were few — confined to a shopping mall with a multiplex movie theater. Doing a little research, we discovered that screening at the mall was the top-grossing movie in the U.S. that week. It wasn't a film on mountaintop removal, it was *Fast and Furious 6*: car racing, car crashes, car explosions, featuring Vin Diesel and Dwayne "The Rock" Johnson. We went to the mall.

The next morning, when we gathered to talk about the film, one of the workshop participants was visibly upset. A devoutly religious man, he was angry we had seen a film that seemed to celebrate everything he believed was wrong with society: violence, sex, and sensationalism. He couldn't understand why anyone would want to see such things, nor did he think it was worth wasting our time working with anyone who did. We were taken aback by the passion of his disgust and the sincerity of his objections and were, for once, at a loss for words. Then Linda Sarsour, a prominent Muslim activist who was participating in the workshop spoke up. "My three brothers love these movies," she said, "they've watched every one — multiple times — and I think they are exactly the people we should be working with and trying to understand." Sarsour summarized precisely what we wish to emphasize: it's only by understanding popular culture that we can understand the needs and desires of most people.

People may like pop culture for a range of reasons, but it is clear that they do genuinely like it. Otherwise it wouldn't exist. In capitalist consumer societies pop culture *must* speak to the realities and dreams

of the population. If it doesn't, then it doesn't sell, and if it doesn't sell, then it doesn't survive. This market logic doesn't make pop culture *good*, but it does ensure that it is popular. And for those of us interested in social change in a democratic system where we need to be able to reach and appeal to a majority of the population, this makes pop culture a *very* important resource.

Dig deep into pop culture with
Exercise 21 in your workbook

The Moral Equivalent to Fast and Furious

WE CAN LEARN A LOT from pop culture, even from examples where this doesn't initially seem to be the case. What, for instance, could we possibly learn from an action movie such as *Fast and Furious 6* that might be of use to American Muslim activists fighting police surveillance?

When we discussed this question in the workshop, there was much we immediately discarded as *not* useful: sexism, the fetishization of consumer products, physical violence, and explosions. These were the very things the activists were against, personally and politically. But after further discussion, we recognized another key theme of the film: the ideal of a multi-ethnic team of ragtag misfits brought together for the greater good of fighting injustice. The celebration of difference is of course not unique to the *Fast and Furious* movies. In blockbuster after blockbuster, people of different ethnicities unite to pit themselves against authority to right some sort of wrong. This reflects marketing strategies that seek to appeal to as wide a demographic as possible, but they wouldn't do this if diversity was not also a popular ideal. This was an ideal we could work with.

By immersing ourselves in an insipid, smash-em-up car-chase movie like *Fast and Furious 6*, we extracted a strategy that could challenge the frame that law enforcement agencies used to demonize

LATINA
BLACK
ISRAELI
EUROPEAN
WHATEVER VIN DIESEL IS??
SAMOAN
LATINA?
JAPANESE

TOGETHER: A RAG-TAG, MULTI-CULTURAL, CHOSEN FAMILY OF MISUNDERSTOOD SOCIAL OUTCASTS TEAMING UP TO FIGHT THE MAN!

Muslims; namely, that American Muslims are different from "regular Americans" and that this difference is threatening. Through our collective analysis of the film, we noted that there is also a great appetite for cultural difference, especially when understood as part of a greater diverse society and connected to a fight for justice. Furthermore, we realized that people are attracted to the idea of fighting an oppressive authority figure — sticking it to the man — especially when he is white, male, wearing a suit, and represents the government.

We discussed ways to make use of these insights, and one idea was to create pieces that cast Muslims as an integral part of the glorious diversity of the United States and portrayed the authorities as a backwards enemy of Multi-Cultural Team America. In this drama, American Muslim activists would have a starring role as underdogs defending their Constitutional rights — and by extension the Constitutional rights of all Americans. The popularity of *Fast and Furious 6* suggested that these ideas potentially had mass appeal, we just needed to adapt them. This was a strategy of drilling deep into pop culture, beyond the explosions and the pithy zingers and into the DNA: the core desires that it taps into and expresses.

Going deep is important in this work. Symbols are the first things

SYMBOLS ARE THE FIRST
ENGAGING WITH POPULAR
IT'S THE MEANINGS

we notice when engaging with popular culture, but it's the meanings we are after. We once worked with a group of tax justice advocates in Massachusetts, and for our cultural outing we went to see the latest Batman movie, *The Dark Knight Rises*. In our brainstorm session, we again asked what we might learn from what we had watched. The first suggestions drew directly from the film: be superheroes for tax justice, get capes and tights! There's nothing wrong with this, and artistic activists like Vishavjit Singh — the "Sikh Captain America" — have dressed up as superheroes to great effect. But in this case it was just adapting surface symbols, and not getting at the deeper dreams and nightmares that popular films can evoke. Reflecting further on *The Dark Knight Rises*, we learned that we could talk about incredibly dark subjects, as long as our audience trusted we'd provide some resolution. This insight launched a discussion about how we might turn tax justice into a dark, compelling story with a positive outcome. The point is not to replicate popular culture, but to learn from it and tap into the basic human needs and desires it speaks to.

Sometimes even what we take to be the negative aspects of pop culture contain positive lessons; for instance, that pop culture provides many with a comforting *escape*. Since our goal as artistic activists is to help people *engage* with the world, "escapism" is often thought of negatively. A few years ago, however, we worked with the Iraq Veterans Against the War. As part of a workshop in Chicago with their leadership,

THINGS WE NOTICE WHEN CULTURE, BUT WE ARE AFTER.

we took the activists out to see the Cubs play at Wrigley Field (and, this being a few years before their remarkable 2016 World Series victory, to watch them lose). The next morning, we talked about why people love to go to baseball games. We discussed the importance of uniforms, rituals, and allegiance to a group — all of which were quickly found to be applicable to the veterans' artistic activism. But we also talked about the importance of escape, of leaving the stresses and strains of life behind for just a couple of hours.

We wondered how we might "move the point" on escape and make political engagement something that veterans would want to escape *to* rather than from. From here, we started brainstorming about the different forms of escape enjoyed by people: sports, movies, dancing, music, drinking, bars — bars! That was it. The Veterans of Foreign Wars organization runs meeting halls — and bars — throughout the United States. In most places, the VFW is run by veterans from the Vietnam and Korean wars, and as they get older the halls and bars are going dormant. This was the opening we were looking for. Why not have IVAW members join the VFW and resurrect these bars all across the United States? The IVAW could provide a service for vets — a place to escape to and unwind in with people who'd had similar experiences — and at the same time the VFW halls could provide a place for the IVAW to meet and discuss its larger objective of ending war. And the overlap between the two functions of the halls could be fruitful: a vet could

of course just come in to have a few beers and relax, but if they had a gripe about treatment received at a Veterans Administration Hospital, or had a question about their legal rights, then not only would the bartenders listen to their problems, but they could also be trained to provide veterans with resources and advice, or connect them with organizations that could solve some of the problems they were trying to escape from. Eventually, these vets might join the IVAW. It could be win-win escapism.

As individuals, we all have our own likes and dislikes when it comes to culture, and this is all well and good. But as artistic activists, we have to be attuned to what other people, particularly those who are not artists or activists, are interested in — *not* what we think they should like, but what they actually do like in today's complicated and compromised world. It's only by understanding popular culture that we can understand the needs and desires that motivate people, and be able to speak their languages. But where we go with that understanding, and what we decide to communicate once we know the cultural code, well, that's up to us.

Create your moral equivalent to pop culture
in Exercise 22 in your workbook

Alternative Cultures

LURKING IN THE SHADOWS of megaplex movie theaters and monumental museums are other forms of culture: alternative modes of expression and ways of living that people create alongside or in opposition to the dominant modes of culture. Sometimes these cultures are the result of forcible exclusion: think of Jews in Europe, Blacks in the Americas, or LGBTQ people pretty much everywhere. And sometimes these alternative cultures are the freely willed creations of people who reject the dominant society: Rastafarians, punk rockers, deadheads, Riot Grrrls, skinheads, deep ecologists, cholo/as,

foodies, makers, bikers, burners, skaters, survivalists, gamers, graffiti artists, etc. Often called sub-, counter-, underground-, or alt-culture, these forms of culture express patterns of living and styles of expression that are at odds with the status quo. No matter what scene each group arises from, they are all engaged in creating culture as an alternative to the mainstream.

Alternative culture is a useful resource for artistic activists. Like all culture, alt culture reflects the needs and desires of those who participate in it. Alt cultures, however, do this in a much more immediate way. Unlike pop culture, where our needs and desires are reflected in cultural products created and sold to us by someone else, alt culture is *created by us*. There are no focus groups or panels of critics to mediate the process, just direct cultural expression. Alt culture is transparent about what makes its creators and its adherents or followers tick. As Public Enemy's Chuck D once said about the relationship between hip-hop music and young African Americans: "rap is Black America's CNN."

Alt culture is *participatory*: those who consume the culture are also the creators, and those who create the culture are also consumers. This do-it-yourself ethos was illustrated brilliantly in the British punk fanzine *Sideburns*:

> Alt culture has a powerful democratic lesson to teach: we don't need capitalists producing our culture, or politicians to change the world. We don't need to ask or pray or hope or wait; we can just go out there and do-it-ourselves. As punk-folk icon Billy Bragg sings, "If no one seems to understand, start your own revolution, and cut out the middleman."

As these examples illustrate, alt culture is also often *rebellious* culture. It is created by people who feel their interests and values are not represented within mainstream culture. Reacting against this exclusion, they create culture that spurns the status quo. Rastafarians, for instance, name white society as Babylon, while punk rockers — through their ripped up clothes and unprofessional music — celebrate what is deemed ugly in polite society. In both cases, they consciously create culture to challenge the norm. Such culture was called

"counter-hegemonic" by Italian Marxist theorist Antonio Gramsci, where the "hegemonic" is the beliefs, language, and art of the ruling political and economic system. His texts are now required reading in university classes on cultural studies, but Gramsci's ideas had revolutionary roots. He was interested in the potential of counter-hegemonic culture to resist the ruling powers.

Any successful revolutionary strategy, Gramsci argued, needed both a *war of maneuver* and a *war of position*. The war of maneuver is the open conflict: the moments when the rebels storm the palaces, seize the factories, take over the communications systems, and rout the enemy. But to win battles, Gramsci argued, a war of position must also be fought. This is guerrilla war, where rebels stake out positions behind enemy lines, creating pockets of resistance that destabilize the dominant system through sabotage and disinformation, and forging alternative structures of power to build upon after the war is won. This is useful for thinking about fighting cultural battles as well. Alt cultures are pockets of resistance within enemy territory that spread alternative ways of understanding and acting in the world.

However, being a cultural rebel is not enough. As with pop culture, we need to move the point.

Radical historian Eric Hobsbawm wrote sweeping tomes with titles like *The Age of Empire* and *The Age of Revolution*. But, early in his career, he also wrote a small book called *Primitive Rebels* about the alternative culture of rural bandits in nineteenth-century southern Europe. These peasant outlaws were the Robin Hoods of their day, using their banditry to resist unjust authority, and stealing from the rich to give back to the poor. But as much as Hobsbawm admired the bandits' rebellious posture, he concluded that they were not equipped for, nor really interested in, engaging in effective struggles to overthrow authority or change the economic system. Stealing from the rich and thumbing their nose at the authorities was flamboyant and fun, but their resistance was largely gestural and ultimately ineffectual. The word Hobsbawm used to describe these bandits was "pre-political."

Most alt culture is similarly "pre-political." The problem with much

of it is that it often remains just that: alternative *culture*. Its criticisms of the system, the alternatives it provides, and the political potentials of its DIY ethos, its beginnings and endings in song, slang, or style, are safely sequestered to cultural expression. When all this opposition remains at the level of cultural expression it has little direct impact on the world it is rebelling against. Or worse: alt culture often ends up supporting the dominant culture as its radical style becomes raw material for the newest consumer lifestyle trends.

Alt culture can be a valuable resource, but in order for it to become a potent political force we need to move it from the pre-political to the political. Artistic activists can help to do this by creating pathways from alternative culture back into mainstream culture — though not in the way that marketers do, stripping alt cultures of their political meaning while seeking to profit from their style. Instead, we can start by taking the cultural demands of alternative cultures seriously, before mobilizing their signs, symbols, and even practices in forms of activism that can align them with political realizations.

Reclaim the Streets provides one example of what this can look like. RTS began in 1990s' London as an unlikely alliance between organizers of underground raves, who were angry with new government restrictions on dance parties, and activists concerned about new highways being built through residential neighborhoods. Separately, each group was largely powerless: ravers threw popular but apolitical raves, while activists held political protests that few people attended. Together, however, they developed a new style of protest: turning the contested highways into massive raves with sound systems, costumes, and thousands of dancing protesters. By staging carnivalesque actions like this, RTS succeeded in dramatically expanding the number of people that would show up at an anti-highway protest, with ravers swelling the ranks of the usual activist suspects. In the process, "party people" were politicized and "political people" learned that protest could be fun.

RTS redefined what a political protest could be. Drawing on the music, dance, and style of rave culture, it *demonstrated* the possibilities of public space. Streets could become open places of play and

imagination, rather than simply thoroughfares for cars going from one place to the next fast as possible. This style of protest proved so popular that Reclaim the Streets spread, with chapters opening up in cities around the world. RTS went on to influence the look and feel of the globalization protests later in the 1990s and the Occupy movement in 2011. What made Reclaim the Streets so effective was exactly this merging of activism with alt culture.

A cynical reading might see this approach as simply replicating that of the marketer, where the artistic activist mines and exploits the newest hip street styles for their own benefit or to promote their "product." But we think there's an important difference in what we are proposing. In marketing, what is being sold usually has nothing to do with the values of the alternative culture it is stripping for its symbols. Take, for instance, the '90s automobile advertisement that claimed "this Subaru is like punk rock." This is not at all what we're

suggesting. Where a marketer taps into alt culture in order to channel people's passions away from creative action and into consumption, an artistic activist taps into the cultural dreams of alt culture in order to help realize them.

Culture with a Small c

AFTER HIGH CULTURE, pop culture, and alt culture, there remains another kind of culture that is both the most difficult to define and the most important for us to work with: culture with a small "c." This culture is so hard to describe not because it's elusive, but because it's all around us. It's the food we eat, the games we play, and even how we brush our teeth. It's the very language we use to write this book and you use to read it. This culture is largely invisible because we internalize it and take it for granted.

This is what makes culture so powerful. Although we may not notice it, our everyday lived culture embodies a certain way of seeing and being and understanding. Our culture shapes what we think is good and bad, beautiful and ugly, just and unjust, normal and strange. It lays the foundation for politics as it outlines the contours of our very notions of what is possible. This culture makes us, as we make it. A human, in the words of the anthropologist Clifford Geertz, "is an animal suspended in webs of significance he himself has spun." If we want to change the world, and sustain that change, we have to weave new webs of significance. We need to change culture.

Gramsci understood this too. As a young man in the first decades of the twentieth century, he was part of a movement of striking workers in Turin who seized their factories from the owners. As per the Marxist blueprint, the proletariat had seized the means of production, and next to come was the inevitable socialist transition to the communist ideal! This isn't how things worked out. Once the factories were won, the workers found themselves at a loss: they struggled to run the factories themselves and before long control returned to the owners, and working conditions to their exploitative norm. So what went wrong? The workers, Gramsci concluded, hadn't developed a radical culture

that allowed them to make sense of their radical actions. They hadn't yet developed the culture necessary for running the factories, and themselves, in a non-capitalist manner. To put it another way: they had banished the bosses from the factories, but not from themselves.

Gramsci spent the rest of his life (much of it in a Fascist prison) theorizing what was necessary for creating a new society. He, too, learned from the high and popular culture of his time, much of which was connected with the Catholic Church. He reasoned that the Church had been so powerful for so long because it had integrated C/culture with power. Stories, hymns, architecture, incense, and communion were just as important to the Church as riches and property, crusades, and treaties with kings. It was the former that legitimized the latter. Gramsci concluded that for a new revolution to be successful it was not enough to seize power and property and to institute new laws and governance; people would have to act, think, and feel in new ways as well.

Gramsci called for a radical "common sense." Communism, he realized, would never succeed if it remained just a political party or an ideology; it needed to be integrated into every aspect of people's lives, just like it was for the Catholic Church. His ideas would eventually be put into practice by radical organizations around the world. The Italian Communist Party, for instance, emphasized cultural events for its members like football leagues, social centers, eating clubs, and parties. It tried to create a communist culture.

If putting culture in the service of politics sounds somewhat totalitarian, it is. But, then again, so is the society we presently live in. Think about a casual conversation with friends; about a relaxing day or evening off from work; about brushing your teeth before you go to bed. Now think about what these everyday practices support. Our conversations with friends tend to concern our day jobs, the clothes we wear, or the movies and TV shows we've seen. We often spend our "day off" shopping or watching videos at home. The evening ritual of brushing our teeth is done with our preferred brand of toothpaste. What all of us do in such daily practices is reproduce consumer capitalism. We don't do this by memorizing ideological tracts, or joining political parties, but just by doing what we normally do, using our "common sense." Every day, throughout the day, we learn, live, and reproduce capitalist *culture.*

Fortunately, this isn't the only culture we live in and express ourselves through. We are part of multiple cultures existing simultaneously: the culture of the region we are from, the cultures of the age, gender, class, sex, religious, and ethnic groups we are part of, and the cultures, including alternative cultures, that we create ourselves. These cultures may be complementary or contradictory, and, together, they make up who we are and how we make sense of the world.

We are all caught in this intricate web of significances. If we are going to free ourselves and others we need to re-weave the web. In the United States, for example, there are plenty of laws on the books to prevent discrimination based on gender, ethnicity, age, sexuality, and religion. But bigotry and prejudice persist in word and deed, they are structured into our institutions and thinking. While laws

may have shifted, culture has not always kept pace. Radical political events happen all the time: demonstrations, occupations, riots, even revolutions. Sustained social change happens much less frequently. In order for political events to have lasting impact, there needs to be a receptive and supportive environment so that the actions "make sense" and the changes that they bring are reproduced. As Andrew Breitbart, founder of the ultra-Right-wing *Breitbart Report*, counseled: "Politics lies downstream from culture."

There is no way to escape culture. What we can do is create forms of culture that express the values we want to see reproduced, instead of passively accepting those of the dominant culture. We need to create a radical new culture. The question of how to actually do this returns us to the circular chart given at the start of the chapter.

Here it is again:

This cycle is our opening. Culture as art is shaped by the norms and patterns of everyday life, or little c culture. And it works the other way too: art shapes everyday life, providing representations of ideals to strive for in our everyday lives.

We are *artistic* activists. When our artistic activist pieces æffectively communicate and resonate with audiences, they influence and alter everyday culture—expanding and prodding what we consider normal, possible, or even conceivable. We might, for example, attempt to create an image that provokes a rethinking of how people look at reality, like Picasso did with his Cubist depiction of the bombing of Guernica. Or we might stage a performance which calls into question what values and institutions are "normal" in a society, as Alfredo Jaar did when he erected a local art museum in Skoghall, Sweden, allowing it to exist for twenty-four hours before burning it to the ground (see chapter 1). Or we could create an artifact prefiguring the world we'd like to live in, like the mythic manufacture of "We the People" in the U.S. Constitution (see chapter 3). All these interventions began as Culture, but successfully transformed culture in ways both big and small. By creating radical Culture, artistic activists challenge and change the hegemonic culture. We can use Culture to influence culture and in doing so provide a glimpse of what a new culture might look like, building a new common sense nor a new world.

Use Culture to help transform culture
through Exercise 20 in your workbook

CHAPTER

5

COGNITION

"Facts are simple and facts are straight
Facts are lazy and facts are late
Facts all come with points of view
Facts don't do what I want them to
Facts just twist the truth around
Facts are living turned inside out
Facts are getting the best of them
Facts are nothing on the face of things

— TALKING HEADS

Remember This

IN OUR WORKSHOPS WE PLAY a quick memory game. We start by flashing a collection of seemingly random letters on a projector screen:

wyembuhstetecgeyarlouhwosetnuhonseitohdi

After a few seconds, we hide the letters and ask people to recall them in the correct order. In over ten years, no one has ever come close. We then we reveal the same letters, but now organized in a random collection of words:

the to change world must the

you see change wish be you in

This time around, people can usually remember at least a few of the words, but not all of them and not in order. The last slide we show arranges those same words into the following sentence:

You must be the change you wish to see in the world.

Even though the sentence appears for only a few seconds, almost everyone is able to remember it. Why? Because the letters are no longer just letters, they are words. And the words are no longer just words, they are words strung together in a meaningful sentence. And not just any sentence, but one that many know as a quote from Mahatma Gandhi.

What's the point of this exercise? To get people thinking about thinking.

Thinking about Thinking

WE THINK A LOT about thinking at the Center for Artistic Activism. After all we've said about our political convictions and motivations being largely emotional and experiential, rather than rationally decided upon, it may seem odd that we'd include an entire chapter on thinking. But artistic activism is not only aimed at people's hearts; it also aims at their minds. Our emotions, thoughts, and actions are deeply interconnected, so we must know how people think, as well as how they feel. We're no experts on cognition, but in this chapter we want to share a bit of what we've learned.

The more scientists have studied how the mind works, the more they've come to realize that those very affective qualities of the arts that *move* us, things like compelling narratives, shocking spectacles, or radical shifts in perspective, are essential to how we think—and to how we might think differently. To understand the mind, then, is to understand how artistic activism is a particularly effective approach to challenging and changing the way people make sense of the world as it is, and think of new worlds that could be.

The Matlock Method

THE LITERATURE TABLE. Some of us have been behind it; we've all been in front of it. A flimsy fold-out table stacked high with flyers, reports, and books packed with facts designed to convince "the people" of what's *really* going on.

And we've all likely seen (or possibly created) artwork that seeks to perform a similar function: using bold images to "visualize data" and illustrate important information that, again, is hoped to awaken people to what's *really* going on. These seemingly different forms of political communication rely on a shared premise: that if we can just get the facts out to people they will understand, be as outraged as we are, and, naturally, do something. This is a common approach in both activism and in political art. At the Center we've come to call this technique the "Matlock Method of Political Persuasion," or MMPP, referring to the popular 1980s television show starring Andy Griffith as criminal defense lawyer Ben Matlock.

The MMPP imagines the social world to be like a courtroom. Here, we cannot persuade anyone of anything until a full study and investigation has been conducted and we are prepared to present our case, having stuffed our briefcase full of studies, reports, books, and other

supporting information. We bring "exhibits" for the "jury": visual aids like PowerPoint slides, graphs, and charts mounted on hardboard and displayed on easels. With all of this material supporting us, we pace the floor like Matlock did on TV, making reasoned and rational claims, pointing out facts with a telescoping pointer. We methodically build our argument from the ground up, constructing an undeniable and impenetrable wall of Truth. The facts are what matter in court: if we veer from the question at hand, objections will be raised, and if we demonstrate inappropriate emotions, we may be charged with contempt.

If political persuasion worked this way, it would make changing the world a lot easier—all we'd have to do is marshal the evidence and prove our point and the "people" would decide in our favor. The problem is that it doesn't.

Our struggles are not waged in a controlled environment like the courtroom. We approach people individually on crowded city streets, or try to attract their attention as they whiz by in their cars (windows up, AC blasting, radio on). No one is sequestered in a jury box, legally bound to listen to evidence. Our jury is busy going to work, coming home from school, going shopping, or trying to relax. The world is no courtroom. And the irony is that even courtrooms don't work in this way. Facts alone don't win cases; rather, as the producers of Matlock understood, lawyers telling persuasive stories about facts win cases.

This is not to say that facts are unimportant. If we want to change the world, and want the world we create to last, then our analysis, plans, and actions need to have solid foundations in facts. Our issue is not with facts themselves, but with the assumption that facts are sufficient. It's too often believed by activists that if people just had *access* to the same information that we do, they would become aware and act on that awareness. So we supply access: problem solved.

Not solved, Matlock. We live in a world awash in information. The democratic dream of a public with full access to the facts has become, in our internet age, a reality. But facts are not enough. No matter how many pamphlets you distribute at information tables, or how informative your artwork is, nothing is going to happen unless people can make sense of the facts you are giving them. Digging up the truth and putting it before an audience may make artists and activists (and journalists and scholars) feel like they are doing something worthy, but it is rarely effective in moving people to act. If people don't know how to process facts and make meaning out of them, then the facts will stay right where they are: on the literature table or in a museum.

In order for us, as artistic activists, to employ facts in effective ways, it will be useful for us to have at least a basic understanding of how our minds and brains work. We can then present facts in ways that people can understand, integrate, and, most critically, act upon.

How We Think

ONE WAY TO THINK OF THE MIND is as a big warehouse. Walking through the world, we pick up bits of information—ideas, experiences, and facts—and store them in boxes in our mental warehouse. When we think, we pull out relevant information from these boxes and use it. It might be visualized like this, with each of the below letters standing in for units of information:

But this warehouse metaphor is too simple. When we use our minds, the bits of information we draw on aren't stored away in their own boxes in *isolation from* each another; instead, we use these bits in *association with* one another. Something more like this:

Information only makes sense when linked with other information. In order to recall, understand, or use ideas, we need to be able to attach them to other ideas. In other words, we need to be able to put information into *context* through associative webs of meaning. And these associations are not random; they are ordered. Depending

on what we are thinking about, we order information in associative strings called pathways. In order to make sense of our letters, for instance, we might order them this way:

A - B - C - D - E - F - G

By stringing our information together in a given order — in this case the Latin alphabet — we are able to understand it better. A leads to B, C comes after B, and so on. We've followed this pathway many times before. You probably learned to sing the alphabet song when you were a kid. You may have even played the tune in your mind as you read the letters above. Singing the alphabet is an effective way to learn because it reinforces strings of associations necessary to remember the data. If we recite the song enough times, when we come across

THE ALPHABET SONG

A B C D E F G H I J K L M N O P

Q R S T U V DOU-BLEU X Y AND Z

NOW I KNOW MY A B Cs, NEXT TIME WON'T YOU SING WITH ME?

the letter D we immediately locate it between C and E. In doing this, we are creating a pathway.

While the specifics of this process are new to cognitive science, humans have known principles of association for millennia. The ancient Greeks used a mnemonic trick to remember speeches or poems called a "method of logi." It worked through the mental creation of a "memory palace," an imaginary place in which you "store" objects. Each object acts as a sort of peg connected to a specific idea or sentence. A picture of a sunset, for example, might be your cue to recall Homer's epithet "rosy-fingered dawn." This reflects an idea of the mind that somewhat resembles the warehouse mentioned above, except that in order to recall the information you need to walk through the imagined space, connecting object to object, and each object to the information associated with it. Basically, you are walking a pathway of association.

This principle of association functions best with complex units of information like words and sentences. As illustrated in the exercise at the beginning of this chapter, it is easier to remember a meaningful sentence than a series of random letters, due to the associative links between the units of information. By changing their context and presentation, we transformed seemingly random bits of information into a sentence with meaning—in other words, we created a story, and one that could be shared with others.

We think in stories. Stories are simply data that is woven together in ways we find meaningful, and they are the way we effectively process and retain larger amounts of information. Remembering a random string of sentences is as difficult as remembering a random group of letters. But if we put those sentences together to make a story, we are able to understand and recall a great deal more. We might not remember the words verbatim, but we are able to understand something far more valuable: their meaning.

In fact, Gandhi never actually said "be the change you want to see in the world." What he said was more nuanced and complex: "If we could change ourselves, the tendencies in the world would also

change. As a man changes his own nature, so does the attitude of the world change towards him.... We need not wait to see what others do." Because of how we make sense of information, what Gandhi actually said is not what's been remembered. The full quote is less poetic, more meandering, and much longer. "Be the change," however inaccurate and watered down, has one thing on its side: it's simpler, and this makes its sentiment much easier to retain (and to fit on a bumper sticker). The lesson here is not that we should use simplistic slogans instead of nuanced calls to action. Rather, the mutation of this phrase is a good example of how the human mind weaves meaningful connections instead of keeping a warehouse of accurate, isolated pieces of data.

To better illustrate the power of stories, let's move from words to images. Take a look at these pictures:

These images aren't connected. What does a person have to do with a table setting or a hamburger? Objectively, nothing. But our mind wants to connect and find associative links between them. It quickly orders the images into sequential frames and creates a story of a hungry woman who loves hamburgers and enjoyed her meal.

Now the order is changed.

What is the story here? It is one of a happy woman who then gets sick after eating a hamburger and leaves the table? In fact, there is none. What is on the page is a series of four independent images. The story we create in our heads is based on connections we've made between the images. The meaning of the frames and the causal relation we imagine taking place between them are things we, as humans, impose. This is called the Kuleshov Effect (named after the experimental Soviet filmmaker Lev Kuleshov).

Hold your hand over any three frames and the remaining one becomes meaningless. Even when all the frames are viewed together,

there is no action that may be witnessed. We don't see the woman *eat anything*. We don't even know if the person in the first frame is the same as the person in the last frame. And really, it's just a bunch of dots on a page that we've all decided represent a person. Our mind is making all these connections so that we can make sense of the information. Again, it is creating a story.

To summarize: our mind makes sense of information by creating connections to other information, and these connections are not random, but ordered in such a way as to make stories. This is still a very rudimentary explanation of cognition, so let's go deeper, past the mental construct that is *our mind* and into that soft, spongy organ that sits inside our skulls: *the brain*. Weirdly enough, it is not only the mental processes of our minds that work through stories and associations, but also the physical processes of our brains.

Cognitive scientists have discovered that the ways in which the mind makes sense of information effect the actual structure of the brain. With repetition, our brains begin to form neural pathways

based upon associations we have learned. In other words, the stories we learn to make sense of reality get soft-wired into our brains. These pathways are not set in stone and we can think in a variety of ways—they are more like well-worn routes, and electricity flows through the path of least resistance. As the neuroscientist jingle goes: "neurons that fire together wire together."

If you think about this it makes sense. Forming mental associations is very efficient. It's the way our brains can figure out what to do with inputs really fast and without much effort. We don't have to relearn every time we think. Very young children still need to recite the alphabet song in order to figure out where to place a particular letter, but when we get older we *know* this almost automatically. We can do this mental feat, instantaneously and seemingly without thinking, because when it comes to the alphabet our neural pathways are pretty well formed.

What does any of this have to do with artistic activism and changing the world? Remember that one of our goals is to change the way people perceive and understand the world and their place within it. We want people to listen to what we have to say, see what we have to show them, and understand and accept the facts and perspectives we have to offer. There's all sorts of ways to do this, but if we want the highest chance of success—if we want to win—we need to know how people make sense of information so we don't go wasting our time and energy with approaches that won't work.

Prepare to Be Depressed

DESPITE WHAT WE'D LIKE TO BELIEVE about the MMPP (The "Matlock Method of Political Persuasion," in case you've forgotten), people don't usually make decisions based on careful examination of all the information available to them. Instead, most of the associations we make and actions we take happen seemingly automatically, without much thought at all. We process information through well-traveled neural pathways that are activated immediately. Simply put, most of our thought is not active thinking at all but is snap judgments.

This makes a certain sense when we think of it in terms of human evolution. Millennia ago, when we were being stalked by saber-toothed tigers on the Serengeti plain, it wasn't a good idea to take time to ponder the possibilities and weigh the evidence: What was that sound off in the distance? What is that moving toward me? Does it mean me harm? My, what large teeth it has! Instead, our brain needed to tell our feet to start moving so that we could escape and go on to live, mate, and propagate our genes. Today, operating on "autopilot" gets a bad rap; we pride ourselves on thinking things through. But from an evolutionary standpoint, thinking everything through can be lethal. It's our ability to learn and make snap judgments that have allowed us to survive everything from grasslands to superhighways.

Both of your authors ride motorcycles and, in a past life, Lambert sold them in a shop in San Francisco. He warned new riders that they were far more likely to get into accidents in the first three months of riding. Why? Because when we first start doing any new physical

activity our brain doesn't have the neurological patterns for that activity in place. Operating a motorcycle takes a tremendous amount of mental effort to coordinate all the bodily movements we need to balance, shift, accelerate, brake, and turn. New riders get into accidents because their brain is focused on the basics and when something unexpected happens their minds are quickly overwhelmed. Inputs overwhelm their cognitive ability and they make mistakes. Over time, the mechanics of operating the vehicle require less and less cognition—our neural pathways get mapped, and shifting, braking, turning, and so on become more automatic. An experienced motorcyclist, or any driver, for that matter, spends very little mental attention on the mechanics of driving—it becomes second nature. Established neural pathways help us better manage everyday driving, just as they helped our ancestors survive on the Serengeti plain. Our brain has a long established and beneficial ability to *not consciously think*.

While learning to drive a motorcycle may seem like a different process to that by which we think about and act upon political issues, overtime both become rote, almost automatic, responses rather than careful and reasoned deliberations. This poses a real challenge for those of us who are committed to changing the way people think, for how can we change the way people think if they are not really thinking much at all?

It gets worse. Researchers have also found that we tend to only consider information that fits into what we already believe. That is, we don't create our sense of reality based on the facts we come across, we find and bend facts so they conform to what we think we know. This is called "confirmation bias." Notions of right and wrong aside, it's cognitively easier to use new information to confirm what we already believe, instead of reevaluating our entire position on an issue. This is why in the United States conservatives love Fox News and liberals enjoy listening to National Public Radio, while viewing the other news sources with skepticism. In each case, they get the facts and opinion that reinforce what they already know.

When we are confronted with information that challenges the beliefs we hold as true, instead of changing our minds we often "double down" on our original belief systems. This is why you will never be able to convince your belligerent half-drunk uncle at the family reunion that he's wrong about 9/11 being a big-government conspiracy, about Covid-19 not existing, and about Trump winning his re-election. Every bit of evidence you present to prove the contrary will be either ignored, reframed to confirm his views, or be taken as evidence of how far-reaching the conspiracy is and how many people have been fooled. We believe in what we already believe in, and you will never win the argument with your uncle, but, then again, he won't win it either. Arguing more fiercely for what you believe in is easier than admitting you're wrong and changing your mind.

It gets worse still. Many of our neural pathways are created when we are young and — quite literally — impressionable. As we grow up, we develop ways of making sense of the world that "work" for us

(even if they are harmful, counter-productive, etc.) and these patterns organize our brain. As we grow older our neuroplasticity—the ability of our brains to grow, change, and regenerate—decreases and it gets harder to absorb new information and think in new ways. Brain science confirms folk wisdom: it's hard to teach an old dog new tricks.

So, to sum up: 1) our political belief systems are soft-wired into our brains, 2) presenting new facts won't change what someone thinks, and 3) the chance of people changing their minds decreases with age. This is why literature tables only preach to the converted, why debates rarely sway anyone, and generally why having the facts on our side doesn't amount to much.

This is *really* depressing—but only *if* we continue doing the things that activists and artists have traditionally done: presenting information in the hopes that people will understand it as we do. If we simply confront people with facts they will make their own associative links and fit these into stories they already tell themselves. Or they will ignore the facts that run contrary to their beliefs. In short, they will "make sense" of information in ways that are routine or most comforting to themselves.

But with a basic knowledge of how human minds and brains work, we can take another approach, one that actually works. Because it's not that people can't change their political minds, it's just that this is hard to do, and exposure to facts alone won't do it. We need to change what people do with the facts we give them.

Telling Stories

NOT TOO LONG AGO WE WORKED with a coalition of activists in Houston, Texas, fighting against the mass incarceration of Black and Brown youth. Children fourteen years old and even younger, including the sons and daughters of some of the activists, were being imprisoned in Texas on minor charges. Once these kids entered the system it was almost impossible for them to get out. The job of these activists was to convince the prison officials, politicians, and citizens of Texas that youth incarceration was not the individual problem of "bad kids" or a policing problem of "preventing crime" but the social problem of an unjust system. The challenge was this: many Texans, including most of those in power, had strong associations regarding people who broke the law in general, and Black and Brown young people in particular. These associations were simplistic, negative, and based on years of racist thinking.

These pre-existing associations meant that presenting bare facts about the details of individual cases, racially biased policing, state

incarceration rates, recidivism, or prison abuse were not persuasive. Many Texans took such facts and slotted them into the fearful fairy tales they told themselves about Black and Brown youth. The very same facts we might use to make the case for a humane justice system would be interpreted as further evidence justifying stricter law and order. The higher rates of incarceration for minority youth, for example, was proof to the activists in the room of a racist system, but for law-and-order types, it was evidence of a proclivity of minorities for criminality. Facts alone would not work.

We soon realized that we needed to create new stories with which people could make sense of old facts. We started with the idea that everyone has kids, knows kids, or has been a kid—and all kids make mistakes at one point or another. Many of us have stories about a dumb thing we did when driving at seventeen, or a dangerous blunder we made in middle school. We can share and laugh about our mistakes, in the same breath as describing how we went on to live positive, productive lives. Kids make mistakes, they learn from them, and they deserve another chance. We don't ponder this, ruminate upon it, or reason through it—we *know* it. We know it because it's a story we've seen play out countless times for our friends, loved ones, and ourselves.

This story of redemption—of second chances that work out well—was one the Houston activists could tell alongside that of the lost potential of generations of Black and Brown youth who are never given that chance. Conveying the facts about youth incarceration in the form of a sympathetic story would increase the chance that people who would otherwise ignore us would listen, and we could begin the process of forging new connections between factual input and cognitive meanings.

To put it simply: as artistic activists we need to become really good storytellers.

Become a better storyteller with
Exercise 23 in your workbook

Learning to Listen

IN ADDITION TO BECOMING good story-tellers, we need to teach ourselves to be really good listeners. By listening to the stories that people already tell themselves, we can begin to figure out how to fit *our* facts into *their* stories. It's hard to tell a sympathetic story about incarcerated Black and Brown kids to fearful white Texans. Their racist beliefs are, literally, ingrained in their heads. But what stories do these same people tell themselves about *their* children and grandchildren? Can we fit our kids into their stories? How would they feel if someone they cherished and loved was locked away for a mistake? The key here is not confronting people head on. It is figuring out what stories people are already telling themselves, what associations they are already making, and then figuring out a way to fit our concerns within this.

Careful listening is something marriage equality activists in the United States have done very well. In 2009, the governor of the state of Maine signed a same-sex marriage bill into law. However, the people of Maine did not overwhelmingly support (or even understand) the law, and conservatives organized a successful counter-campaign to repeal it through a popular referendum. What had seemed like a victory for marriage equality quickly turned into a bitter defeat. In response, the activists didn't (just) point fingers and hurl accusations of homophobia, nor did they (just) present facts and figures, but they also found a way to present the case for gay marriage through a story that was already familiar to many citizens of Maine.

"Down Easters," as folks from Maine are called, tell themselves a lot of stories about marriage. Some, learned through tradition, religion, and right-wing media, are stories in which homosexuality is sinful and marriage is only between a man and a woman. But the activists discovered that Down Easters tell

themselves other stories too — about love and commitment. The activists knocked on doors and asked people to talk about their own relationships. They asked them how it would feel to not be allowed to marry the person they loved. And they asked them to think about friends, neighbors, and relatives who were gay and lesbian. They told them about their own committed, same-sex relationships. And *then* they asked: Should gays and lesbians be able to wed the people they love?

This strategy of what came to be called "deep canvassing" worked. By telling a popular story of *marriage equality*, rather than framing the issue within the narrow appeals of the constitutional rights of minority groups, activists were able to reach and persuade a critical number of people. In 2012, the citizens of Maine re-voted on "marriage equality" and the referendum passed, making Maine one of the first U.S. states to pass such a law by popular vote.

We cannot ignore the associations that people make — but we can mess with them. We discovered this, again, in Texas, when we worked with activists and artists who wanted to change the state budget so that more money went toward social services and less toward corporate welfare. It was a hard fight in a state where old boy crony capitalism is a way of life. Looking for a political opening, we asked the group to brainstorm the associations that Texans had about their state. We discovered that Texans — even radical activist Texans — loooove Texas. Texans think Texas is exceptional, and, despite the negative forms this exceptionalism takes (incarceration rates, regressive tax structures, and so on), Texas pride runs deep. It's not worth fighting against, so our job was to find a work-around.

Through brainstorming, one person suggested that we take a look at Texas's anti-littering campaign. In Texas the land seems to stretch forever, and Texans considered it their God-given right to throw garbage out the windows of their cars and pickup trucks. Consequently, Texas was *exceptionally* polluted. There had already been nationwide anti-littering campaigns (famously, the TV spot picturing a "Native American"— played by an Italian American actor — with a tear rolling down his cheek as he looked out onto a garbage-strewn landscape), but

most Texans had negative associations with anything environmentalist. Environmentalism was identified with tree-huggers from the coasts and bureaucrats from Washington, D.C.

In the mid 1980s, the Texas Department of Transportation began a campaign to change Texan associations regarding environmentalism. Its slogan was simple and powerful: *Don't Mess With Texas.* By making littering an affront to Texas, the DOT was able to harness Texan pride and transform environmentalism from something imposed from outside into a protective challenge issued by Texans themselves. And it worked. In the first four years of its implementation, roadside litter in Texas dropped by 72 percent, and thirty years later the slogan is still in use. The Texas DOT didn't try to change the stories Texans liked to tell themselves, they merely made anti-littering part of them.

Write your concerns into other people's stories in Exercise 24 in your workbook

We're of Two Minds

WE HAVE ANOTHER SPOT of good news: the brain is not a one-party system. Most of us have more than one mind when it comes to our beliefs. We make liberal and conservative associations and tell ourselves progressive and reactionary stories. A staunch supporter of self-reliance in the marketplace, for instance, may also believe just as fervently in mutual aid when it comes to his family and friends. Rationally, these beliefs are at odds, but of course we don't always think rationally. There's room in our minds for Ayn Rand *and* Peter Kropotkin. Strange bedfellows, true, but we all know that logical consistency has little effect on who we chose to shack up with. We're all complex people with a wider range of beliefs than cable news would have you believe.

This provides an opening for artistic activists. Linda Sarsour, the Muslim American activist mentioned in chapter 4 who understood the political appeal of *Fast and Furious 6*, told us a great story of how she used people's mental ambiguity to create an unlikely ally. The opportunity arose in the wake of the hurricane that devastated the coastline of New York and New Jersey in 2012. Linda was volunteering with Occupy Sandy, an Occupy Wall Street spin-off providing aid directly to the storm's victims (itself a creative strategy of retelling the story of Occupy). Wearing a hijab, she went door to door offering food and aid in a New York City neighborhood — one in which the residents had recently protested against the construction of a local mosque.

At one house, an elderly white woman opened the door a crack, peered out, and asked Linda, suspiciously, what she wanted. Linda patiently explained who she was and what she was doing. When the woman told her that she had been without power for her stove or refrigerator for weeks, Linda offered to provide her with some ready-cooked food. The woman agreed and while Linda unpacked the food they started talking. In the course of conversation, the woman asked Linda if she was Muslim, to which Linda said yes, adding the fact that she was born and raised in Brooklyn. The woman awkwardly confessed that she had been active in the neighborhood

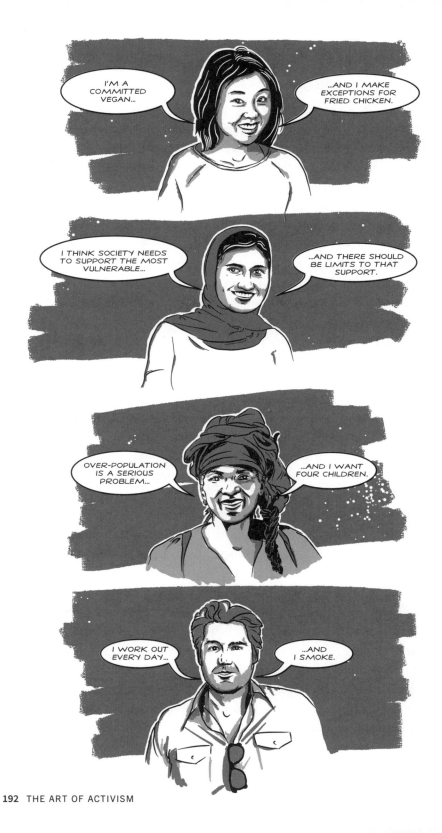

fight against the mosque. They talked some more: about the storm, about New York, about the importance of good neighbors and, by the time Linda left, the woman admitted she had been wrong to fight against the mosque and wouldn't mind having a Muslim like Linda as her neighbor.

What's important here is what Linda did not do. She didn't approach the woman as an activist denouncing those who wouldn't let Muslims build a mosque in the neighborhood. Had she done this, she would have triggered the woman's routine, likely Islamaphobic associations. Instead, Linda met the woman as a fellow New Yorker who was there to help; a neighbor who happened to be Muslim. Approached this way, the woman inserted Linda into another narrative: the story she routinely told herself about what made good neighbors. She didn't so much "change her mind" about Muslims, but just slotted Muslims like Linda into an existing part of her mind. Now, Muslims made for good neighbors, exactly the people you would want building a local community institution.

Understanding that people often have more than one mind when it comes to an issue is not about pointing out their logical fallacies: "How can you call yourself pro-life when you support war?" People are inconsistent, and pointing this out will not further your cause. We need to recognize that people are full of contradictory ideas, then bypass the ideas and associations that run counter to our objectives. Then we can focus in on and work with the ones that can help us.

Explore the stories other people tell themselves
in Exercise 25 in your workbook

Rewriting the Story

BY TELLING STORIES people are open to hearing, and understanding how we can fit our concerns into stories people already tell themselves, we can get them to listen to what we have to say and look at what we want to show them. A bit of knowledge about how the mind and brain work, and a creative, story-based approach to activism, allow us to bypass some of the cognitive barriers that stand our way. But there is also a problem with this approach. The storytelling strategy we've laid out so far depends upon stories that, in some way or another, are already written. We can intervene in and add to these stories, but the associative structures are pre-existing. That is to say, *these stories are part of the very world we want to change.* Telling stories that people are already receptive to hearing is effective because it meets people where they are. But when we do this we're working within cultural structures — sets of associations and collections of stories — that were created for other, sometimes detrimental, purposes. The marriage equality activists, for example, were able to effectively tap into people's associations of love and marriage, but in doing so they reinforced the traditional idea that love and commitment are best expressed through marriage. Linda may have changed one person's understanding of Muslim New Yorkers, but what about Muslim "foreigners" from different neighborhoods, cities, or countries? And the Texas DOT effectively channeled Texas pride to stop littering, but they also perpetuated Texas exceptionalism. There are also some pre-existing cultural stories that are impossible to work within: it's not worth trying to figure out a progressive spin on bigotry, for example.

Storytelling tactics are powerful and effective tools for artistic activists, but we need to go further. If we really want to bring about revolutions in thinking and being we need to disrupt the stories people already have and help to write new ones. This isn't easy. We are proposing a move from understanding and fitting into pre-existing mindsets to intervening in and, ideally, creating new ways of understanding the world. But we can do it, because we have a secret weapon.

Surprise!

SURPRISE IS OUR secret weapon. As we've established, the problem with our thinking is that most of the time we're really not thinking much at all. We often act on autopilot, making associations and following patterns that have worked for us in the past. Because they've worked, we see no reason to challenge or change them. Unless . . . we are *surprised*. When something happens that violates our expectations, something that we can't immediately make sense of, our autopilot fails and manual control takes over. This is an opportunity for increased cognition and remapping of associations; in short, for thinking differently.

Here's an everyday example: on your trip home, you plan to stop and pick up some groceries. It's important that you do so because you have a recipe planned for dinner that night. It's a long, uneventful drive home that you take five days a week and, next thing you know, you're walking through your front door and you've forgotten entirely about the groceries. The journey flew by, your mind lulled by the routine,

and there you are at home, with nothing to cook. Happens all the time. This time, imagine you are driving home, taking the route you always take, absorbed in your own thoughts...when all of a sudden a deer steps out onto the road in front of you.

In a flash you ask and answer the following questions:

What is that thing on the road?

Is that a dog?

Is that a deer?

Is that a bear?

Do bears have antlers?

It's a deer.

Is it moving?

What direction is it going?

Does it see me?

How fast am I going?

Am I braking fast enough?

Am I braking too fast?

Am I skidding?

Is there anyone behind me that might hit me?

How else can I avoid hitting this deer?

And you act accordingly: hitting the brakes, swerving around the deer, or traveling straight through because the deer keeps moving. All this thinking and doing happens in a few seconds. When unexpected things happen, we do a lot of cognitive processing very quickly, and time seems to slow down because of it. This sort of conscious, reflective, and active thinking brings opportunities to think in new ways.

Surprise is at the center of a lot of avant-garde art ("shock" is the term that art historians sometimes favor). Surprise, or shock, was what Marcel Duchamp hoped to provoke when in 1917 he mounted a urinal in an art show and called it a "fountain." Visitors to the show naturally expected to see original works of painting and sculpture. They could make sense of art that conformed to these expectations without much effort, before, untroubled, they went on their merry way. This is exactly what Duchamp did not want to happen.

① Find Urinal

② Rotate 90 degrees

③ Sign using alias

④ Add to art show

How to create a sensation in art and culture in 1917

Duchamp wanted the public to make sense of something that seemed insensible. In this case: a ready-made object usually found in a bathroom sitting in the middle of an art show. (An equally shocking surprise would have been to mount a painting in the bathroom in place of the urinal.) Why did Duchamp do this? In part, to make a name for himself as an avant-garde artist, but also for social and political reasons. By 1917, the "Great War" that would eventually kill 9 million soldiers and 7 million civilians had been raging in Europe for three years, for no clear causes and with no clear victors. Mass destruction had become commonplace, almost acceptable. Duchamp and his fellow Dadaists created "nonsense" to question what had become sensible—stopping people in their tracks and demanding they make sense of something that didn't.

The problem with a lot of activism and a lot of art is that it isn't surprising at all. When we stage a protest in a public space with placards on poles and loudly chanting syncopated slogans, no one is surprised. This is what a protest is supposed to look and sound like and, because of this, it is easily dismissed as "just another protest." If you are an activist, and have positive associations with protests, you might run over to check it out. If you are law-and-order minded, you might grumble and gripe about misguided commies and kooks. But for most people, it's just a protest: something to observe for a moment or two, or perhaps figure out how to avoid, but in all cases, something known, and ignored. A march comes as no surprise and

therefore places no additional demands on cognition. The purpose of the protest matters little; its form practically guarantees that it will be given little thought.

Art often works the same way. We may like it, hate it, or not understand it, but we know what to do with it — file it away under "Art." Almost a century since Duchamp's urinal, we are even used to art being "shocking." When viewing art, we expect to see things that we don't, and may never, understand. But we often seek to resolve our confusion by thinking: "Oh that's some weird artwork, I don't get it, I'll just move on." No matter how surprising art might seem, the fact that it is "art" mitigates the moment of incomprehension, and even the most shocking pieces are rendered sensible. Duchamp's urinals are now featured as great works of art in established museums, something to appreciate on a pleasant Saturday sojourn. In this way, art is even easier to dismiss than a protest.

But what happens when we see an activist artwork or political protest out of context? Creating contextual surprises was a strategy of Reclaim the Streets. Reclaim the Streets, as described in chapter 4, was a group of activists who created protests that looked and sounded like raves. A casual passerby might know how to categorize — and ignore — a protest with placards and chants, but one with people dressed up in costumes and dancing to a thumping sound track of electronic music? A political demonstration like this doesn't *automatically* make sense, and so people need to stop for a moment to *actively* make sense of it. That's exactly what Reclaim the Streets wanted to have happen. (It's no coincidence that one of the founders of RTS in London, John Jordan, was an artist influenced by the avant-garde.)

We used the principle of surprise ourselves when we worked with activists fighting to increase access to medicine in Barcelona in 2014. Outside a major hospital, we staged a spectacle to protest the selling of drugs to treat hepatitis C at inflated prices by the pharmaceutical company Gilead. What we created didn't look like a protest — it looked like a carnival, and a creepy one at that. Clowns in lab coats welcomed people through a gateway reading "La Bolsa o La Vida!" (Money or Life).

Carnival goers were then steered to an unwinnable shell game and a wheel of fortune that always landed on the highest price. Outside, buskers played music to raise the $84,000 needed to cover the cost of a single course of hepatitis C treatment. What might have been understood, and summarily dismissed, as a protest against Big Pharma, instead became a puzzling (and amusing) sight for patients and hospital staff. Initially confused, they wandered through, had some laughs, and also thought about our message. Before leaving the hospital, visitors were asked to join the carnival and fill out "official" complaint letters to send to government officials, hospital administrators, and the price-gouging pharmaceutical company. The surprising nature of this political demonstration had other advantages — it confused the police and hospital security, who weren't sure if this was a protest, an art performance, or a real carnival, or whether the activists wearing lab coats were medical staff, and therefore didn't know how to respond. We were able to stay in front of the hospital for the whole afternoon.

Iraq War Veterans staging maneuvers on U.S. city streets; environmental protesters dressed as grooms and brides in Southwest China; Victorian factory workers appearing in a nostalgic celebratory parade...all of these examples of artistic activism use surprise to disrupt the common associations made by the public and authorities when confronted by political protests. "When you surprise someone, you're *earning a moment* because you're opening up a space," our friend and collaborator Larry Bogad once told us. Protests often focus on "taking up" space, but, through surprise, they can also "open up a temporal, experiential space where anything can come in." When we do something *unpredictable,* we open up space for new thinking. In this "open space," be it physical or mental, there's a chance to remap old terrain and chart out new territory. Often this process is uncomfortable, as it asks us to cast aside the comfort of the known for the unpredictability of the new. But as artist Darren O'Donnell once taught us, all learning begins with discomfort.

So perhaps old dogs can learn new things after all. Recently, scientists have suggested that the brain is much more malleable than once thought and that changes in environment, behavior, emotions, thinking, as well as meditation and trauma can change our neural pathways well into adulthood. We can change our minds, but it takes some sort of disturbance to knock us out of our patterns and prompt us to form new associations and neural pathways. Disruption forces us to think, and makes us open to thinking in new ways.

Build surprise into a piece of artistic activism
in Exercise 26 in your workbook

Figure and Ground

WHEN OUR BRAINS DECODE visual scenes, they decide within a split second what to focus on and what is background information. This is called figure/ground organization. As you read this, your

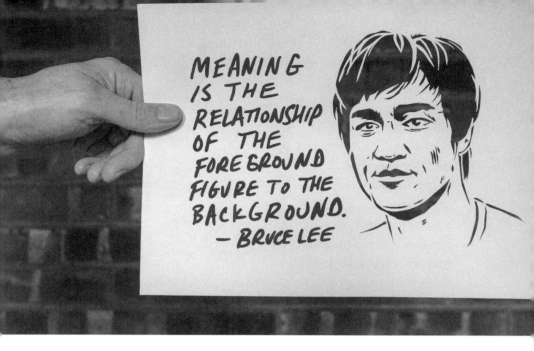

MEANING IS THE RELATIONSHIP OF THE FOREGROUND FIGURE TO THE BACKGROUND.
— BRUCE LEE

brain decodes the black forms on the page as letters and words — the figure — and the white page as the ground. This may have just shifted: when we drew your attention to the paper you may have first noticed its texture and color as it became, for a moment, the focus.

Everything we see exists in relation to a background. We see certain colors differently in relationship to other colors. This is why it can be so difficult to pick out a color at the paint store; you have to take a swatch home because you need to see that color in the correct context. Similarly, a man in a ski mask appears very differently depending on whether he is walking into a ski lodge or into a bank. "Meaning is found in relationship," martial arts master and philosophy student Bruce Lee once said, explaining that "meaning is the relationship of the foreground figure to the background."

When taking a long drive home, the individual stripes on the road, every blade of grass, the leaves on the trees, even the deer grazing near the edge of the woods fall into the background of our perception. But when the deer starts heading toward the road, we perceive it differently; what was ground has now become figure. This change can be noticed in a split second. In controlled studies, people notice a difference before they can even identify what is different. As artistic activists,

we want our work to be the figure that stands out from the ground. We want to be the deer in the road—the surprise.

If a surprise is too surprising, however, it can be difficult for people to make sense of, and end up being ignored. Duchamp's urinal worked because even though it was surprising, there were enough cues for people to be able to locate it as art that they could stretch their sense-making ability without breaking it entirely. In other words, no person has mistakenly taken a piss in Duchamp's *Fountain*. Reclaim the Streets demonstrations, while not traditional protests, also provided clues—banners, for instance—that something was being protested against. These clues helped the passerby, after a moment of befuddlement, to "get it." Without context provided by the artist and the activist, both of these acts would likely have been *illegible.* Another way to put it is: weird is good, but don't get too weird. Good artists and activists learn how to walk this line.

Conflict Kitchen straddles the line between contrast and context, figure and ground, and surprise and expectation masterfully. The creation of artists John Rubin and Dawn Weleski, Conflict Kitchen is a takeout restaurant located in downtown Pittsburgh that serves food from countries with which the United States government is in conflict. The cuisine—Iranian when it first opened, and since then including Afghan, Cuban, Venezuelan, North Korean, and Palestinian—is served, like most takeout food, packaged in wrappers. But these wrappers are different to those used by most fast-food places. In place of brand names and calorie counts are the words of ordinary people from the countries whose cuisines are being showcased, on all sorts of topics, cultural and political. This promotes understanding between peoples through a medium enjoyed by all: food.

Conflict Kitchen works because it couples the familiar with the unfamiliar. Many people might feel uncomfortable engaging in some sort of a "cultural exchange" with people in countries identified as enemies by their government. It's simply too out of the ordinary. But introduce something that is part of everyday life: takeout food, bought at a stand, packaged in paper wrappers, and all of the sudden the unfamiliar becomes familiar enough to engage with and explore.

Striking the right balance between the familiar and the unfamiliar means paying careful attention to variables like time, space, content, form, and tradition.

What is routine in one space can be surprising in another. Take, for example, the performance staged by the Iraq Veterans Against the War discussed in chapter 1. Scenes of U.S. soldiers carrying out combat missions on the streets of Baghdad would, unfortunately, not be very surprising. But switch the context to a U.S. city and suddenly you've created a spectacle that runs counter to expectation and demands to be noticed. Figure is distinguished from ground. But not too much: had the IVAW activists dressed in gorilla suits while staging combat maneuvers their actions would be so outside the norm that people would have ignored or misinterpreted them.

Timing is also critical. In 2007, when the anti-war veterans staged their action, the United States was engaged in open war in Iraq. Passersby could easily, after a beat or two, understand what the soldiers were protesting and why. With images of the war and occupation airing on the nightly news, the spectators were asked only to shift the spatial context. The same action done today, or ten years earlier, however, would likely not work. The gap in time between the occupation of Iraq and the performance would (on top of the spatial shift) ask too much of the spectator and probably make the action illegible.

The relationship between content and form is also critical. Die-ins, a protest tactic of lying on the ground and pretending to be dead, are part of the standard activist tool set. They can be very effective. When ACT-UP performed massive die-ins during the AIDS crisis, for example, they gave public visual form to something abstract and out

of sight: the lethal devastation of the disease. Recently, the tactic has been revived by Black Lives Matter activists demonstrating against police violence. In both cases the tactic worked not only because it was surprising to see people feigning to be dead in public places, but also because its symbolism resonated with their message: people are dying and nobody seems to care. These die-ins made the invisible visible. Unfortunately, the die-in has become a routine protest tactic aimed at all sorts of issues, even when it makes much less sense—at demonstrations against global economic institutions, for instance. Here there's too much contrast without enough context. Yes, the tactic is unexpected, but there's too great a gap between the issue and the

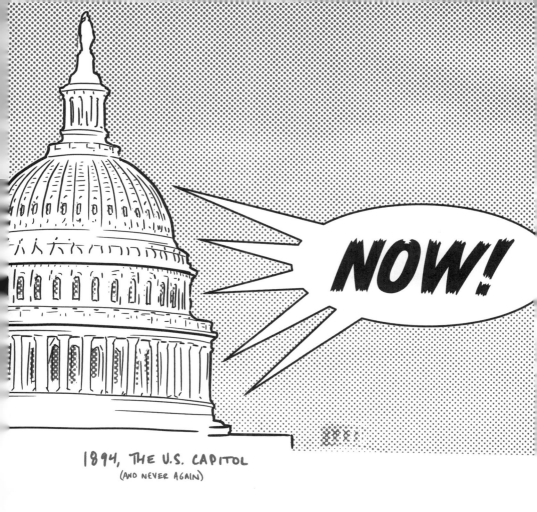

1894, THE U.S. CAPITOL
(AND NEVER AGAIN)

action. With too much to make sense of, most spectators don't bother, and the piece is ignored.

Finally, when working with surprise, we need to consider tradition. The march was once a new and surprising form of protest. We can imagine how amazing it would be to have witnessed or participated in the first March on Washington (often credited to "Coxey's Army" of unemployed workers in 1894). And it was still an awe-inspiring tactic when Martin Luther King led the March on Washington for Jobs and Freedom in 1963 (the "surprise" being that the march was organized by Black Americans). But today large marches with tens and even hundreds of thousands of people are pretty routine. The only way to make

them surprising is to play the numbers game: stating that "millions" will attend, or at least hustling to turn out more people than the last time, and this entails a massive outlay of time and resources. The other "surprise" is to have the marches turn violent, which overshadows the cause and can set back the movement. Large protest marches, while necessary for demonstrating mass discontent, unfortunately lost the element of surprise decades ago.

A more recent and more "artistic" protest tradition is that of flash mobs. The mysterious gathering of people carrying out a coordinated action in a public space was pretty mind-blowing the first time it happened back in 2003. It still carried the capacity to shock the second, third, and perhaps even thirtieth time, but not the three thousandth time, and definitely not now that mainstream cultural institutions and marketing companies stage flash mobs. Flash mobs have become so routine, and so well documented and disseminated, that their surprise factor is near nil. But again, figure is always in relation to ground: a mass march or a flash mob at an atypical time, or in a society where it is a novelty, or tied to a particular issue for which such a gathering makes sense, can still have the capacity to surprise.

There's no set formula to follow for creating an ideal surprise. We need to be constantly asking ourselves:

- What is the contrast that makes my piece jumps out?
- What is the context that allows it to make sense?
- Is there enough contrast?
- Is there enough context?

We need to test and experiment, reflect and revise. Finding the sweet spot between disruption and being dismissed is what makes artistic activism an art.

Find the sweet spot between disruption and being dismissed in Exercise 27 in your workbook

Hearts *and* Minds

We've argued in this book that politics is about emotions and perceptions and sensations as much as it is about thinking and cognition, and that this is why an artistic approach to activism is so *affective*. But in this chapter we hope we've convinced you of something new: that the mind and brain work in ways that make an artistic approach to activism *effective.*

In order to reach people where they are and show them another world is possible, we must appeal to their emotions *and* their intellect. If, as cognitive science suggests, we think in stories, then we need good storytellers to help us think. If surprise helps us to rethink what we know, then we need people who are masters at playing with figure and ground. Artistic activism is a full-service approach to reaching hearts *and* minds, and this is what makes it so æffective.

CHAPTER

6

PERSUASION

"If it doesn't sell, it isn't creative.

—DAVID OGILVY, ADVERTISING EXECUTIVE

We Need Nick

YOU LOVE RIDING your bicycle. You ride it to work, to the grocery store, you even pedal to parties. You love cycling so much that you've become an advocate: organizing other riders and campaigning for bike lanes. But the guy who lives next door—let's call him Nick—is not a cyclist. He's a middle-class white guy, a good neighbor and a nice person, but he drives his massive, gas-guzzling SUV to work, to softball practice, to his kids' school—*everywhere*. (Another strike against Nick: he plays Billy Joel songs really loud in his car). You decide to say something to Nick about giving his SUV a rest and taking up cycling with you. You make your best case, pouring all your knowledge of and passion for cycling into your arguments, but try as you may you simply can't persuade Nick, and in the end he politely declines and walks away. Don't beat yourself up—this happens more often that not.

It is very, *very* difficult to persuade most people to give up their old ways and try something new. In part, this is because (as described in chapter 5) people have their own ways of making sense of the world and when presented with arguments that run counter to their views they either ignore them or fit them into the cognitive and behavioral patterns they've already developed. But people are also often hard to persuade because they have valid reasons for thinking and acting as they do. Maybe Nick likes the feeling of power he gets from driving his SUV, or maybe he knows someone who died in a subcompact car. Maybe he drops his kids off at school before driving to work, or he may simply like the time alone listening to his car stereo. Asking Nick to take up cycling is asking him to do without these things that give him power, safety, convenience, and pleasure. It's even harder to get people to change their behavior. Even if you are really persuasive and manage to convince Nick that cycling is safe and more enjoyable than driving, he may still never cycle to work.

When people don't agree with us, and when they don't change their behaviors in the ways we'd like, we too often dismiss them as bull-headed, ignorant, or even stupid. We tell ourselves that they suffer from "false consciousness," that they are blind to what is in their own self-interest. And so we speak louder, get more insistent, but still they don't listen! Then, too often, we conclude that there's no point trying to convince those who don't agree with us and we give up.

But we need Fictional Nick. We can't isolate ourselves from the very people we hope to persuade. We need a majority of people on our side if there is to be substantial and sustainable social change. It's relatively easy to get others' attention and tell them what we think, but it's hard to get them to listen, change their minds, and, most importantly, alter their behaviors. This chapter is about acknowledging and understanding the obstacles many people have to changing their minds and behaviors, and then developing practices of artistic activism that can overcome these and move people in the direction of social change.

Fortunately, we have teachers, people who work tirelessly, day in

and day out, to persuade others to change their minds and behaviors. Who are these noble knights of change? Marketers.

Yes, Marketing

EVERY DAY, MARKETERS are hard at work trying to change the way we think. Using signs, symbols, stories, and spectacle, they labor to persuade us that our lives will be better, that we will be more attractive, powerful, successful, and happy, if only we drink Coke, drive a Lexus, or brush our teeth with Crest. And beyond influencing our ideas, they impact our behavior. The aim of an advertiser is not, ultimately, to change our minds, but to get us to buy particular products; in short, to translate their ideas into our actions.

We all know that marketing is manipulation. It fuels capitalism through excessive consumption, fostering dissatisfaction and destroying the Earth. But we have tremendous respect for the intelligence and artistry of marketers, despite being horrified by what the marketing industry uses these talents for. Like so much else about commercial culture, we don't need to like it, but as artistic activists we do need to learn from it.

We can learn the most from a type of marketing called social marketing. Its function is not to sell products, but to change social behaviors in often positive ways, promoting initiatives like public health. Social marketing has a long history, with media such as persuasive speeches, printed pamphlets, and broadside posters being used to communicate public messages for centuries. Today, communications through SMS, email, and social media platforms are frequently used in addition to public advertising on billboards, buses and subways, and radio and television to encourage behaviors like seat-belt use, healthy eating, or stopping smoking. Sure, some of these campaigns are laughable. Readers from the United States of a certain age might recall the image of an egg being fried on a hot skillet with the ludicrous tagline: "This Is Your Brain on Drugs." But other social marketing campaigns are inspired and successful, like the Texas Department of Transportation's anti-littering campaign: "Don't Mess With Texas!"

While you won't find social marketing taught in art schools, it does share similarities with art-making. While their aims are not usually as singular or direct as increasing seat belt use, artists generally seek to generate some kind of affective response from the viewer, be it awe, disgust, laughter, wonder, contemplation, or something else. Activists, too, share a general aim with marketers: to influence human behavior in order to have a demonstrable impact. Activist aims might be more political than those of most social marketers — building bike lanes rather than encouraging helmet-wearing — but the overall goal is the same: to have a social effect.

Beyond Raising Awareness

AS ARTISTIC ACTIVISTS we try to get an idea, perspective, or message across to people in order to impact how they think and feel about a particular issue. While this is important in itself, we need to go further. The ultimate of changing people's hearts and minds is to get them to *act* a different way. Assuming that spreading righteous ideas and beliefs will automatically lead to a better world is magical thinking. Even the best artistic activism — the protests, occupations, and political performances that capture the public imagination — doesn't necessarily produce social change. In order for this to happen, we need to pay attention to that all important step between awareness and change: action.

The first thing we can learn from marketing is to think in terms of specific outcomes. In marketing, the desired outcome is simple and clear: success is measured in sales. With artistic activism, results

are more difficult to define. If we are cycling advocates, for instance, our desired outcome might be to make cycling a more viable form of transportation. But what would this actually look like? We need to be more specific and ask ourselves: What do we want people to *do*?

Countless activists and artists have described the purpose of their work to us as being to "raise awareness" or "start a conversation." Is that really the outcome they are after? If they were successful, and everyone was sufficiently aware, would that be good enough? A tobacco executive would never say, "What I'm really trying to do is raise awareness about cigarettes" or, "I just want to have a conversation about tobacco." If they were being frank, they would say, "I want more people to buy more cigarettes!" or, "I want to create more smokers!" The aim is to change how people act in ways that facilitate the selling of cigarettes.

Ideas and awareness are important. That's how people change their minds and then take action. One requires the other, and getting people to think and talk about an issue is absolutely critical. But if it stops there, and stays at the level of changed consciousness, then nothing is ever going to change. We need to manifest general ideas into specific actions that can be visualized and thus enacted. For instance:

- Calling elected leaders to demand bike lanes
- Writing an op-ed arguing for sustainable transportation
- Voting in support of a municipal bond issue to support cycling infrastructure
- Attending an action outside the mayor's office demanding bike lanes
- Office workers riding their bicycles to work

While visualizing our objectives in this way may seem simple, a focus on behavior doesn't come naturally.

Imagine what change looks like by moving from ideals to behaviors in Exercises 28 and 29 in your workbook

The Five Ps

IF YOU'VE EVER studied marketing (and if you have the opportunity, we suggest you do) you probably learned "the five Ps": Product, Price, Place, Promotion, and Positioning. These key concepts for developing a marketing strategy can also be used to hone our artistic activism.

PRODUCT

Marketers know what their product is: a thing or a service. Our product might be broadly conceived as social change, but we need to get more specific. Again, if we're cycling advocates, our "product" might include the following behaviors:

- Thirty percent more people riding their bicycles for daily transportation
- A political leader signing a budget allocation for building bike lanes
- Voting to elect a bike-friendly politician
- Citizens speaking up at a city hall meeting to ask for more bike lanes

Thinking in terms of behaviors and actions makes us be more specific about what we actually want our piece to do, which in turn helps us to create better pieces.

PRICE

For traditional marketing, the price is the cost to people of acquiring the product or service. There are attendant costs too when we, as artistic activists, ask people to act differently: Does the new behavior take time, energy, effort, or thought? Are there social or psychological costs? To return to our example, the "costs" of cycling to work might include:

- The price of a bicycle
- The physical effort required to peddle
- The extra time taken to get to work

- Having to wear special clothing
- Not being able to drop the kids off at school on the way to work
- Not being able to unwind and listen to music on the journey

The costs (and benefits) of social change are discussed further below. Here the simple point is that if we want people to change their behavior, it is good to know what it will cost them.

PLACEMENT

Placement, in this context, means where one goes to obtain the product. If we sold soda pop, placement would be in grocery stores, restaurants, vending machines, schools, and more. If what we are "selling" is changed behavior, then what sites will this behavior involve?

Do people need to be in a specific location to perform the action? Where can they access the necessary materials to do what we want them to do? To get more people biking to work, we might need to consider placement in these terms:

- Where can you buy a bike?
- Where can the bike be maintained?
- Where are safe roads to ride?
- Where can people store their bikes at work?

The auto industry and their government allies have this all figured out: car dealerships, publicly subsidized roads, city-owned parking lots, and so on. If we are serious about getting more people riding bikes we need to consider placement as well.

PROMOTION

Promotion, of course, is key for any marketing campaign. Why would anyone buy a product or service they'd never heard of? Consumer goods are promoted on television, radio, the internet, and billboards and signs. How can we get our messages in front of our audience? What sources of media are favored by our audience? What kind of publicity will help us reach this audience? To reach an audience who might be interested in switching to bike commuting we could try:

- Passing out flyers in traffic jams
- Stenciling in parking lots
- Setting up a poster-making contest for kids in a local school
- Buying a radio ad during a drive-time radio show
- Getting Billy Joel to do a public service announcement

These forms of promotion "raise awareness" about the specific activity we want people to engage in. As we're in the business of signs and symbols, promotion is bread and butter for artistic activists, but it's important to think about how to do it in such a way that it inspires action.

POSITIONING

Monopolies are rare. Companies carefully analyze their competition and how their product compares. Marketers then use this knowledge to differentiate a company's product from that of its competitors. As artistic activists, we often try to cooperate with other like-minded groups, so we don't compete in the sense that, say, Toyota and Ford do, but we should still consider how the behaviors we promote might compete with people's other behaviors.

In thinking about our cycling campaign, we must consider how to position the behavior of cycling not only in regards to driving, our main competitor, but other desirable behaviors, such as:

- Carpooling
- Taking the train
- Riding the bus
- Walking
- Telecommuting

People have options, and our job is to persuade them that ours is the best.

Awaken your inner marketer and chart out the five
Ps for your issue in Exercise 30 in your workbook

Benefits and Costs

LET'S LOOK CLOSER AT TWO of the Ps: Price and Positioning. One
of the simplest ways to conceptualize the process by which people
change their minds is as an exchange. When people are presented
with an invitation or argument to change their behavior, they weigh
their options. If our marketing strategy is effective, they will choose
to give up something—time, effort, maybe money—in order to get
something in return, whether this is something concrete such as bike
lanes, or more abstract such as a healthier life and a better environ-
ment. When we are trying to convince people to change their minds
and behaviors, we are implicitly asking them to make these sorts of

exchanges. But they won't do so unless the deal seems worth it. Cycling might be the "right thing to do" from our perspective, but it won't be taken up by others unless it's the right thing to do for them. Marketers have developed a powerful tool to account for why people might, and might not, want to change what they think and do. It's called a cost–benefit analysis.

While this may seem out of place in a book about creativity, we've found that it often generates new, creative ideas and insights among our workshop participants. The basics of the cost–benefit analysis are simple: the costs associated with a certain product, way of thinking, or behavior are stacked up against its benefits, typically in a two-column table. We like to invert the conventional order and lead with the benefits, thinking of all the positive reasons for people to adopt a certain idea or behavior before considering the negative reasons for why they shouldn't.

We compare benefits and costs all the time, it's what the reggae toasting pioneer U-Roy is doing when he sings "Love is lovely. War is ugly," this is just a way to do it systematically. But sometimes benefits and costs aren't always obvious. Let's use the example of someone con-templating cutting sugar from their diet. Benefits may include weight loss, better health, increased self-esteem, and so on. Some of the costs will be obvious, such as suffering sugar cravings, but others less so, like new difficulties associated with grocery shopping, following recipes, and ordering in restaurants, or the social cost of saying "no thanks" to your colleagues when they surprise you with a birthday cake.

To determine whether the benefits of eliminating sugar outweigh the costs, or vice-versa, it's not as simple as tallying up the number of factors on each side. The weight of each side depends on the impor-tance placed on each factor by the individual (or group). The costs and benefits that matter are those that are *perceived* to matter by the person or people making the decision. This is *really* important because people bring with them their own unique feelings and experiences.

Of course, as artistic activists we are not only concerned with why people think, feel, and do what they do, but in *changing* what they

think, feel, and do. We therefore need to go a step further and compare the benefits and costs of the old way of doing things, the status quo, to those of the new behavior we are proposing.

It would be easy to condemn Nick as a selfish, brain-dead "cage-driver" who doesn't care about the environment—demonizing him as "the enemy." But we are not going to do that because we need Nick on our side. Instead, we'll chart out the benefits and costs that Nick is likely to associate with each of these behaviors in order to better understand his current motivations and better promote our healthier, environmentally friendly alternative.

Put into a table, the benefits and costs of the old and new behaviors for Nick looks something like this:

	BENEFIT	COST
OLD BEHAVIOR: DRIVING SUV TO WORK	• Feelings of power or control • Safety • Convenience of dropping off the kids at school on the way to work • Comfort of leather interior • Speed • Enhances a macho self-image • The ease of carrying business papers, lunch, or groceries • Conformity • Blasting Billy Joel from the car stereo	• Money spent on gas, parking, and the registration and maintenance of the SUV • Time wasted in traffic jams • Risk of getting into an accident • Impact on physical health and body image • Impact on the environment
NEW BEHAVIOR: RIDING A BIKE TO WORK	• Promotes physical strength, leanness, and fitness • Enjoyment of physical activity • Effects on mental activity, i.e. alertness and productivity • Saving money • Environmentally sustainable • Good activity to do with kids	• Time and money spent on purchasing and maintaining a bike • Physical effort required to ride every day • Safety concerns • Not being able to drop off kids on the way to work • Not knowing anyone who doesn't drive to work • Riding a bike threatens a 'serious businessman' identity • No car stereo to blast out Billy Joel tunes

Mapping the benefits and costs of the course of action we want to promote allows us to hone our message and create a range of pieces to emphasize different points. For example, once we've identified parents' needs to get their kids to school as an obstacle to cycling, we might address this by promoting child seats or bike trailers, or appealing to them to ride with their children. And if a rough and rugged image is important to those we are targeting, we can play up the macho factor of trail bikes with their knobby tires and plentiful gears.

Once you are familiar with the idea of benefit–cost analysis, you'll see it used all over the place, both formally and informally. Our favorite examples, because they're so over-the-top, come from infomercials.

The first part of most infomercials emphasizes (and exaggerates) the costs associated with our usual behavior. We see a world in black and white, all the vitality sucked out of existence, while a frustrated every-woman attempts to use a dull, traditional knife to cut food. She hacks and fumbles, winces and groans, exasperated by the mere act of cutting a tomato. Then she waves her arms in the air, cocks her head to the side, and looks directly into the camera as the narrator says "There *has* to be a better way!"

Then, as the screen goes to color, the new knife appears! We're shown a razor-sharp blade that can cut through anything and will never need sharpening! We see how easy it is to use and how happy it makes the every-woman. The knife even has the power to literally return color to her life. These are the benefits of the new behavior — of buying and using this particular knife. At the same time, the infomercial addresses and minimizes the costs of the new knife. It's never forty dollars, but always "Only four easy payments of $9.95." Finally, a sense of urgency is created ("Buy now and we'll send you a free football phone!"), impressing upon viewers that they must act immediately in order to receive the most benefit for the least cost. Before you know it, you're dialing the 800 number.

Hopefully, the things we "sell" as artistic activists won't soon be cluttering a kitchen or thrown in a trash can, but we can still learn from infomercials' technique. Mapping out how people perceive the "exchange" required of them when shifting their behavior gives us a clearer idea of the terrain we're working on. It helps make obvious certain obstacles we may have missed, and illuminates possible pathways around them. Ultimately, as artistic activists, we're making a persuasive case: emphasizing the benefits and minimizing the costs of new behavior, while playing down the benefits and highlighting the costs of old behavior. We're encouraging people to decide that changing their behavior is worth it, that it's the right thing for *them*.

Map out benefits and costs for your issue and audience in Exercise 31 in your workbook

Benefits and Costs Are Not Equal

IT IS EASY TO ASSUME that once we have our table of benefits and costs, all we need to do in order to shift people's behavior is match every benefit of the old behavior with an equal cost, and likewise meet every cost of the new behavior with an equal benefit. Unfortunately, it's not so simple. The problem is that our minds do not weigh costs and benefits equally. There is a revealing thought experiment used by psychologists to demonstrate this, the basic version of which asks you to imagine that you are given $1,000 and are offered a wager: double or nothing on the flip of a coin. Would you take the bet? If you decline, deciding to keep your $1,000 and walk away, you're in good company. Psychologists have found that most people don't want to risk losing $1,000, even for a 50/50 chance of doubling this. The bet is then made more tempting, with the amount wagered triple or nothing. Nevertheless, most still decline, preferring to keep their money. Finally, the amount one can lose is lowered to $500 — but even with this much in their favor, few are willing to take the risk.

	OLD BEHAVIOR	NEW BEHAVIOR
BENEFITS	NO LOSS	POTENTIAL GAIN
COSTS	NO GAIN	RISK OF LOSS

For most of us, the idea of putting hundreds of dollars on a coin flip is stomach churning. But those who are mathematically minded will see that three to one odds on the 50/50 chance of a coin flip, statistically, is a great bet. While it might not *feel* that way, the risk is minimal. In fact, if you're able to make this kind of bet repeatedly you are almost guaranteed to make a killing. But most people won't take the chance because they don't think in terms of statistical calculations; rather, they think about what they could do if they kept that initial $1000. Researchers use experiments like this to study what's called "loss aversion." The principle is simple: we're protective of what we have and we'd rather not lose it, even if we stand to gain a great deal more.

As artistic activists, we're interested in influencing people's decisions and actions, but loss aversion makes this harder. To encourage our neighbors to take up cycling, we have to create an exchange that seems worthwhile to them. We need to emphasize the things they have to gain, while assuaging their fears of what they might lose. The problem is that many people think more about the potential costs than the benefits, not because of foolishness or lack of information, but because they tend to be *unreasonably* loss averse.

When we're trying to produce changes in people's behavior, we might think that the exchange of one behavior for another is perfectly logical. Who wouldn't trade being stuck behind the wheel of a gas-guzzling SUV for the fun and freedom of riding a bicycle? There's so much to gain and so little to lose. But the little we actually have

looms much larger in the mind than the gains we've never seen. It's like the old aphorism: "a bird in the hand is worth two in the bush." Our aversion to loss explains why—in the face of so many good arguments, and when there's seemingly "nothing to lose"—people can yet be so resistant to change. In practical terms, this means that we have to make our case—for the costs of the old behavior and the benefits of the new behavior—beyond *reasonable* doubt. We also need to understand why, even in the face of all the good arguments we put forth, and why, even when there's seemingly "nothing to lose," people are so resistant to change. Not because they're bad, dumb, or stubborn, but because they, like all of us, experience loss aversion.

Understanding tendencies of loss aversion can help us to become better artistic activists. It is important that our work acknowledges the various costs people face and validates their fears and doubts. This not only allows us to build trust with those we work with, but also means that the resistance we inevitably encounter when asking people to change is less frustrating. By understanding loss aversion, we can also better relate to and empathize with the people we're trying to help. We see people where they are, instead of where we wish they were.

Storyboard an infomercial that accounts for benefits, costs, and loss aversion in Exercise 32 in your workbook

From Awareness to Action

NOW THAT WE HAVE a better understanding of why people do what they do, and the kinds of factors that make them resistant to change, it's time to consider the kinds of techniques we can employ to shift people's behavior. Once again, we can learn a lot from social marketing. Just as tobacco companies are not interested in making people aware of smoking but rather want us to become smokers, marketers working on public health campaigns are not satisfied with making people think about stopping smoking—they want us to actually stop.

And they've devised techniques to do this. One of these that we've found useful is the "Information Processing Paradigm" used by Rina Alcalay and Robert A. Bell in their study, "Promoting Nutritional and Physical Activity Through Social Marketing."

According to this paradigm, there are a number of stages that people need to pass through in order for a message to change their behavior permanently. This makes intuitive sense. We know that merely *seeing* an election sign on a neighbor's lawn, or an advertisement for a new car—that is, being exposed to a message—does not secure our vote or make us run to the dealership cash-in-hand. We know that a lot more needs to happen in between, but we usually don't know exactly what. The Information Processing Paradigm brings this into focus with twelve stages:

1. Exposure
2. Attention
3. Interest
4. Comprehension
5. Skills
6. Agreement
7. Memory
8. Recall
9. Decision
10. Behavior
11. Reinforcement
12. Identity

To understand how the Information Processing Paradigm works in practice, we'll return to the example of a cycling campaign. Let's say that, through the generosity of an anonymous donor, we've secured funding for a thirty-second infomercial to be screened during the Super Bowl. This is a great opportunity to speak to our demographic—middle-aged, masculine commuters such as neighbor Nick—and make the case for switching to cycling.

Stage 1: Exposure. Our thirty-second infomercial comes on during a commercial break as Nick watches the Super Bowl. We've succeeded in putting our message in front of him and millions of others like him.

Stage 2: Attention. Our infomercial is loud and colorful enough to get Nick to look at the television and listen to our message.

Stage 3: Interest. To hold Nick's attention throughout the ad, we need to capture his interest. To do this we might use comedy, suspense, surprise, or link our message to one of his existing concerns. After doing our research, we decide to connect biking with improved health and productivity. Nick is interested!

Stage 4: Comprehension. In order for Nick to comprehend our message, we need to speak a language he understands. This needs to take into account not only his mother tongue, but the cultural languages he is embedded in, which will depend on his upbringing, education level, economic class, political leanings, as well as his interests,

hobbies, friend groups, and so on. Success at this stage means that our audience understands what we are asking them to do: cycle to work instead of driving.

Stage 5: Skills. If the previous stage is about learning *what* to do, this one is about learning *how* to do it. Skills can be imparted through straightforward instructional means or through modeling behaviors. Our commercial employs the latter, showing a man purchasing a bicycle, giving up his car, and cycling to work safely, day after day, in all kinds of weather. This enables the audience to understand how they can perform the action we are asking of them.

Stage 6: Agreement. At this stage in our ideal campaign, Nick says to himself: "Okay, I should do this." He overcomes his hesitations and adopts our viewpoint as his own, accepting that this new behavior is the right thing for him. He resolves to purchase a bike in the weekend and cycle to work starting Monday.

It's easy to see the moment wherein we successfully change people's mindset as the culmination of a creative campaign, and it is a significant milestone. But our goal is to produce a change in people's behavior, not just elicit their agreement, and for this additional stages of informational processing are needed.

Stage 7: Memory. Behaviors don't change easily. Nick's attitude toward cycling has shifted, and he now believes he should ride his bike to work. But come Monday, he may climb into his SUV simply

♪♫
I'M GONNA PUMP MY TIRE,
SO IT IS ALWAYS TURNING,
AS I RIDE THIS MORNING!
♪♫

out of habit. To prevent this, the message of our campaign must not only capture people's short-term attention but also tap into their long-term memory. Advertisers often do this through catchy jingles or slogans, one of our favorites being the old *but not forgotten*: "Schaefer is the one beer to have when you're having more than one." Luckily we've learned from this and incorporated into our infomercial an unforgettable, singable slogan (adapted, of course, from a Billy Joel song) that will lodge itself forever in Nick's head, reminding him that he's decided to cycle to work.

Stage 8: Recall. If Nick is to remember and act on his decision, he needs to be able to recall exactly what to do and how to do it. Car mechanics are masters at prompting people's recall, often posting a sticker with the garage's contact details on the inside of customers' windshields to remind them when the car is next due for an oil change. Similarly, we might send Nick email reminders to show up for the local commuter ride he signs up for after watching our commercial. Or, if the information we are communicating is difficult to remember — such as bike maintenance tips — we might send him a credit card size check-list to keep in his wallet. Now, all the information Nick needs to start cycling to work is at his fingertips.]

Stage 9: Decision. This is the moment that Nick, in agreement with the cause and armed with information, is standing in his garage on Monday morning, deciding whether to drive his car or ride his bike to work. Moving through the previous eight stages does not guarantee one will follow through. Nick may still choose to drive the car. We need to provide a stimulus to help him move from agreeing with our issue to deciding it is the right thing for him to act upon at that moment. To do this we send Nick an attractive and informative invitation requesting him to join his cyclist colleagues in their ride to work. He says yes.

Stage 10: Behavior. This is where we *finally* get to the change in

behavior. Our team has done an immense amount of work to get Nick to this stage. But now it's up to him.

And he does it! He follows through on his commitment, gets on his bike, and rides to his office. Another major milestone.

Stage 11: Reinforcement. After the behavior we've campaigned for is successfully taken up by people, we need to let them know that their action is recognized and appreciated. If Nick feels out on his own performing the new behavior, he is far less likely to stick with it. Maybe we send Nick an email telling him how great it was to see him on his bike. Maybe we create a cookie pit stop on his bike path home, reminding him that he deserves to treat himself because of all the calories he's burning. Or perhaps we create and bestow upon Nick a "New Bike Commuter of the Month" award.

Stage 12: Identity. Anyone who has quit smoking knows how hard it is to sustain a new behavior over the long haul. At the first sign of rain, Nick can easily slide back into his old SUV-driving ways. The final stage in moving people from idea to action is when they completely integrate the new behavior into their thought structures and behavioral patterns, making it part of their everyday life. We don't want Nick to be an SUV owner who has ridden his bike to work, we want him to be a cyclist, maybe even a cycling activist, who occasionally drives a car when he must. Rituals of reinforcement can help cement identity, but the best practice of identity formation is to integrate people into the struggle itself so that our issue becomes *their* issue, and our practice *their* practice.

In the real world, moving through the stages between exposure and identity is a very difficult and lengthy process. Looking over the above example, we can see why each stage of the Information

Processing Paradigm must be accomplished before we can move to the next. You may be able to combine stages, and you may think of other stages not included in this model, but what is *not* possible is to skip straight from awareness to action. You can't simply expose a person to a piece of artistic activism and expect them to have an epiphany and be magically converted to your cause. If we expect this of our pieces, we'll only end up frustrated, angry, and confused.

We shouldn't expect to move people through the whole process at once — a few stages is a substantial accomplishment. In fact, trying to make a piece that achieves everything will leave you burned out and depressed — trust us, we've learned the hard way. Breaking the process of behavioral change down into stages allows us to focus on where we can be most effective, where the most work is needed, or where we have the most leverage. We should assess, for any given project, what stage the majority of the audience is already at. Maybe they are already on board but just don't know how to do what we are asking them. We also want to consider which stage(s) will allow us to move *the most* people forward. It may not be worth spending time targeting the few

people who need a reminder when most people are not even aware of our issue. Our overall campaign should address all the stages, but each piece we create needs only to address a few, or maybe just one.

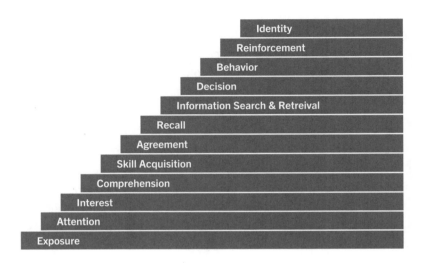

The first few stages — exposure, attention, interest — are relatively easy to achieve, especially for anyone with training in the arts. Artists and designers are usually well practiced at communicating messages and making them noticeable through media like flyers, posters, or even murals. The later stages dealing with behavioral change are more difficult, and those concerned with identity formation harder still. And the audience diminishes at every stage: many more people will see our pieces than will join our cause. This is to be expected. While it's good to begin with what's easy and what we are good at, it's important not to focus exclusively on the low-hanging fruit of getting exposure and attention. We need to challenge ourselves and aim higher too.

Design a piece of artistic activism that addresses a
stage in this process in Exercise 33 in your workbook

Audiences

AS ARTISTIC ACTIVISTS we need to always think of our audience. These are the people we hope our message will reach, and whose behavior we want to change. Yet, all too often, our audience is the last thing we think of. While we might envisage the things our pieces will make people feel, think, and do, the identity of our audience often remains elusive.

A common mistake is seeking to define the audience solely in terms of exclusion, where one person's inclusion entails the cruel rejection of another. We've all experienced the trauma of not being chosen for the school baseball team, and we don't want to repeat this in our artistic activism. When we try to narrow down our audience, we focus on all those we're leaving out: What about the elderly and the ill? What about the youth? And the teachers, coal miners, crossing guards, and yoga instructors? Eventually someone jumps the species boundary and cries, "But what about the animals?" This line of questioning, whether spoken outright or not, reconfirms the noble idea that *we should not exclude anyone*, and circles back to the idea that *we will reach everyone* with our work.

The reasoning is both moral and strategic: if we want to change society, we really do need to reach everyone. But let's be realistic, this is logistically impossible. Trying to reach everyone is neither an efficient use of resources, and nor would it be effective. Once we accept this, we can start thinking of an alternative strategy. Here's another way of thinking about audiences (indulge us for a moment): if we wanted to be most effective, we would choose an audience of *one*.

Imagine we are rolling out our cycling campaign in Albuquerque, New Mexico, a city of almost 550,000 people. It would be a tough campaign if we tried to reach everyone, but here's the thing, we've decided to set our efforts on increasing cycling for *one person*: Mirabella Susanna Velasco, age 48, who lives on Marble Avenue in Old Town. We will use all of our resources to get Mirabella consistently riding her bike to work, to the local store for food, and to visit her friends. We'll interview Mirabella, learn about her background, cultural context,

and political beliefs. We'll study her frequent destinations and possible routes to develop a highly individualized pathway that addresses her every concern. We'll design and build her a custom bicycle that can haul her groceries, and create support networks to ensure cycling becomes part of her everyday life. Our success is practically guaranteed: Mirabella is highly likely to understand, agree with, and be moved to action because the campaign is designed specifically for her.

Focusing on one person would be effective, but not at all efficient.

As artistic activists, we need to compromise between being effective and efficient. One way to do this is by grouping similar individuals together, or what communications experts call "segmenting the audience." By breaking our audience into small groups, we can find an equilibrium between the very effective messaging of a highly individualized campaign, and the efficiency of reaching the largest number of people possible.

Who is Mirabella? She is a middle-aged woman of Latina descent who lives within the city limits. As a middle-aged woman she likely cares about her health, but may also be fearful about riding a bicycle on the open streets. As a Latina in the United States, she is probably bilingual in English and Spanish. And as a city resident, her work, shopping, and community activities all take place within a couple of miles of her home. Demographically speaking, there are a lot of Mirabellas in Albuquerque. By identifying and analyzing them, we broaden our audience without losing the specificity necessary for making a targeted appeal.

With the Mirabellas of Albuquerque in mind, we might design a series of pieces that address safety concerns about cycling on the street. We might even seek to stir all the Mirabellas to action to demand barrier-protected bike lanes. We would target the geographical area of the city and draw attention to the ease and health benefits of short commutes, especially for middle-aged and older people. And we would ensure our piece could be understood by both English and Spanish speakers.

We've pretty much hit the bull's-eye for the Mirabellas of Albuquerque. But there's other people we want to reach too. To enable us to identify and prioritize audiences, it can be useful to group them into primary, secondary, and unintended categories. Our primary audience is that one group we simply *must* reach in order to bring about the change we want. It might be:

- Residents of a certain neighborhood
- Commuters who drive a certain route
- People effected most by specific laws or policies

In this case, our primary audience is potential bicycle users within the city limits of Albuquerque. We might, as above, keep this group narrowed to middle-aged women, if we are particularly concerned about their take-up of cycling, or we might broaden it to include other genders and ages. There are always risks in expanding our audience. This introduces greater diversity, and requires that our message

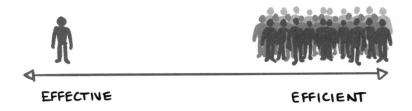

EFFECTIVE　　　　　　　　　　　EFFICIENT

becomes less individualized. A broader message may reach more people, but with less depth and resonance than if we targeted a small group. On the other hand, a narrow audience means a more directed and effective message, but sacrifices efficiency. The art is finding the æffective equilibrium; impacting a targeted group through individualized appeals, while reaching the maximum number of people necessary to have a significant effect.

We can also consider a secondary audience. This is not the audience that our piece is centrally aimed at, but it's one that we'd still like to reach. For instance, while mobilizing Albuquerque citizens and potential bike users is essential for the campaign, to be effective we *also* need policy makers and politicians on our side. This is a very different audience to the Mirabellas, and if we expand our primary audience to include city officials, our work will become too diffuse to be æffective. However, the message directed at our primary audience can also be crafted to resonate with our secondary audience. If, for example, our piece excites the support of voting and taxpaying citizens, officials, who are mindful of elections and budgets, are apt to support it too. In our design process we can strive to align our piece to focus on one group while simultaneously moving others along in the process of change. At the very least, we can make sure that our piece does not upset or alienate our secondary audience. Maybe the Mirabellas would respond well to us portraying policy makers as pigs,

but it will no doubt upset the very people we need to legislate the construction of bike lanes.

The final group to consider is the unintended audience. Our work is often public, which means that we can't always control who comes into contact with it. People may react in all sorts of ways, both positive and negative, that we never considered. For the present example, unintended audiences might include:

- Police and sanitation officials
- Suburban bike enthusiasts
- Road construction workers
- Vandals

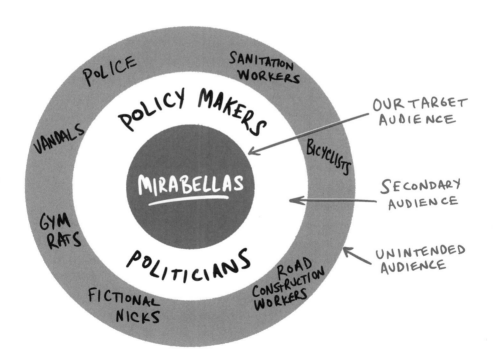

TRY AND **UNDERSTAND** WHY PEOPLE THINK WHAT THEY THINK AND DO WHAT THEY DO, AND THEN USE THIS TO **BUILD A BETTER WORLD** TOGETHER.

Think back to our suburban neighbor Nick. Nick inhabits a different cultural and social world to Mirabella, and is neither a policy maker or a politician, so he's not part of our primary or secondary audiences. But he's recently become a cycling activist, and on one of his weekend rides into the city with his cycling group he spots our piece. He's interested, he gets our message, and he wants to help. We didn't intend to reach Nick, but we did, and our cause is stronger for it. It doesn't always work out so well. Our piece is also noticed by some road-construction workers. They take an interest, but they misinterpret the message, viewing it as an anti-road diatribe. Fearing that their jobs might be threatened, they destroy our piece and take up their case with their union. A picket is organized in front of our office, and we are accused of being wealthy tree-huggers who destroy the jobs of ordinary people. Not the outcome we intended.

After taking up Nick's offer of help and demonstrating to the union that new bike lanes can generate more work, we might want to reflect

on how our next piece could be crafted differently so as to appeal to suburban bike commuters and construction unions. But even the best planning cannot anticipate all possible audiences and reactions. All we can do is anticipate that something unanticipated will arise, and be limber enough to respond creatively.

There is one audience we shouldn't give much thought to at all: *haters*. As artists and activists, we are sometimes tempted to address our work directly to those who vehemently disagree with us, only to then become enraged (and perversely excited) when this audience rejects us. There will always be bigots, reactionaries, and extremists. To target them as our audience only absorbs our focus and limits our ideas. Just remember: haters gonna hate.

We Are All Human

WHY DO PEOPLE SO OFTEN make such poor choices? Why do they seem to act against their own interests? Why do they support policies that hurt them? It might be tempting, as an activist or artist, to assume that people are idiots, that there is something wrong with *them*. This train of thought can lead us in one of two destructive directions: to the arrogant belief that "the people" are unpersuadable and we, the enlightened few, must lead them toward truth, or to a righteous retreat to our artist and activist ghettos where we surround ourselves with like-minded people and keep the barbarians at the gate. Vanguard or avant-garde, take your pick, just stay out of the feedlot.

But there's another way: to try and *understand* why people think what they think and do what they do, and to then use this to build a better world together. Instead of dismissing people's decisions as ignorant or nonsensical, we can learn to make sense of the thinking behind them. Instead of wishing that others thought more like us, we can learn to think more like them. We don't need to agree with what they think and do, only to understand it. And ironically, the very marketing industry thought to make people into "sheep" provides us with important tools for this task.

CHAPTER

7

ÆFFECT

"Just because something works doesn't mean it can't be improved.

— SHURI, WAKANDA CHIEF ENGINEER

RAISING AWARENESS IS NOT A GOAL. RAISING AWARENESS IS NOT A GOAL.

Does It Work?

IF YOU'VE MADE it this far in the book, you are either a masochist or you've drunk the Kool-Aid. If you are a masochist, we advise you to put down this book and give up on being an artistic activist. Too many masochists already populate the worlds of activism and art. For the rest of you, hopefully by now you are convinced that artistic activism is awesome — it's fun, it's creative, it's the cutting edge of art and activism! Your authors wouldn't have devoted our lives to theorizing, training, and practicing artistic activism if we didn't believe this ourselves. Yet we are haunted by a simple question: *Does it work?*

Our work can be fun, creative, and on the cutting edge, but if that's all it is, it's not good enough. Artistic activism is about challenging the world as it is and transforming it into something new. It's about social change. When we talk about whether our piece works or not, we need to be able to answer this question aesthetically and politically, in terms of affect and effect. Yet the question of does it work? need not only be answered in the conventional ways that arts funders, executive directors of NGOs, political operatives, and marketing firms often favor, whether this be number of votes, signatures, or attendees. Artistic activism delivers in all sorts of other meaningful ways that hard numbers will never show. This chapter is about encouraging you to discover the ways that *your* practice works in the ways that *you* want it to so *you* can make it work better.

Being an artistic activists means taking the art of activism very seriously and this entails, among other things, seriously interrogating impact. An apolitical artist can always use the time-honored art-world subterfuge and claim that creators don't need to take responsibility for their creations, but this option isn't open to an artistic activist. We've signed on to the project of using our creativity to fight injustice and create change. If we are going to take this pledge seriously, it means asking ourselves, over and over: does it work?

When it comes to artistic activism, questions of "what works?" and "how do we know?" are difficult to answer. Art and social change are complex phenomena. There's consensus that art moves us, but how and why is still an open debate. Indeed, as we've argued before, it is art's very power to seemingly circumvent reason and rationality that makes it so powerful. It's also difficult to determine with any precision *when* social change happens and what causes it. How can we know if, or to what extent, our actions caused a given change, or if it just happened coincidentally?

But perhaps the greatest difficulty of these questions is asking them in the first place. When we pose reflexive questions about what works and how we can know, we are made to confront our worst fear: that maybe what we are doing doesn't work. Maybe all this talk of the

merging of arts and activism is pure bunkum, and we're wasting our time and deluding ourselves. To avoid such dark conclusions, it is tempting to simply continue making our work, avoiding our doubts and waiting for something to appear. This type of thinking is better suited to alchemy than to modern political strategy. There is magic in artistic activism, and we hope to help create a wonderland of peace and justice, but closing our eyes and clicking our heels together won't get us there. We need a plan.

Planning a Campaign

ACTIVISTS ENGAGE IN planning campaigns all the time, but popular understandings of political activism tend to downplay their importance. Think of conventional narratives of the civil rights movement: there's Rosa Parks sitting down on the bus, then students staging a sit in at a segregated lunch counter, and finally Martin Luther King Jr. giving his "I Have a Dream" speech. We remember these as singular moments, but they were all just points — what we'll describe as *tactics* below — in a much larger campaign for civil rights, involving many organizations and sub-campaigns, that stretched from the early twentieth century through the 1960s and beyond. The successes of the civil rights movement did not come about because of a few spectacular actions, but because those pieces were part of a larger plan.

Any time we organize a trip, plant a garden, or simply make dinner, we use planning. We ask ourselves: What do I want to do? How do I want to do it? What steps do I need to take? And what actions do I need to do? Goals, strategy, objectives, and tactics — these are the basics, too, of planning any campaign. Let's explore how these components work together in artistic activism.

Most people think first of tactics when planning for activism, art, and in other domains, so we'll start there. Tactics are the basic unit of activism. They are the things we do: the actions we stage and the pieces we create for people to see, hear, and experience. When people encounter our mural of the victims of police brutality, or are drawn in by our street performance of waterboarding, these striking pieces

are, to them, artistic activism. But for us, tactics are only important in so far as they move us closer to achieving a result. For tactics to be meaningful, purposive, and effective, they need to be connected to objectives.

Objectives are demonstrable, measurable milestones. They allow us to gauge whether our tactics are moving us in the right direction, and whether our strategy for reaching our goal makes sense. They are used to define, in the short run at least, where we want to go and what we want to happen once we're there. We've found that people frequently confuse tactics and objectives. A simple way to differentiate them is to think of objectives as outcomes, or what happens, and the tactics are how that happens.

Objectives, in order to function as solid markers of our achievement, need to be SMART:

- *Specific*: we need to identify a particular thing we want to achieve, change, or impact
- *Measurable*: we need to be able to determine, with a certain degree of surety, whether we've accomplished our objective, or made progress toward it
- *Achievable*: we need to set a doable objective, something we can realistically hope to attain
- *Relevant*: our objective should make sense given our overall goal; it should align with what we have accomplished before and what we hope to accomplish after
- *Timed*: our objective should be accomplishable within a given time-frame

The SMART model, borrowed from management literature, helps us to establish effective short-term goals through which to identify, accomplish, and evaluate success (or failure). Setting good objectives is an essential means of evaluating progress and ensuring we don't get lost on the way to our ultimate goal.

As we meet each objective, one milestone leads to the next and we are brought closer and closer to our goal. Goals are our destination,

where we want to end up after our long, arduous journey. We may never reach this destination, and, in fact, if our goal is sufficiently utopian, we definitely won't. But having a goal in mind allows us to orient ourselves in the right direction.

In order to reach our objectives and our goal, we need strategy — what some Atlanta, Georgia, activists we worked with called the "thoughtful how." Once we know where we are going, we need to map out the best way to get there. As with any trip, there are multiple routes to our final destination. In charting our path, we might think about the particular skill sets and resources we have at our disposal, and about what the most efficient way is to get from A to B. There are many activist strategies to employ: legal, electoral, educational, and mass mobilization, to name a few — or there's the creative strategy of artistic activism we propose in this book. Strategies don't tell us where we are going, but they give us the shape of the journey.

Combine tactics, objectives, goals, and strategy and you have a campaign. Represented visually, a "campaign template" might look something like this:

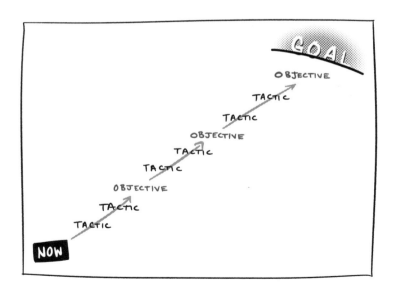

This diagram makes campaigns look misleadingly simple. They usually turn out like this:

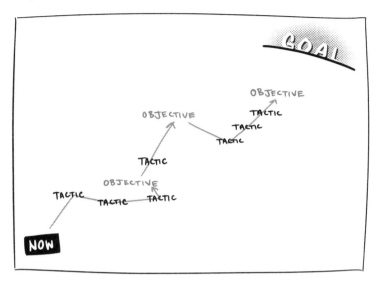

Or this:

Where some planned tactics don't work as you'd hoped, others succeed in ways you don't anticipate. What you thought were good objectives turn out to be lousy, and you come up with new ones along the way. A moment of reflection might even spur you to reconceptualize the whole campaign. You move backward in order to move forward, and sometimes you feel like you're just moving sideways. All this is to be expected.

While campaigns are essential for bringing about social change, many artistic activists tend to overlook them in their focus on the creative intervention. We call this *tactical myopia.* We cannot tell you how many pieces we've seen that never move past the "really cool piece" stage. People pour all their time and creative energy into tactics, and all the rest becomes an afterthought, if thought of at all. We want to emphasize that tactics are only æffective in terms of how they fit into a strategy, how they help achieve objectives and move us closer to our goal.

One way to avoid this problem is to start at the other end, with conceptualizing our goal. In 2016, we worked in South Africa with the Asijiki Coalition to Decriminalize Sex Work, which was preparing to speak at the International AIDS Conference in a few months' time. We began our first meeting by asking the coalition to imagine that the AIDS Conference was over and they'd done an incredible job; then we asked them: "What did you accomplish?" The activists described their vision of success: sex work would be discussed as the front line of AIDS prevention on every relevant panel, and sex workers would be an unavoidable presence at the conference. With this as our destination, we devised a number of tactics, big and small, to move us there. And while not all of these worked as planned, enough of them did to deliver the results the coalition dreamed of. According to this method, we first envision our overall goal and then plot out where we are now. Once these two points are set, we can begin to fill in the *objectives* that can move us measurably closer to our goal. Then, and only then, we can think about the *tactics* that can help us reach our objectives.

This isn't as difficult as it might seem in the abstract. Let's pull back

from art and activism for a moment and use a simple example from everyday life: the small, personal goal of getting healthy.

Getting healthy can mean different things for different people. Perhaps you start by envisioning yourself with toned abs, or running around with your grandchildren with ease. Possible strategies for getting healthy then might include eating better, exercising more, or quitting harmful habits. If we have the time and resources, we can take all three paths. For this example, we'll choose exercise as the best strategy to reach our goal of better health.

Now that we have a goal and a strategy, we set objectives. One is going to the gym twice a week; another is losing five pounds within two months. These objectives are SMART: specific, measurable, achievable, relevant, and timed. While it can be difficult to assess whether we have definitively met our goal, we can know with confidence when we've accomplished each objective. Gym twice a week: check! Lost five pounds: check! It feels good. And if, after a few weeks, we're not making it to the gym, or if, after weeks of working out, we're not losing pounds, we might need to rethink our strategy to focus more on diet, for instance, or re-evaluate our objectives.

GYM LOG			
	WEIGHT	GYM 1st	VISIT 2nd
WEEK 1	170		
WEEK 2	169	✓	
WEEK 3	169	✓	✓
WEEK 4	169	✓	✓
WEEK 5	168	✓	✓
WEEK 6			
WEEK 7			
WEEK 8			
TARGET →	165		

Every objective calls for multiple tactics. Our first action might be freeing up time in our schedule; second, joining a gym; and third, borrowing a library book on exercise techniques, and so on. These tactics should be ordered logically so that each one builds off the last. To go somewhere we need to put one foot in front of the other; it is the accumulation of small steps that allows us to reach our destination.

The terminology of strategy, goals, objectives, and tactics may be new to you, but the principles won't be. We run though some variation of them almost anytime we do anything. Clarifying the component parts of any given artistic activist campaign helps us determine the actions necessary for it to be æffective. The road to change is long and often crooked. Carry a map, revising it as you go, and you won't get lost (at least not as much).

Practice planning a simple campaign
in Exercise 34 in your workbook

Directing Our Efforts

WHEN WE ARE WORKING ON a campaign we really care about, it's common to overextend ourselves, thinking that the harder we work, the more hours and energy we put in, the better we are doing the job. But this is the metric of masochists. With planning, we can

"work smarter, not harder." Changing the world is a pretty big ambition — how do we concentrate our efforts so they are most effective? One way is to have a strong idea of the sort of change we want to bring about. We can borrow from policy experts and social marketers here in distinguishing between three levels of change: individual, policy, and advocacy.

INDIVIDUAL

For our purposes, the first level of change concerns how we can æffect an individual's attitudes, beliefs, and behavior. We want to have an impact on things people can do thaemselves. For example, if we wanted to increase recycling in an office building, we could create a piece that encourages workers to sort their rubbish correctly. Our objective here is to make the office workers act differently in their everyday lives. Here, social change comes about cumulatively through the changed actions of many individuals.

While many activists gravitate toward campaigns aimed at individual change, this is not the only option, and may not be the most effective.

POLICY

Individuals can and do make a difference, but meaningful change often also requires shifts in policies and laws, practices and structures. In terms of the office recycling campaign, if we ask the workers to sort their rubbish but do not ensure the provision and maintenance of appropriate bins, then they won't recycle even if they individually want to. The outcome will be similar if the employer and the garbage contractor lack recycling policies. Without supportive policies and structures in place, working for change at the individual level can be counterproductive. In this case, it's more effective to set our sights a level higher: changing policies to enable individuals' actions.

When our goal is policy change, we direct our efforts toward policy makers. It's sort of like lobbying, but instead of campaign donations, boozy dinners, and golf trips, we employ artistic activism. We might directly target a certain politician, or we might work to generate public support in the hopes that this will, in turn, put pressure on policy makers. And when we turn our attention to public opinion, we begin moving in the direction of . . .

ADVOCACY

When policy makers' doors are closed, or the scope of our issue calls for more than individual action, we need to consider campaigning on the level of advocacy. While it is helpful for individuals to recycle, and beneficial to implement recycling policies, if we want to prevent climate catastrophe, we need to make deep changes in people's perspectives on the environment. Through advocacy, we can reframe an issue, set agendas, and "move the needle" on public opinion. Advocacy changes the culture around an issue, creating more favorable terrain for both policy and individual change. If advocacy is our aim, we need to cast our net wide and far, creating pieces that are likely to be recorded, reproduced, and disseminated in the media.

The decision as to whether an individual, policy, or advocacy approach is best will depend upon our particular issue, objectives, strategy, and circumstances. To illustrate this, let's return to the cycling example from the previous chapter. If our town has a strong weekend cyclist culture, with many people owning bikes and cycling for

exercise; good cycling infrastructure with bike lanes; and supportive public policy, then a "ride-to-work" campaign targeting individuals would be an effective use of our time and yield significant results. However, if there is no cycling culture, low bike ownership, and little infrastructure in the town, trying to change individual behavior will yield little result. In fact, it might harm our cause as our demands might seem out of touch and unreasonable. In this context, our time would be better spent working at the policy level, pressuring city planners to implement things like "complete streets," which include space for pedestrians, cyclists, public transit, and cars, and creating incentives for bicycle-friendly businesses.

Now let's pretend our situation is worse. The town mayor, Mayor Jerkface, who owns a chain of successful car dealerships and is hostile to what he calls "bike Nazis," has just steamrolled a new highway through town. To top it off, local news media publishes the mayor's press releases without analysis. Pushing for policy change here will be a waste of time. A creative strategy aimed at changing the public conversation around cycling — framing the issue in terms of personal health, family happiness, and building a green, "livable" city — has a better chance of working. If successful, the mayor, mindful of the next election, may enact bike-friendly policies despite his personal opinion.

We have to decide case by case which approach or combination of approaches will yield the best results. If we are strategic about this, our choices can save us unnecessary work and frustration. We can always revise our strategy. The one essential is to always have a clear vision of what we are aiming for. This guides us in our work and provides a standard by which to evaluate our decisions as we proceed; it's our orientation point on the horizon.

Practice directing your efforts toward all three levels of change in Exercise 35 in your workbook

You Are Not Alone

IF CONFRONTING BIG CAMPAIGN GOALS and real objectives feels overwhelming, remember: you are not alone. We are artistic activists, not solipsistic bohemian artists isolated in our garrets. We are more productive and creative when we work with others. Working collaboratively means you don't have to burden yourself with the responsibility of designing and executing every aspect of a campaign. It is far less work, far more fun, and far more æffective to do it as a group, with each person lending their own vision and creativity to the process. And artistic activism can't win on its own. Our creative strategy can, and probably should, work concurrently with other strategies leading to the same goal. If we want to reframe cycling as an environmental issue, for instance, we can find common cause with activists working on recycling in office buildings. One of the advantages of thinking in terms of campaigns, not just singular tactical pieces, is that it focuses our attention on what really matters: reaching our goal. The pieces we create, the tactics we employ, are just means to that greater end. This allows us to recognize that there are many possible means of reaching that end, some more effective than others. By experimenting with our own pieces, and working with others who have different tactics and strategies, we increase the possibility of all of us having a greater impact.

Why So Much Art and Activism Fails

WE'VE BEEN DOING artistic activism for a long time and have seen and experienced many ways in which it can fail. In fact, we've failed ourselves so many times in so many ways that you might call us experts on the subject.

Our workshops usually end with a collective artistic activist piece. We give ourselves twenty-four hours to brainstorm, plan, and execute an action. It is simply not possible to create a completely successful piece in twenty-four hours (or even twenty-four weeks). Each of these pieces fails in particular ways and succeeds in others, and we learn

as much from their failure as we do from their success. As Samuel Beckett wrote in *Worstward Ho*:

> Ever tried. Ever failed.
> No matter. Try again.
> Fail again. Fail better.

If we are going to be creative and try new things, we are guaranteed to fail, over and over again. Here are some of the common mistakes we see people make (and make ourselves). We share them with you so we can all fail better.

GOOD INTENTIONS

Artists and activists working on social and political issues generally act with the best of intentions. Fueled by passion and compassion, we put our talents and ideas out into the world. Surely, if we are good people doing good things, then good results are bound to follow... Unfortunately, good intentions don't necessarily lead to good results. Actions motivated by the best of intentions can be ineffectual, misdirected, and have unforeseen detrimental effects. For good intentions to lead to good results with any regularity, we need to carefully evaluate the impact of our actions, and then plan how to fit actions together to multiply their impact. When our goal is to work with others to change the world, a focus on having noble intentions is not enough. We must turn our attention to the æffect we have on things outside of ourselves: other people, relations, and material conditions.

POLITICAL EXPRESSIONISM

Many readers will be familiar with abstract expressionism, the 1950s arts movement typified by the communication of the artist's rage, joy, disgust, or hope directly through their medium. Jackson Pollock was the movement's poster boy: the rebel artist expressing his passion though the paint he dripped, splashed, and threw upon on the canvas. Political expressionism functions similarly in the domains of art and activism, except that instead of personal emotions, it is one's political passions that are being expressed. Here, the bold act of political self-expression is in itself the purpose of the work, and the piece's success is determined by how well it conveys its author's feelings about the political moment. The assumption, conscious or not, is that the mere expression of hope or rage will bring about change. Political expressionism is based upon a misunderstanding: that social change happens and movements ignite because people are finally angry enough. Accordingly, to express your anger is to do something noble and necessary. You are sticking it to the Man.

Anger and disgust certainly can be motivators. As the Clash sang,

> Let fury have the hour,
> anger can be power.
> D'you know that you can use it?

But, as we've already learned, the process of moving from anger (or hope) to action is complex, and the expression of anger can retard action as easily as motivate it. Thinkers as far back as Aristotle have recognized that mere expression can function as an escape valve for social unrest, providing a way for people to blow off steam before returning to work for the Clampdown.

Furthermore, like good intentions, political expressionism is really more about the individual artist or activist and less about the issue they want to address. And, because it's all about the artist and *their* expression, there's little space for participation by others. This is not to say that political expressionism doesn't have any utility at all. For some artistic activists, it is a burning desire to express their passions that fuels them to action, getting them off the curb and into the street. But nothing concrete happens just because you show the world how angry you are. The important question is (to tweak the Clash), "H'you going to use it?"

LIFESTYLE

A tendency related to political expressionism is for people to get caught up with living an "authentic" life as an artist or activist. The thinking goes something like this: "I've refused to be part of the system. I am not a banker or a real estate agent! I don't work in advertising or sales! I have chosen to live my life with political and artistic integrity. I am an artist! I am an activist! *This* is my political act." Committing ourselves to creative expression and social transformation *is* political. But being an "artist" or an "activist" — or an "artistic activist" for that matter — is a means, not an end. It's the things we create and the actions we take that have political impact, not our identity. If we view lifestyle as the beginning and end of our politics, our actions will be geared to perpetuating our idealized self-image as an artist or activist instead of engaging with the world. And an individual's self-identification as an authentic outsider, an incorruptible rebel, can be a further barrier to their ability to understand and communicate with the "ordinary" people they are supposedly trying to reach. As the revered Detroit

activist Grace Lee Boggs said: "You cannot change any society unless you take responsibility for it; unless you see yourself as belonging to it and responsible for changing it."

This is not to say that reflecting on our intentions, emotional expression, and identity have no place in the development of our artistic activism. But we need to be aware of the risk of becoming absorbed in such processes, leading us to turn inward and gauge our success on who we are, rather than our social and political impact. Our success should be gauged on how we æffect others.

RAISING AWARENESS

We've already touched on the issue of "raising awareness," but it deserves further mention here because it lies at the roots of many mistakes in artistic activism. The impetus behind raising awareness is noble. To expose inconvenient truths, to reveal uncomfortable facts that are otherwise unknown to the public at large is certainly a worthy aim. The problem here is not information itself; sustainable social

transformation must be built upon facts and evidence. Rather, it is the delusional faith that mere exposure to facts, information and, ultimately, Truth, will automatically spur people to action and bring about social transformation. We all know from personal experience that this simply isn't true. Case in point: Duncombe is a smoker. He's read the warnings, knows the facts, yet continues to smoke. Why? There are many reasons: pleasure, stress-reduction, lack of willpower, addiction... but lack of awareness is not one of them. We all fall prey to the delusion that if people just had the right facts on pollution, inequality, injustice, oppression, etc., then something is bound to happen — even when we know this not to be true in our own lives.

The assumption that "the truth shall set us free" is based upon several fallacies:

People don't have access to the information. In totalitarian societies, or in the pre-internet age, this was a pretty safe assumption. Today, in much of the world, it is naïve. Most people have access to more information than they know what to do with. And this might be the very problem: we know too much. Faced with enormous volumes of information, we feel overwhelmed by infinite possibility and doubt and, paralyzed, we turn away. Lack of information about an issue is surely an obstacle to action, but we need to focus on the quality of information, too — do people have access to useful information they need to change things for the better?

The right information just isn't presented in the right form. Designers and artists, in efforts to make cold facts more aesthetically receptive, employ their talents to sculpt data into visualizations from charts and diagrams to interactive displays. This can make for interesting (and sometimes dreadful) art, the best of which draws people in and increases their comprehension of an issue. Too often, however, the art speaks louder than the data, facts are sacrificed for form, becoming something to be appreciated and admired, but not necessarily acted upon.

People will do what we want them to do with the information we give them. We often presume that once people have the "right" information, they will act in the "right" ways. But we can't control how the facts are received. People *make sense* of facts in various ways, putting them into context and giving them meaning. Unfortunately, one of the key ways we make sense of information in consumer societies is to see it as just another commodity. Knowledge is something we possess, maybe show off at parties, but ultimately store away on a shelf. Or, if it is not something to hoard, it is disposable, something to use up and throw away. In neither of these cases are ideas something we act upon. If we want people to do something other than merely consume information, then we need to provide compelling alternative models of what they can do with it.

Information is action. College professors (mea culpa) often suffer this particular delusion, propping up their radical credibility while justifying their lack of activity by insisting that their activism happens in the classroom. So they expose students to the "lies" their (other) history teacher tells them, or espouse the latest subversive theories, trusting

that the mere transference of specialized knowledge will create change. This idea that the exchange of information is a transformative activity also haunts forms of political activism. It is most apparent among conspiracy theorists, who often seem to think that simply sharing the truth about power will cause it to crumble. Like magic.

Action without awareness results in an unthinking artistic activism with stupid, and sometimes terrible, consequences. But awareness without action is perhaps worse. It results in the appearance of political engagement without any of its results. It is an artistic activism of bad faith. Therefore, while awareness is important, it is not enough. Ultimately, information needs to empower people and move them to action.

THE WHOLE WORLD IS WATCHING

We've interviewed scores of talented political artists and worked with hundreds of activists, and the most common criteria they use to gauge the success of their projects is media attention. If the work is covered by the mainstream news or the art press, or commented upon in activist or art circles, then it is deemed a great victory. This makes a certain sense: the more people hear about our piece, and the more they are exposed to the issues, then the more they might be moved

to think and act in a different way. Media attention is also a nice and easy metric for success. We can measure how many times our piece was mentioned, the quality of the coverage, the audience size, and so on. For these reasons and others, designing pieces with potential media attention in mind is important.

But media is a means, not an end. Literally. *Media* is the plural of *medium*, which comes from the Latin for "middle." Media is a means for delivering our ideas or feelings to another person or, in the case of mass media, many other people. It's a conduit; that's all. What really matters is the message and what people do when they receive it. Yes, we know that the medium, too, has its own message, but when we forget that media is a means to an end and let "media hits" become the Holy Grail, then it's too easy to start creating pieces whose primary function is to capture the attention of newscasters and bloggers. Media click bait. When this happens, aesthetic form and even social content can become secondary. An audience of millions matters little if our piece has no content. And if having the whole world see our piece is really the ultimate goal, then cat memes are a surer path to success than artistic activism. Kittens are lovable, but they are *not* the revolution.

STARTING A DISCUSSION

Many artists, and even some activists, no matter how political they are, are reluctant to take a stand and have their work convey "a message." Instead, their goal is to stir the pot and begin a dialogue around a topic so audience members, either individually or collectively, can arrive at their own conclusions. There's a lot to commend in this approach. In a democracy, decisions should be arrived at through discussion rather than decree, and by opening up space for conversation through our pieces, we are facilitating this critical component of a free and open society. This is the power of the public sphere. Besides, telling people what to think makes for bad art, and ineffective propaganda.

The problem, again, is confusing means and ends. Facilitating free and open conversation about a topic is great, but is this really

the end we are looking for? What do we actually want that conversation to do? The public sphere is politically important not just as a forum for discussion, but because this discussion spurs the creation of new perspectives, the identification of problems, the formulation of solutions, and the taking of actions. Our goal can't simply be talk and more talk. This is a fine activity for a coffee house or a seminar room but it isn't — by itself — very effective in challenging power or creating change. The *power* of the public sphere doesn't come from dialogue itself, but from what comes after.

GOD FUCKS GOATS (OR, SHOCK VALUE)

There's another problem related to the two previous ones. What gets the most media coverage and generates the most conversation? Controversy. Burn a flag! Get naked! Put a crucifix in a vat of urine! Art and activism have long histories of using shock value to get people talking. It often works — but what do people talk about? Usually the controversy. This may boost the artist or activist's own renown, but it usually doesn't get people talking about the real issues (other than about the right to create such shocking work). Our work should foster *meaningful* dialogue that leads somewhere.

In chapter 4 on culture, we described how a radically new per-
spective can reorient our fundamental coordinates of reality: a
"redistribution of the sensible." In chapter 5 on cognition, we wrote
about the value of surprise and how creating a piece that counters
expectations can open up opportunities for rethinking. But this is
only the case when this new sensibility truly challenges the normative
structures of society; when it shocks us out of how we "make sense."

Today, however, shock value *is* our sensibility. In a world where a
celebrity billionaire who spouts a steady stream of scandal, provoca-
tion, and outrage can be elected president of the United States, and
advertising moguls like Charles Saatchi sponsor art exhibitions that
spark public furor and media frenzy, controversy constitutes the core
of the system. Maybe once, when sober Victorian values held sway,

shock value had some transgressive and transformative value, but that time has long passed. Shock value has been devalued; "shocking pieces" are often not that shocking.

And Then What Happens?

MANY OF THESE common mistakes encountered in art and activism are not really mistakes at all. There's nothing wrong with expressing your rage, getting media attention, or starting people talking. Good intentions are key, and awareness is important. The mistake lies in means and ends — our tendency to conflate the two. Simply put: ends are where we want to go and means are the steps we take in order to get there. But less simple is that means and ends work in cycles: an end may be a means to an even greater end. Still, in order to be æffective as artistic activists, it is important to clearly establish our ends and distinguish them from our means.

In our own practice, and through working with others, we've come up with a technique to avoid many of the common failures we've witnessed (and perpetrated ourselves). It's really, really simple. As you plan your piece and think about what you want it to do, ask yourself this question: *"And then what do I hope happens?"*

- If I have good intentions, then what do I hope happens?
- If I express my anger (or alienation, frustration, hope, or joy), then what do I hope happens?
- If I live an authentic life, then what do I hope happens?
- If I make people aware, then what do I hope happens?
- If I start a discussion, then what do I hope happens?
- If I shock people, then what do I hope happens?
- If I [fill in the blank], then what do I hope happens?

We have a friend who is an extremely talented artist and a committed revolutionary activist. He makes powerful and provocative work about racism and injustice in the United States, and thinks deeply about the æfficacy of his work. We had a conversation with him about the relationship of his art to his politics, and asked him

what success would mean for him. He explained that he wants his work to reveal an ugly truth about society, and provoke people into thinking and talking about it. In meeting these objectives, our friend is an unqualified success — his work is widely seen, discussed, and critically acclaimed, and even denounced by his adversaries.

But then we asked our follow-up question: *And then what do you hope happens?* What happens when truth is revealed, people are provoked, and conversations are started? Our friend, our highly articulate, politically sophisticated, theoretically learned friend, seemed at a loss for words. He was clear about his ultimate goal: a global revolution, but he, like most of us, struggled to make the connections between his objectives as an artistic activist and a larger strategy that moved toward his ultimate political goal.

He's not alone in overlooking this disconnect. We often hope that our first gestures will be imbued with grand and magical powers, transporting us great leaps forward, further than we've bothered to plan for or even imagine. Back in reality, taking giant steps is almost guaranteed to lead to missteps. We need to think through the steps we take, methodically. Asking what happens next can help us do this. Answering this question honestly also provides answers to two other critical questions:

- What do we expect our piece to actually do?
- What is our ultimate goal, and how will this piece help get us there?

The first question helps us devise better tactics, and the second pushes us to think in terms of an overall campaign. In addressing these questions we are a step closer to becoming truly æffective artistic activists.

Clear Intentions

IT IS RELATIVELY easy to measure success and failure using a simple model of communications.

It works like this: the speaker encodes an idea into a statement

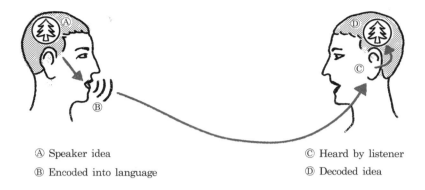

Ⓐ Speaker idea

Ⓑ Encoded into language

Ⓒ Heard by listener

Ⓓ Decoded idea

that is heard and decoded by the listener. In this model, the thoughts of the speaker are mirrored in the ideas of the listener. Any variance between the thoughts on either side is considered a problem caused by poor communication or listening skills. The goal is to create a clear and direct transmission: message sent = message received. If you've achieved this then you have succeeded.

But artistic activism works differently: we encode an idea into a piece that is then seen, heard, or otherwise experienced by others. Unlike the traditional communications model, which strives for perfect correlation between message in and message out, artistic activists use their work to explode meaning. Think about what happens to light in a prism. In a dispersive prism, a singular beam of white light is aimed at a certain angle into a triangular chunk of glass. The white light is then refracted by the angles of the glass and broken up into its spectral colors: creating a rainbow. Similarly, the artistic activist focuses their ideas and intentions into their work, but what results when that piece is experienced by other people is not a single, distortion-free message, but, rather, layers of meanings and ideas that can be interpreted and acted upon in a myriad of ways. We shine one light *in* but what comes *out* is a spectrum of æffect — and this is something we can't entirely control for.

What artistic activists can control is our input, and this must be strong and focused. If the light that hits a prism is weak and diffuse,

Duncombe and Lambert Model of Artistic Activism

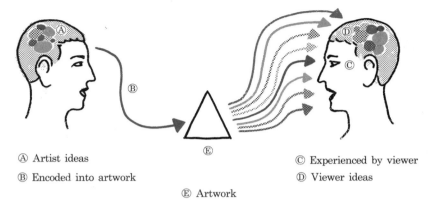

Ⓐ Artist ideas

Ⓑ Encoded into artwork

Ⓒ Experienced by viewer

Ⓓ Viewer ideas

Ⓔ Artwork

nothing much happens: no beautiful rainbows. Similarly, if our intentions as artistic activists are feeble and our pieces are not carefully considered, then little will happen. This is why all the thinking and planning about affect and effect, tactics and campaigns, intent and measurement is so critical. Not so we can predict and control exactly what happens, but so we can make sure that *something* (and something beautiful) happens, and then, once we've determined what's happened, *refocus* our efforts

Focus your intention with Exercise 36 in your workbook

Sublime Propaganda

ART CAN BE beautiful, provocative, funny, mysterious, unsettling, calming, and even sublime. And, in the opinion of your authors, it can also be politically powerful. Here's a story that might explain how we see these two aspects of art working together.

A few years back we were in Houston, Texas, with the earlier mentioned group of prison justice activists working on youth incarceration. It was late afternoon on the final day of our workshop. We held our graduation ceremony and said our goodbyes, finished packing up the conference space, and headed for the airport — only to be told that the

entire Northeast had been shut down because of a hurricane. We were marooned in Houston. We made the best of it by consuming copious amounts of barbecue and visiting local sights like Rick Lowe's Project Row Houses, the Rothko Chapel, and the Beer Can House (constructed out of 50,000 cans!). After a few days in Houston and many hours on the telephone, we finally found a flight home via an old Air Force base in upstate New York. We spent our final evening at Rice University where we saw James Turrell's immersive light sculpture, *Twilight Epiphany.*

Turrell is famous for his light and space works, including his installation inside an extinct volcano in the Arizona desert: the largest light sculpture in the world. The installation in Houston is a bit smaller, but it's still impressive. It rises out of the ground like a Mayan temple from the future. Openings are sliced into the side of the structure, with stairs leading up to the rim, and a ramp sloping down into a square amphitheater inside, at the center. Concrete benches line the four sides of the amphitheater and, looking up from the benches, one sees a flat roof floating above: square, broad, and stark white. In the middle of the roof a smaller square, its sides slightly bowed, has been removed, opening up to the sky above.

The sky was still bright with the east Texas sun on the evening we visited Turrell's piece. As the sun set, we entered the amphitheater with a group of about forty strangers. We sat down on the benches and looked up: through the hole, at the sky. But it wasn't the open sky we had seen before entering the structure. This was a sky with

hard edges as the artwork's borders framed what we saw. The sky appeared at once as if it were a painting, flattened out like a canvas in a museum, while at the same time infinitely deep, as it extended out into space. Into this blue field a cloud entered every once in a while, before passing through, furthering the illusion that we were viewing an impossible picture.

At sunset, the ceiling above began to glow, illuminated by LED lights around the rim of the pyramid. Slowly, the white concrete slab was filled with pinks and blues and greens and oranges, each color melting into the next. The colors started weak, reached full saturation, and receded. Wave upon wave. What drew our eyes, however, was the aperture. As the artificial light changed color, so did the sky. Against a green background, the blue sky appeared light grey; when the lights shone blue, the sky disappeared into the surrounding ceiling. The sky then reappeared as a hard, black square enclosed by orange, before transforming into a deep, vivid blue when the lights faded to beige and moved toward pink. Clouds passing in and out of frame generated new variations: popping out white against a background of blue, or receding into the grey of the sky when surrounded by green. As the sky grew darker with the setting sun, the colors continued to change, creating new hues of sky: pink, purple, blue, green, orange, red, and black. For the forty-five minutes of the show we were, literally, awestruck.

James Turrell has deep moral and political convictions. In 1966 he went to prison for advising draftees how to avoid the Vietnam War—a level of commitment to a cause that most artists, and even activists, can't top. But there is nothing overtly "political" about the content of his work: light, shapes, and colors. It doesn't directly challenge the wars in Iraq and Afghanistan, intervene in debates on income inequality and the climate crisis, or draw attention to structural racism. But we walked out of *Twilight Epiphany* that evening convinced that it was one of the most profound pieces of activist art we had ever seen.

What æffected us so deeply was the profound challenge posed by the piece to our sense of perspective. With the sky framed in a defined square, we were made to look at it anew. The sky was not something to

be taken for granted, but a sight to be explored and examined. Through juxtaposition, we were made to acknowledge that even the color of the sky exists in relationship to the surroundings in which we see it. And this relationship is forever changing.

We couldn't measure the impact of *Twilight Epiphany* with exactitude, but we both knew we had *experienced* something profound that shaped our ways of thinking about reality and context. What we knew to be blue we then saw as a rainbow, which prompted us to question the reality we see every day through our own eyes. We realized — through our senses — that perception is subjective, and is able to be manipulated easily. And, coming from a weekend working with prison justice advocates, we saw the political ramifications of the piece's ability to shift our experiences of things taken to be

self-evident; for instance, what we see and what we believe about prisoners and the police, justice and the courts. We weren't, and still aren't, sure what *Twilight Epiphany* was "about," but it moved us in ways both personal and political.

Aesthetics and politics are intimately connected. The connections between the two range from the mundane to the profound and have all sorts of implications, but the one that concerns us here is simply that *bad art makes bad activism*. Without the power to attract, move, and challenge audiences, artistic activism is useless. If it is an aesthetic failure, it will also fail to change people's hearts and minds and thus change the world.

Artistic activism that doesn't move us leaves us standing still.

Explore what moves you in order to move
others in Exercise 38 in your workbook

What Do *You* Want to Do?

THERE IS NO SINGLE FORMULA for guaranteed, 100% æffective artistic activism. The practice is so broad and varied and there will always be a multitude of ways to gauge its success. It is also necessarily local: tailored to addressing particular problems or seeking particular outcomes, to the cultural conditions in which it operates, and the resources at hand. There are many ways to enact change, from bringing people together for a planning meeting to encouraging broad shifts in perspective, and there are many strategies that can lead to success. What's important is knowing what it is that you want to do as an artistic activist. Not critics, not foundations, not jurors or committees, not other artists or activists. You!

Being clear about what you want your work to do is the *essential* first step to measuring its success. Once you know this, there's a simple way to evaluate whether your artistic activism is working: you compare

your original intent to the final outcome by asking yourself the following questions:

- What did I want to have happen?
- What actually did happen?
- What worked as I wanted?
- What didn't work so well?
- What surprised me?

And then, perhaps the most critical question of all:

- Knowing what I now know, what might I do differently?

Maybe your piece worked better than you ever anticipated. Maybe it fell a bit short. Maybe you realized you could have been more ambitious. These insights become part of your experience for the next project.

To get anywhere, we need to take steps. Sometimes we take steps that are too large and we get frustrated when our legs won't stretch the distance. At other times the steps we take are too short and the ground we cover is negligible. Our steps are sometimes uncertain or confused; we walk in circles, become lost, and retrace our steps without realizing that we've been in the same place before. Or our steps come to an end too early: we fool ourselves (but rarely others) into thinking we've arrived at our goal and our journey is at an end. Knowing what steps to take, and recognizing when we've taken them, can help us on this perilous journey. While our ultimate goals are forever on the horizon, hazy and far off, the steps that will move us closer can be clear, defined, and measurable.

There is no single, definitive answer to the question "Does it Work?" But there are answers, *your* answers. And we hope this chapter has helped you to ask the right questions.

Does it Work? Create your own evaluation in Exercise 37 in your workbook.

CHAPTER

8

ETHICS

" **A Jedi's strength flows from the Force. But beware of the dark side. Anger, fear, aggression; the dark side of the Force are they. Easily they flow, quick to join you in a fight. If once you start down the dark path, forever will it dominate your destiny . . .**

— YODA, TO LUKE SKYWALKER

The Dark Side

JUST BECAUSE ACTIVISM IS ARTISTIC doesn't mean that its politics are on the side of the angels. The dark side also understands, sometimes better than us, the power of artistic activism and history has proven this, over and over again. In fact, the most brilliant artistic activists of modern times were not working for peace and justice, or racial, gender, or sexual equality. They were not working for a more democratic society. Quite the opposite: they were engaged in a struggle for racial purity, hierarchical power, and military domination. They were the Nazis. The Nazis were evil, racist, and genocidal. They committed crimes against humanity that can never be forgiven. And as uncomfortable as it maybe, it must also be acknowledged that the Nazis employed the techniques of artistic activism.

Adolph Hitler himself was an artist, painting scenes of battlefields when serving in WWI and, afterwards, streetscapes of Vienna. He wasn't a very good painter, and was twice rejected by the Academy of Fine Arts in Vienna, but to dismiss him as merely a mediocre artist with thwarted ambitions is to miss the more important point: Hitler was a very successful artist, only his medium was not paint and canvas, it was politics and power.

HINDU
GOOD LUCK
SYMBOL

NAZI
ARYAN VICTORY
SYMBOL

Consider the swastika. In using the swastika as the symbol of their party the Nazis put into practice important principles of artistic activism. First, they selected a simple, bold, and visible sign that would lend recognizable coherence to all their varied activities and institutions. For a person living in Germany in the 1930s and '40s, the swastika unequivocally signified the Nazis. Second, they mined popular culture by appropriating a symbol already in circulation. The swastika has a long history in Indian religions, as well as Chinese, Japanese, Korean, and Native American cultures. The Sanskrit word *svastika* translates to something like "to be good," and by the early twentieth century Europeans had adopted it as a good luck symbol. By picking the swastika as the symbol for their movement, the Nazis drew upon people's positive associations and familiarity with the symbol. But they also subverted the meaning of the swastika by reversing its direction and transforming a symbol of goodness into one of power and domination.

Finally, the Nazis chose a symbol and colors they believed resonated with their movement's values and goals. As Hitler himself explained in *Mein Kampf*: "In *red*, we see the social idea of the movement; in *white*, the nationalistic idea; in the *swastika*, the mission of the struggle for the victory of the Aryan man, and, by the same token, the victory of the idea of creative work." *The victory of the idea of creative work*—yes, those are the words of Adolf Hitler.

The Nazi's "creativity" carried over into their costumes. High boots, peaked cap, death's head insignia, all black. The Nazis were evil, really evil, but they also understood style. While the uniforms of other forces active in WWII were constructed for comfort or safety, blending into the desert, jungle, or snow, those of the SS (the elite Nazi force) were designed for the human environment: to instill fear and respect, desire and admiration. The SS uniforms were conceived of by a professional artist and an accomplished graphic designer, and many of the uniforms were produced with slave labor by Hugo Boss, a Nazi in good standing. The Nazis understood that style matters. (Another strange

fact: Hugo Boss's fashion house designed the wide-shouldered suits and pastel-hued outfits for the cast of *Miami Vice* in the 1980s. Make of that what you will.)

Through massive public works projects like the building of the Autobahn and the reforestation of Germany, the Nazis marshaled "armies" of men in constructive projects, giving them work and dignity. Their "Strength Through Joy" program provided low cost group vacations and entertainment for everyday German (aka non-Jewish, Roma, queer, or Communist) citizens, creating community and capitalizing on the power of play. These *moral equivalents of war* (see chapter 4), however, were in no ways a replacement for war — they were preparations for the real thing.

The Nazis also understood the art of spectacle. Rallies, marches, and theatrical productions: the Nazis performed their politics. Probably the best-known performance was the 1934 Nazi Party rally at Nuremberg, which was captured in Leni Riefenstahl's *Triumph of the Will*. Both the rally and the film were designed to introduce the newly elected Nazi Party to the country and to the world. *Triumph of the Will* was classic political spectacle: replacing reality with fantasy. In place of the social chaos of interwar Germany — a chaos ably

assisted by the Nazis — the audience was shown neat, ordered rows of marching troops. Masking the physical deprivation brought about by rampant inflation are scenes of soldiers eating and smiling. In place of listless, unemployed youth are images of boys and men laughing, singing, and engaging in wholesome (and, frankly, homoerotic) camaraderie. Against a divided Germany, a unity among regions and between classes is on display. And eclipsing the weak and ineffectual democracy of the Weimar Republic are the strong and resolute leaders of the Nazi Party. All of this was a carefully fabricated performance, acted out by a cast of thousands, and its star was Adolf Hitler, who had taken acting lessons to enhance his public performances as a leader.

Here is Hitler's take on some of the core principles of artistic activism, directly from his *Mein Kampf*:

Politics is an affective experience.
"The art of propaganda lies in understanding the emotional ideas of the great masses and finding, through a psychologically correct form, the way to the attention and thence to the heart of the broad masses."

Meet people where they are.
"The receptive powers of the masses are very restricted, and their understanding is feeble. On the other hand, they quickly forget. Such being the case, all effective propaganda must be confined to a few bare essentials and those must be expressed as far as possible in stereotyped formulas."

The Truth won't set us free.
"Propaganda must not investigate the truth objectively and, . . . it must present only that aspect of the truth which is favorable to its own side."

And a final parallel, from notes Hitler scribbled in the margins of an early speech: "Politics is not science — but — art."

Hitler's words don't exactly align with our definitions of the principles of artistic activism, but they are close enough to make us very, very uncomfortable.

The Nazis also understood the importance of dreams and nightmares. The significance of utopia and dystopia to artistic activism is discussed at length in the next chapter, but suffice here to say that the Nazis possessed and mobilized a vision of a radically different — and, to their eyes, better — world than that of their present. After the defeat of WWI, the humiliation of the Versailles Peace Treaty, and the economic depression, the German people were looking for an alternative. And the Nazis delivered. It was a horrific alternative of hierarchy, conformity, racial purity, and total war, but the Third Reich — in its ideology, its culture, and its mission to transform the world according to a radical, new image — was nothing if not utopian.

For the Nazis, politics was not about reason and rationality, but about hopes and dreams, and, critically important to their movement:

fears and disappointments. Their appropriation of powerful symbols like the swastika; their staging and documentation of pageants, marches, and rallies; their use of art, monuments, and architecture; and their attention to sartorial style and acting techniques — all of these tactics were part of a larger aesthetic strategy meant to captivate, inspire, and frighten the public in the service of their overall goal of genocide and world domination. The Nazis recognized the power of signs and symbols, story and spectacle, and they used them very affectively, but they also did something that many other artistic activists neglect: they married creative expression with effective material organization: building a party, mobilizing people, and seizing the structures of political power in order to turn their visions into reality.

Thankfully, this reality was short lived. The Third Reich, which was supposed to last a thousand years, was over in a dozen. But the use of artistic activism within military conquest did not disappear with the Nazis. When the Allies firebombed German cities or the United States dropped atomic bombs on Hiroshima and Nagasaki, they intended to make an emotional as well as material impact, and the distribution of films depicting the U.S. nuclear tests in New Mexico and the Bikini Atoll during the Cold War were designed to impress domestic citizenry and intimidate foreign enemies.

It's not just powerful military states that have employed artistic activism. When the terrorists of Al Qaeda crashed hijacked planes into the World Trade Center and Pentagon (only missing their third target: the White House) they were targeting symbols of America's commercial, military, and political power, painting a picture in blood and fire meant to move their sympathizers and their enemies alike. As the artist Damien Hirst told a BBC reporter at the time: "The thing about 9/11 is that it's kind of an artwork in its own right. It was wicked, but it was devised in this way for this kind of impact. It was devised visually." In other words: it was artistic activism. And today, the ethnonationalist Right from India to Israel, throughout Europe and in the United States is employing potent signs and symbols, telling stories (most of them false), and staging vivid spectacles.

GRANDFATHER OF PUBLIC ~~RELATIONS~~ MANIPULATION
EDWARD BERNAYS

Not Just Nazis

IT'S ALSO NOT just extremists of political power and violent destruction who understand the aesthetic and emotional impact of their work. Turn on the television, flip through the pages of a magazine, or browse the web and you'll see artistic activism in daily practice. Advertisers, marketers, and public relations agents are in the business of using signs, symbols, and stories that tap into our dreams and nightmares in order to prompt a very particular and focused material action: buying stuff. And they are very good at what they do. While they are no Nazis or terrorists, marketers don't tend to mobilize their talents for the good of humankind either.

One of the best in the business was Edward Bernays, a man recognized today as the father of public relations. As a nephew (twice over) of Sigmund Freud, Bernays was fascinated by the idea of using psychological methods to tap into deep rooted human desires in order to change people's ways of thinking and patterns of behavior. Whereas Uncle Sigmund was interested in the study of our unconscious drives to help his patients rationally comprehend the irrational and thereby attain a certain mastery over their lives, the mastery that Bernays sought was for his advertising clients: he wanted to understand the irrational and unconscious drives of people in order to better sell products, corporations, and political ideas — and sometimes all three. In 1954, as a consultant for the United Fruit Company, the largest banana producer in the world, Bernays was tasked with selling the CIA-backed, anti-Socialist coup in Guatemala to the U.S. public. He succeeded.

Bernays's most ambitious campaign, however, was in the late 1920s when the American Tobacco Company hired him to increase sales of their Lucky Strike cigarettes. Bernays strategy was simple: sell cigarettes to women. But there was a problem with his plan: women in the United States didn't smoke, at least not publicly. The trick was to convince women that it was *desirable* to smoke — the question was how. Bernays pioneered the theory that people don't buy products, they buy dreams of becoming a particular kind of person *through* the accumulation of products, fueled equally by nightmares of what could happen if they don't. In researching his audience, he realized that cigarettes, and having the freedom to smoke them, could be mobilized to symbolize women's power. Women may have recently received the right to vote but, as second wave feminists would later highlight, equality at the ballot box did not translate into equality in the home or on the street. Capitalizing on this social and political frustration, Bernays came up with a creative campaign that sought to equate women's smoking with women's liberation.

One of the highlights of the New York social calendar in the Twenties was the Easter Day stroll down Fifth Avenue. It was quite the spectacle: an event at which to see and be seen. All the papers

covered the event, chronicling who was with whom and what they were wearing; it was the Oscars red carpet of its day. Bernays had a plan to leverage this event. According to his own account, he sent out letters to young socialites in advance of the stroll, asking them to take part in a public "protest" against the laws and mores prohibiting women from smoking. (Later historians claim he carefully selected the women and paid them to participate.) He instructed the women to attend the parade with their escorts and then, at a set time, to ignite and boldly hold aloft "torches of freedom." You can guess what these "torches" were. Cigarettes.

Bernays's stunt attracted the attention of press photographers, whose images were used to illustrate newspaper articles, which then prompted editorials, and so on. And Bernays, never one to leave anything to chance, also hired his own photographer to record the event. It was a smashing success for Bernays. By understanding women's desires for social as well as political equality, and then using cigarettes as a sort of Jamesian "(im)moral equivalent" to liberation, Edward Bernays kick-started a public conversation about women's smoking. And his campaign further contributed to a demonstrable material change: between 1923 and 1935 the number of women smoking increased 12 percent.

Although it's painful to admit, some of the best practitioners of artistic activism have not exactly changed the world for the better. So, what's the difference between what they do and what we do? Simply this: *ethics*.

Our Ethics

ETHICS ARE A SET OF moral principles that shape, guide, and, hopefully, determine how we behave. The Golden Rule of reciprocity, or "do unto others as you would have done to yourself" is a good example of an ethical principle — albeit one not shared by either the Nazis or many marketers. However, while it would be easy to merely condemn the practices of Nazis and marketers as unethical, this isn't quite the case.

Nazis and marketers *are* ethical — it's just that their ethics are different to those of most progressives. Different, *and* worse. Nazis believed in order, discipline, war, hierarchy, and the exclusion of the Other. Marketing agencies generally promote the ideologies of the free market, private property, and the attendant right of individuals to express their desires through consumption. Given this, both Hitler and Bernays acted ethically in their artistic activism. The Nazis' Nuremberg rallies, for instance, with the endless marches of troops, the staged speeches of leaders, and the blonde, muscular, male camaraderie, expressed — in spectacular form — Nazi core values. Similarly,

by locating women's longings for equality and channeling this collective desire into individual consumer purchases, Bernays was merely acting out the ethos of consumer capitalism.

This is why it is so important that we develop our own ethical code. We're not genocidal Fascists, nor do we necessarily want to work on Madison Avenue. Our values differ from theirs. Our job is to devise a practice that conforms to our *own* set of values.

Ethical Artistic Activism

NOW COMES THE REALLY HARD PART: applying your values to your practice, *all* of it: your tactics, your strategy, your objectives, your goal, and your process.

A while back, Duncombe wrote a book called *Dream or Nightmare: Re-Imagining Progressive Politics in an Age of Fantasy.* He was interested in the political use of spectacle, but recognized that most political and commercial spectacles are created to serve ethics radically different than his own. He wondered what a progressive spectacle might look like, and his first task was to define progressive ethics. These included values like:

- Democracy
- Equality
- Community
- Diversity
- Truth

From this set of values, he thought a different sort of spectacle might be imagined and created: a spectacle in which everyone knowingly and meaningfully participates, and one that includes a diversity of perspectives in both planning and execution. A spectacle that dramatizes reality (and is transparent about being just a spectacle) while also setting the stage for the prefiguration of a better world we want to bring into being. In short, an "ethical spectacle."

Occupy Wall Street in New York City makes for a good case study of an ethical spectacle. First off, it was egalitarian. Anyone who made

their way down to Zuccotti Park in the autumn of 2011 could participate in the occupation and become part of the community. This included the hard core of activists camping out, but Occupy was open enough that day-trippers could step into the park and take part, as could office workers on their lunch breaks. The political structure of Occupy was both participatory and democratic. At a General Assembly, anybody could speak and share their own opinions about what should be done and what direction the occupation should take (and at some particularly long and grueling meetings it seemed as if *everybody* did). Occupy was also what it presented itself to be: an occupation, and its claim that "This Is What Democracy Looks Like" was backed up by the General Assemblies and the plethora of signs whose varied, personalized, and sometimes contradictory slogans represented a political plurality (at least of voices on the Left). Finally, Occupy Wall Street didn't merely reveal a truth about the reality of income inequality, it practiced a new reality — if only for a brief time and in a small space — that it wanted to bring into being: a social and economic system based upon mutual aid.

So was Occupy Wall Street an ideal "ethical spectacle"? Mostly. But not every action can conform to all of our values, and as artistic activists we might create an action that is democratically conceived,

but carried out by only a few people in our group. Or we might stage an intervention that demonstrates the future we envision but does nothing to reveal the world as it is. Occupy, for example, made symbolic claims that "We are the 99%" while really only being a minority of activists. So strike one against literal Truth. This is to be expected. These are all creative decisions that need to be made case-by-case when designing a successful piece. Our next piece might pick up on other values, and the one after, still others. In fact, it's best not to try and pack all of our ethics into one tactical expression, remember: there's no one piece that will do it all.

Once you have developed a code of ethics, synchronizing your practice with your ethics will, to a degree, take care of itself. We have our values and, no matter what structure or method we use, we are not likely to *act against those values*. If we highly value honesty, we're less likely to lie to people — it's just not something that would occur to us as a choice of action. Except that in daily life things get messy. We're rarely presented with clear cut ethical decisions; rarely, for example, will someone appear by your side to ask: "Would you prefer to tell the truth or to lie?" Planning new pieces can be exciting and we can easily become obsessed with technical and logistical details and getting things done, while ethical concerns fall by the wayside. To avoid this we must periodically, and self-consciously, check our plans against our values. To create ethical pieces we need to *constantly* remind ourselves of our ethical code.

**Write your own ethical code in
Exercise 39 in your workbook**

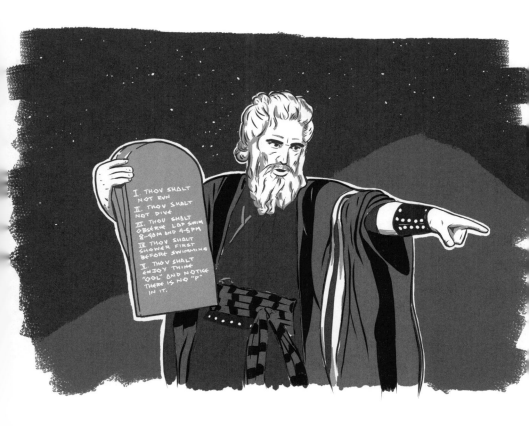

Rules to Live By

THE ABRAHAMIC GOD handled this whole ethics problem a couple
of millennia ago by delivering the Ten Commandments. Carved in
stone, they laid out clearly what one had to do to be a good person.
However, even God had trouble setting out rules of right behavior,
and for millennia rabbis and priests, ministers and imams have been
questioning and debating the fine points of what he/she/it/they/thou-
who-shall-not-be-named actually meant. The problem with codes and
rules is that they seem clear on paper or stone, but when put into
practice they get hazy awfully fast. We are always facing circumstances
where our values conflict with one another, or the complexity of the
situation pressures us to compromise.

ETHICAL PRACTICE

BUT THAT DECISION IS AL

We think about the ethics of our own practice quite a bit. Some decisions are easier than others. A corporation once asked us to help train them in using creative tactics to better reach consumers. We said no. We were asked to organize a training with undocumented youth working as immigration activists in South Texas. We said yes. But other decisions are harder. In order to finance the training with immigration activists should we take money from a foundation bankrolled by an international capitalist investor and philanthropist? Taking money from this source violated our anti-capitalist values, while working with the money honored our values of human dignity. In the end, we decided to take the money and work with the immigration activists, reasoning that the good outweighed the harm. But at another moment, in another situation, we might have decided differently. Ethical practice demands a decision, but that decision is always open to revision.

Ethical values are essential, but they can be a bit abstract. In applying ethics to our day-to-day lives and practice we've found it helps to put ethics in the form of questions we can ask ourselves. For example, Lambert values artistic integrity. Whenever he's approached to collaborate with commercial interests he always begins with the question "Can I do whatever I want?" If the company representative hems and

DEMANDS A DECISION, WAYS OPEN TO REVISION.

haws and starts qualifying, it makes declining the offer much easier. Asking this question has prevented Lambert from getting into ethically compromising situations with companies from Absolut Vodka to Ogilvy.

Prior thinking about which values we hold dear, as well as those we revile, help clarify the ethical boundaries in which we'll operate. This makes it easier to navigate the difficult periods when we must make complex decisions in the moment. Ethical dilemmas will arise, and the decisions we make in these moments are part of the practice. Struggling with these questions will also make us better practitioners.

We've come up with the following questions you might want to consider as you develop your work. There are no correct answers here, and you'll bring your own values to your responses, but asking yourself questions like these as you move through your work will help you keep on the righteous path.

- Are my tactics, strategy, objectives, and goals consistent with my ethical code?
- Are the values expressed by my piece true to my ethical code?
- Is the intended æffect of my piece in line with my ethical code?
- Was my piece created according to my ethical code?

These are the big, important questions, but they are also abstract, formal, and perhaps slightly intimidating. These, more pointed, questions may be more helpful:

- If your piece were a person, how would you feel about them? Is it someone you want to be around? For example, are they funny, smart, and sincere or do they seem kind of duplicitous, sleazy, paranoid, or angry?
- Is there anything about your reasoning, research, motivation, or funding that you would be afraid of your audience finding out about? Are you trying to trick your audience in any way? If so, how would they feel about you, your piece, and your cause if they were to know *everything*?
- If you were part of the target audience, how would you feel about the work? Would you want to be treated or addressed in the same way that you are treating and addressing others? Are you talking down to your audience? Are you respecting your audience's intelligence?
- Your message may be appropriate for your target audience, but what about unintended audiences? Could your work could be misread, or misinterpreted by people who don't share your beliefs or values? If you are using irony or satire, will it be read as such? Is there a way you can address this possible misinterpretation within the piece? If not, is this the right piece to be showing to a wide audience?
- Do you stand to personally gain anything through your work? Money? Fame? Position? Exhibitions? Think about how you'd proceed if these benefits weren't at stake. Is this consistent with your ethical code?
- Are your means consistent with your ends? Do they allow you to be the change you want to see in the world?
- Lastly, how would your parents or grandparents, or your kids or grand-kids, feel about your piece? Consider calling them and asking.

We could probably come up with a dozen more questions like this, and so can you. Like many of the lists we provide in this book, the point isn't to check them off in a mechanical fashion to arrive at a definitive answer of "yes, I'm ethical," or "no, I'm immoral." These questions are meant as prompts to get us thinking about what we do, so we can do it better.

Come up with a list of guiding questions that reflect *your* ethical values in Exercise 40 in your workbook

Using the Master's Tools

IT'S NOT ALWAYS easy being an æffective and ethical artistic activist. Many of the best techniques of artistic activism were developed to stimulate the purchase of superfluous consumer goods or generate support for heinous political regimes, and they contain within them the traces of these uses. In response, many artists and activists reject these "tainted" methods. This is quite understandable: few of us want to be known for being inspired by Madison Avenue, not to mention the Nazis. But such rejection, while allowing us to feel pure and good and "ethical," can ultimately be defeatist: it cedes too large a territory to our adversaries.

Sometimes techniques used for less-than-noble purposes *can* be adopted and adapted... and done so ethically. Throughout this book we've drawn ideas from many places and, as chapter 6 on persuasion makes evident, we can learn a lot from questionable practices like marketing, particularly social marketing, about honing our message, understanding our audience, and moving people from ideas to action. But we have to critically pick, choose, and adapt our lessons.

One of the things we can learn from marketing, for example, is how to mobilize visions of utopia. Again, utopia and its uses will be discussed in the next chapter, but here we simply want to recognize that the appeals of advertising often tap into our most idealistic dreams

and desires. These visions of utopia are then mobilized in order to stimulate "action" in the form of shopping. Few companies market their products based upon what their products actually do. No one sells shampoo, for instance, by explaining how it will make our hair cleaner. No, instead we are treated to glamorous images of who we will become once we use the product: attractive, sexy, and powerful, with the magical ability to attract attention and affection.

In a recent advertising campaign, for instance, the Coca-Cola Company promises consumers that in buying a Coke we "Open Happiness." Like a hallucinatory revision of its 1971 "I'd Like to Buy the World a Coke" advertisement, a three minute commercial/music-video takes viewers on a tour of Coca-Topia. Infectious music plays as people of all cultures and ethnicities come together as one. Giant fish fly in a rainbow-filled sky and smiling suns look down upon us. Laws of gravity are amended as people walk up walls. Children dance in a classroom in which "Imagination Inspires Nations" is written on the chalkboard. And a news headline crawling along the bottom of the screen reads: "People Joining Open Happiness." It's a movement! So much fun, so much happiness! Who wouldn't want to join this world? Selling the dream of a better world is what artistic activists do, and we can learn a lot from advertisers in terms of how they present these utopias: the dreams they tap into, the scenes they set, their use of color, sound, images, and words. Advertisers often steal ideas from artists and activists, why not steal some back?

So what's the difference between advertising and artistic activism? The difference is this: all advertising is built upon a lie. The recent Coke advertisement, like *all* advertisements, violates the ethic of honesty. The product being sold cannot deliver the dream it promises. We might like the taste of Coke (Duncombe does), and it might be enjoyable to drink a Coke, but no amount of carbonated sugary beverage is going to get us closer to "Happiness." In fact, there is an inverse relationship between the product and the dream. The more Coca-Cola you drink, the sicker you become as your teeth decay, you gain weight, and may even develop diabetes. A decidedly unhappy state.

(Curiously — or revealingly — no one is ever seen drinking a Coke in Coca-Topia.)

As artistic activists, we operate according to a different set of ethics. When we present a dream, no matter how utopian, we also offer a real pathway with concrete objectives, which, if achieved, *will* lead us closer to the Promised Land. For example, when we conjure up the dream of a world without fear, we also provide a concrete course of action that will get us there: laws against street harassment, civilian oversight of the police force, closing the school-to-prison pipeline, transfers from military to social spending, and so on. Accomplishing these objectives may not immediately transport us to some fantastic world, and there may be new challenges along the way, but — unlike a bottle of Coke — they are at least steps in the right direction that will improve people's lives in very real ways.

We can learn lessons from the world of advertising and marketing and adapt their techniques, but to do this ethically we need to consider all of the ramifications of what we are doing. For example, think of the slick advertisements produced by big environmental and animal rights groups, or how they employ earnest young people with clipboards to stop people on the street and ask if they "have a moment to save the planet." In an effort to increase their public profile and build their base, big activist organizations have been known to hire marketing firms to design their publicity and outreach campaigns. These firms use the tools they are familiar with in order to do what they do well: targeting individuals with appeals that offer immediate transformation through the magic of the marketplace. They then apply this model to social change. This may be effective, but effective at what? Those kids with clipboards are more than just annoying, they are reproducing a model of social engagement that is antithetical to the very values they hold dear.

Soliciting donations through earnest appeals and heart-tugging ads "work" if you are interested in people as "consumers" of the political "service" you are providing. It's a good way to raise money for campaigns and add another name to an organization mailing list. If, however, you are trying to encourage people to have a sustained and deep interest in your cause and turn them into active agents of change, then such tactics are probably not going to work — not because they aren't effective, but because they are designed to be effective for another purpose. Consumerism depends upon us being consumers; activism counts on us being active.

Another example of the artists and activists uncritically adopting the creative techniques of consumer marketing and political persuasion is seen in the use of FUD. FUD stands for Fear, Uncertainty, and Doubt, and exploiting these emotional states in consumers or citizens is a standard marketing and political practice. It's used so frequently because it is highly effective. Fear, for instance, is as powerful an emotion as hope, and if tempting people with visions of the good life doesn't work, they can always be scared with nightmares of the world

gone horribly wrong because they didn't buy a particular product or vote for a certain politician.

Because it's so æffective, FUD is sometimes used by progressives. We demonize and make enemies of the Other — rapacious capitalists with black top hats and vampire fangs, or politicians with Hitler mustaches — or we conjure up dystopic images of the ecological wasteland that awaits if people don't join our cause for environmental reforms. This can effectively raise people's attention and stimulate action, particularly in the short term, but we need to ask ourselves: Does this approach align with the values we hold? Do we want to build a world based on hope or on fear? Faith or uncertainty? Confidence or doubt?

Audre Lorde famously wrote that "The master's tools will never dismantle the master's house." The master, however, has some slick power tools. These are particularly well suited for working on the master's construction sites of the mass media, commercial culture, and political spectacle — sites in which we sometimes need to be able to work. If we tossed out every tool that was ever used unethically we'd have few left to use. At the same time, we can learn from Lorde by acknowledging that the master's tools were designed for the master's purposes. These tools will only be æffective for the sort of work *we* want to do if we pull them apart, critically examine them, and then rebuild them. We can't simply adopt the tactics and strategies of our enemies; we need to adapt them to our goals and, above all, our ethics.

Examining Our Own Tools

IT'S EASY TO CONDEMN the creative tactics of Nazis and marketers, even as we adapt them for our own purposes. But if we are going to take the ethics of our practice seriously, this also means turning a critical, ethical eye on our own tactics and strategies.

Art and activism have their own standard sets of practices. Artists show their work in galleries or perform in theaters; activists organize marches and rallies. These are things we do because we've been trained to do them and because artists and activists have done them in the past. They are part of our culture. And, like all routinized practices,

they lose their æfficacy over time. When Igor Stravinsky debuted his *Rite of Spring* at the Théâtre des Champs-Élysées in Paris in 1913 it caused a riot in the audience; when A. Phillip Randolph and Bayard Rustin organized the March on Washington for Jobs and Freedom in 1963 where Martin Luther King Jr. gave his "I Have a Dream" speech it helped pass the Civil Rights Act. But there hasn't been a major riot in a symphony hall in at least a couple of years, and although millions marched against the U.S. war on Iraq in 2003, it happened anyway. When we do the same things over and over, and expect the same results, we are fooling ourselves.

Like many activists we've been to a lot of marches and rallies. In fact, we've helped organize a number ourselves. The standard model goes something like this: activists from all over the country, or even the world, assemble in one or more designated areas, often in capital cities, on a certain day, usually a weekend. Upon arriving, participants are informed of the march route, usually circular, that has been worked out in advance between the organizers and the police. During the march we are kept in line by fellow activist "marshals" who have volunteered to keep the event running smoothly. We walk in a slow plod holding signs aloft and reciting chants, which more often than not start with "Hey Hey, Ho Ho . . ." Because it's the weekend, and all governmental business is shut down, there are few people to see or hear us other than fellow protesters, the police, and a few reporters.

After a few hours we arrive at our destination, often the very place we started. A stage has been erected and for the next hour or more we listen to prominent figures tell us what we already know through a sound system that practically guarantees we can't hear a word they say. Then, if we feel particularly committed, we might make our way to the "sanctioned civil disobedience zone," where the police are waiting. If we are angry, maybe we'll get into a yelling and pushing match with the police, who will then arrest us. We go home hoping that the march has warranted a fifteen-second mention on the evening news, with a reasonably accurate count of the protesters who attended. Perhaps there is also an image of one of us, hands cuffed

behind our back, being loaded into a police van. And just maybe — if we are really lucky — a photographer snapped a picture of a cop using violence against a protester! We go to bed satisfied, feeling as if we've been part of history.

There are many good reasons that the march and rally tradition is the stock-in-trade of social movements. It is a physical manifestation of the democratic ideal of people petitioning the government; it feels good to be surrounded by others who support the same, often unpopular, causes that we do; and there are many historical examples of marches that were highly æffective. But we should also query whether large marches remain effective in getting political messages across, or whether they instead lend themselves to becoming mere spectacles of cops vs. protesters. Are marches and rallies a good use of scarce activist time and resources? Or do they lead to a sort of narrow numbers game, where each protest must be bigger than the last in order to garner news coverage? Once, several participants in one of our Center for Artistic Activism workshops were in the early stages of planning their "25th Annual March Against the Death Penalty." Toward the end of the workshop, they had a realization: "If we've held twenty-five of these marches, and we still have the death penalty, maybe it's time to try something else!"

We should also ask ourselves another set of questions. Regardless of their æfficacy, do such tactics conform to our principles? What values do these kinds of marches and rallies demonstrate? Following leaders, marching in circles, counting numbers, staging civil disobedience by cooperating with the same state against which we are protesting, and celebrating news reports of our own incarceration and abuse... what does this demonstrate to the world, and to ourselves? In the name of "people power" progressive activists routinely stage a spectacle of our own *disempowerment*.

We'd have a different picture if, when marches and rallies were proposed, the organizers took themselves off activist auto-pilot and asked: Does this tactic resonate with the values we hold dear? Authoritarians and masochists might find themselves answering "yes," but, given

the chance for reflection, most people would probably question this approach and propose creative alternatives. The result might be different forms of marching and rallying, like the group bicycle rides of Critical Mass or the free-flowing and carnivalesque protests of the counter-globalization movement in the late 1990s. We might decide to try a new model entirely, like the occupation of public spaces like Tahrir Square, Puerta del Sol, or Zuccotti Park in 2011. We may even dream up a possibility that has never before been imagined.

To be clear, we are *not* arguing that marches and rallies are useless and should be abandoned. Upon thoughtful reflection, we might just decide that the traditional march and rally *is* the best tactic for a particular cause, audience, or time and place, even if it rubs against our values slightly. This is OK too — we can be flexible, as long as we are conscious of what we are doing and why. Campaigns are long, and there are always multiple tactics to put into play.

Adapt tactics in ways that are both æffective
and ethical in Exercise 41 in your workbook

With Great Power...

THIS CHAPTER BEGAN with a line from a movie and it will end with one too. In *Spider-Man* there is a scene in which Peter Parker is sitting in a car with his uncle Ben. Peter is just beginning to learn his powers as Spider-Man, and his uncle, knowing nothing of his superpower but understanding a great deal about growing up and coming to terms with the powers we all possess, gives his nephew the following advice: "Peter, these are the years when a man changes into the man he's going to become for the rest of his life. Just be careful what you change into.... Remember, with great power comes great responsibility."

Artistic activism is a great power. It can be used for good, and it can also be used for evil. This is why we must use the tools carefully and thoughtfully and continually ask ourselves if the creative processes we

use and the pieces we produce align with our politics and the vision of the world we aspire to build. However, we've also experienced situations in which the rigid application of ethics serves to cripple artistic activism. Since no real-world activity is absolutely ethically pure, so the reasoning goes, it is safer to do nothing at all. Considering ethics is always important, and sometimes the right ethical decision may be not to carry out a particular piece. But it's important to remember that deciding to do nothing is an ethical choice too. Continuous ethical reflection takes time, and a great deal of honesty — especially with yourself — but such ethical reflection is absolutely necessary if our actions are to reflect our ideals. With great power comes great responsibility.

CHAPTER

9

UTOPIA

>" And your young shall see visions,
and your old shall dream dreams.

— ACTS 2:17

OK.
THEN WHAT?

There Is an Alternative

ONE OF THE KEY EXERCISES in our workshops is something we call "Imagine Winning." We ask participants to imagine what would happen if they had limitless funding, countless volunteers, popular and political support, and everything went their way. We ask them to imagine the best case scenario. What would their success look like? We then ask them to imagine some more, prompting them to continue imagining until they've reached a place where no further wins are possible, and there is nothing more to do. A world in which everything they've wanted to do has been achieved. A world in which they can — if they wish — retire from being an artistic activist and spend the rest of their life gardening or fishing or painting pictures of thatched cabins in the woods. The world of their dreams.

Guiding people through this process is one the most challenging exercises in our workshops. Over and again, participants find themselves struggling to imagine a world in which they have succeeded. They hesitate. They ask to "pass" to the next person. They resist and object to discussing *their own success*. It's as if they are afraid to allow these thoughts to enter their minds because acknowledging them will make it too difficult to return to the everyday reality of setbacks and struggle.

Being so close to the issues we are struggling with, we often get caught up in the immediate problems we face. When we worked with the group of criminal justice advocates in Texas, we witnessed this first hand. The activists, as you may recall, were organizing and agitating for rights and services for young people locked up in Texas jails. We asked them what a win would look like for them. Their immediate response was very specific: the full implementation of Texas State Senate Bill 103, a piece of legislation that offered some protection and rights to incarcerated youth and their families. Their objective was understandable. A lot of their organizing effort was focused on this bill, a number of the activists were mothers whose own children had been incarcerated, and "winning" the proper implementation of SB103 would be a considerable political and personal victory. It made a lot of sense for these activists to focus on this bill.

The problem was this: *no one* outside of these activists and some lawyers, politicians, bureaucrats, and politically active prisoners knew, much less cared, about Senate Bill 103. So we pushed them, again asking, "After you've won this, then what?" We soon arrived at another place that went beyond a single legislative victory. The activists described a place where incarcerated youth are released and are living with their families, sitting around a big table and eating meals together. A place where people are cared for, mistakes are forgiven, crime is not a problem, and jails are a thing of the distant past. A place where the smell of hot waffles and sweet syrup wafts through people's apartments and sounds of children playing outside can be heard through open windows. A place where the sun shines and everyone is happy.

They described a fantastic world, but it's important to take such fantasies seriously because this is what the activists in Texas were *really* fighting for—it was the core vision that motivated them. And, as important, it is a vision of a better world that other people can also fight for, no matter what their relationship is to the Texas prison system. The implementation of Senate Bill 103 was merely an objective, which, while it crucially needed to be met, was only one step toward a much larger goal. A goal that others—whether they are aware of, care about, or understand our specific problems or objectives—are likely to want to reach with us. Goals motivate movements. From San Antonio to Senegal, regardless of the group or issue, it's remarkable how similar and relatable these ideal worlds are. As diverse as people are, it seems we share some common dreams.

**Imagine winning in
Exercise 42 in your workbook**

Our goals need to encompass our most personal fantasies and our common aspirations. They need to be sufficiently broad-reaching to guide our journeys and attractive to others so that they want to join us. Our goals must be utopian, for imagining utopia is essential for any creative and effective transformative action. As the radical scholar Robin D. G. Kelley reminds us, "The most radical art is not protest art but works that take us to another place, envision a different way of seeing, perhaps a different way of feeling." That's what this chapter is about: using our imagination to establish goals that inspire people, provide direction, and stimulate creativity, helping others to envision different ways of seeing and feeling. It is about finding utopia.

This isn't easy. We are taught to distrust utopia. Politics is a serious business, we are told, dealing with dire realities, and we can't just imagine it all away through silly speculations about fantasy worlds. The same argument is applied to political art as well, where its proper function is thought to be to problematize and challenge, not to conjure

up happy visions of unicorns and rainbows. At a workshop we ran in Sweden, we were interrupted one day by an activist artist who, upon hearing us hint at utopian ideas, insisted that "We need to be honest about what cannot be done." He demanded, with righteous urgency, that we focus on the hard realities of the situation and the limits these placed on what we could possibly do. This, he insisted, was being realistic; he dismissed our interest in utopia as naïve.

Many activists and artists operate under this premise: that the biggest problem we face is that most people don't understand *The Problem*. And, since most people don't understand what's wrong, it is our job to tell or to show them. This may be true in some cases. But in most instances, people know something is wrong because they are suffering, or are witnessing suffering. Night after night they watch the horror show of reality on the news, and every day presents new examples of how fucked up the world is. It's not that people don't know that something is wrong, it's that alternatives are so difficult to imagine.

It is true that we need to be realistic, but our interest in utopia is far from naïve—it's based in a serious, grounded, and *realistic* assessment of how power works and why change happens. We'll share our theory of power with you now: *The dominant system doesn't dominate because most people agree with it, it dominates because we can't imagine an alternative.*

"There Is No Alternative" was the mantra of Conservative British Prime Minister Margaret Thatcher. To any complaint about the inequity of power or wealth, or the brutality of cuts to public services, she would simply reply: "There is no alternative." It was an æffective tactic, and

her mantra has been embraced by rulers around the globe to justify austerity and promote the spread of neoliberalism. Thatcher understood that the job of the powers-that-be is not only, or even primarily, to keep people down. Instead, it is to deny them the possibility of looking up.

What can one possibly do if one accepts that the world that we live in is the only possible world there is, and that our station in life is not the result of political decisions, but the natural, inevitable outcome of history? There may be inequality, injustice, and oppression but if *there is no alternative* then what is the purpose of rebelling? Given enough time, those in power may not even need the institutions of law and the military as people normalize their own domination so completely that they expect it, accept it, and even ask for it.

We seem to spend much more of our time and attention focusing on what keeps us down instead of looking up. Challenging oppressive laws and throwing unfit politicians out of power is absolutely necessary, but getting rid of the problems we face does not guarantee that we arrive at a better outcome. Even if capitalism, patriarchy, and white supremacy were abolished, it wouldn't really matter unless we are able to imagine an alternative to these structures. Your authors believe that the job of artistic activists is to examine the present with a critical eye, but also to imagine and create a new world, and help others do the same. We are critical, but we are also creative. As the pioneering science fiction author Ursula Le Guin once said, "We live in capitalism. Its power seems inescapable. So did the divine right of kings. Any human power can be resisted and changed by human beings. Resistance and change often begin in art."

Exorcise your demons of "realistic" limits
in Exercise 43 in your workbook

There's No-Place Like Utopia

IF PRESSED TO define utopia we might put it this way: it's a place that is far, far better than the world we live in now. Utopia is a place where everyone has enough to eat, all people are respected and valued, and the sun is always shining. The promised land.

And utopia is a place that doesn't exist.

The word "utopia" was invented five hundred years ago by the English writer and statesman Thomas More to describe a fictional, faraway island in his book of the same name. More's fictive world is everything his sixteenth-century society was not. Utopia has a democratically elected government and priesthood, in which women can attain positions of power; there is public health and education and Utopians are guaranteed the freedom of speech and religion; Utopia provides foreign aid to other countries, targeted toward their poor; life and labor are rationally planned for the good of all; and, perhaps most utopian of all, there are no lawyers. (More was a lawyer himself.) At the root of Utopia, the source from which everything grows, is shared wealth and community of property. The quality of

VTOPIAE INSVLAE FIGVRA

this society is best described thus: "Every house has a door to the street and another to the garden. The doors, which are made with two leaves, open easily and swing shut of their own accord, freely letting anyone in (for there is no private property)." Utopia is, well, pretty utopic.

But for a book that gives birth to such a commonly used word, *Utopia* is an exceedingly curious text, full of contradictions, riddles, and paradoxes — the grandest being the title itself. "Utopia" is a made-up word, created by More from the Greek words *ou*, meaning

"not," and *topos*, meaning "place." Utopia is a place which is, literally, no-place. Over and over in his book, in all sorts of ways, More creates a vision of an ideal world and then tells us it isn't possible.

Why does More create this wonderful world only to then tell us that such worlds can never exist? It's not just some sort of cynical trick. The power of Utopia lies in its ability to be possible and impossible, real and unreal, all at the same time. More's storytelling convinces readers that Utopia is a real place, providing specific details on how the Utopians live, what their mating customs are, and how their cities are constructed. The world that More sketches is so lucid, so convincing, that we imagine we are there. Like when we watch a good movie or theatrical performance, we lose ourselves in this other world. What is foreign becomes familiar and what is unnatural is naturalized. More is a master of affect. Not only are readers told that an alternative model for structuring society could be possible, but they are shown and thus feel that it *is* possible. Through his vivid writing More provides us with a vision of another, better world. And then he takes it away by calling it a no-place. Why? Because More wants us to imagine our own utopias.

The problem with most utopias, be they prophesied by holy men,

imposed by political dictators, or envisioned by scientists on the pages of *Popular Mechanics*, is that they are presented as The Answer. All the imagining and planning is done by an enlightened few and the role of the rest of us is to get used to it. And if we don't? Well, then the problem is with the people, never the plan. Off to the gulag with those who disagree!

More solves this problem by refusing us the possibility of believing in *his* Utopia. He takes us there — lets us see it and feel it — but

then reminds us that this place is just imaginary. He doesn't want us to simply swap our world for his alternative, so he makes his alternative impossible for us to inhabit. But it's too late for us to go home; we've already been exposed to the idea of an alternative. We've been to Utopia, and once we can imagine someplace else, then we know that the world we live in today is not the only possibility. We can imagine another world.

Here's how Thomas More's *Utopia,* as a piece of artistic activism, works.

1. We believe that the world we inhabit is the only world possible. There Is No Alternative
2. We read *Utopia* and experience an alternative world
3. Having experienced this alternative, we question whether our world is the only one possible
4. We think and feel that Utopia is better than our world and want to live there
5. But More won't let us live there — he keeps insisting it's no-place
6. We then either have to go home to our world, knowing that something better has been imagined, and wallow in despair . . .
7. Or, we can imagine better worlds for ourselves, our own utopias, and begin to create them

In short, utopia is not a place we will ever reach, but is rather a space that helps us to think about where we want to go. It is not a plan of a new society, nor is it a cynic's prank, it is a *prompt* for us to imagine new worlds.

Putting Utopia to Work

THEORY IS FINE, but in order to be useful be able to apply it in the real world. Here are five ways that artistic activism æffectively use utopia.

INSPIRE: UTOPIA DEMONSTRATES ANOTHER WORLD IS POSSIBLE.

A creative utopian project has the ability to transport people into a radically alternate universe. This is not an alternative we theorize, but one we can see and feel, and maybe even taste, smell, touch, and hear. It is an alternative we affectively experience. As we've argued above, the biggest obstacle to change is the belief that there is no alternative: that the world as it is now is the world as it always was, and will forever be. To feel the possibility of a different way of living and being can free us from this prison house of the imagination.

Whereas we might often attend protests or socially engaged art exhibitions out of a sense of obligation, utopia works differently. If it is well constructed, utopia is something that attracts people. It is a place that people want to visit, live within, and help to create. It's a place people will follow us to. It "demonstrates" the world we want to bring into being. And, of course, utopia is no-place. We can't create a real utopia, but as artistic activists we can stage it in temporary and local forms. We can create the experience of an alternative.

We created such an alternative in a park in Skopje in 2014, the capital city of North Macedonia. There, we were working with activists advocating for the rights of LGBTQ and Roma peoples, who were marginalized and discriminated against. The nationalist government in power at the time had invested in the construction of immense monuments to mythologized heroes of Macedonian people, including a thirty-meter high, gold plated statue of Alexander the Great astride a horse in Skopje's main square. In this depiction of Macedonian nationalism there was simply no place for LGBTQ, Roma, and other "outsider" groups.

The Macedonian activists we worked with were experienced, smart, creative, and embattled. As LGBTQ and Roma themselves, they felt that they were being pushed out of their own country, and their first response was to push back. All of the actions they initially proposed included some sort of confrontational provocation: sticking up the proverbial middle finger to those who were doing the same to them. These actions might be emotionally satisfying, and could even

① Warrior Statue
Ploštad Makedonija

② Full–Grown Adult

generate some media attention, but with what ultimate result? The right-wing government was promoting the fantasy that LGBTQ and Roma people were a threat to Macedonian society, and these actions would only reinforce this.

So we did some more brainstorming. We came up with a lot of wonderfully silly ideas. Since Alexander the Great was famous for having male lovers, we thought of staging a queer Alexander the Great talk show and broadcasting it on local TV. A fun possibility, but since we only had twenty-four hours to plan, prepare, and stage an action, we rejected it — and about twenty others. But through these absurd ideas we found the kernel of good one: Why not create the country we wanted Macedonia to be? A diverse, accepting, loving Macedonia. We couldn't do it for real. But we could do it for a brief time through a performance.

Over the next day and night we built a new Macedonia. Playing off the country's much despised official name, "the Former Yugoslav Republic of Macedonia," we called our country "the Future Republic of the Former Republic of Macedonia." We printed passports for our new republic that, instead of a binary choice, allowed for a spectrum of gender identities, which were written in pencil so that people could change their minds. We erected an entrance to our new republic complete with a border guard to check paperwork. Whenever a person entered our country, the border guard blew her whistle and the new

"citizen" was met with joyous clapping and cheers from the crowd. Since "old" Macedonia was chock-full with statues, we built an empty statue podium for people to climb upon and hold aloft signs declaring themselves everyday heroes and heroines of our New Macedonia. We had music, food, and tables and crayons for kids to draw pictures. Over park benches flew

brightly painted banners inviting people to sit down, talk, and get to know their LGBTQ and Roma fellow citizens.

For two hours, on a beautiful Saturday in the capital city's most popular park, we welcomed people into our utopia. And they came: the usual activist and artist suspects, of course, but also parents with kids, old people, teenagers, and the curious. More than five hundred people took our passports, entered the gates, claimed their rights as heroes and heroines, and pledged their allegiance to a more open and accepting Macedonia. It was the biggest and most inclusive demonstration of marginalized peoples in the capital in almost a decade. (And to underscore the principle that no utopia is ever perfect, we should note that we inadvertently forgot to assign someone to call the press, so our republic was ignored by the Macedonian media.)

Our Future Republic of the Former Republic of Macedonia demonstrated not what the activists were against, but what we were for. It may have lasted only for a short time, but it inspired those who partook in it to imagine an alternative Macedonia. Our utopia allowed them to ask: What if?

CRITIQUE: UTOPIA LETS US LOOK BACK AT OUR OWN SOCIETY CRITICALLY.

A step into utopia is a step into an alternate world, and once we experience this alternative, our relationship with our own world is fundamentally altered. Think about what it's like traveling to other places and experiencing other cultures. Not only do we get to know a culture that is new to us, but in the process we also get to see our own culture in a new light. It's the same thing when visiting utopia. Once

we've been to the future we look back upon the present with new eyes. What we once accepted as the only possible reality is now understood as only one of many. Our perspective shifts.

In the late 1990s Duncombe was involved with a group of artists and activists who transformed New York City subway trains into rolling parties. We would meet at a certain subway stop at a certain time, and then enter the train en masse, hanging cellophane over the subway lights, covering advertisements with streamers, passing around drinks and party favors, and setting up a boom-box or bringing aboard a live band. For the next hour or so, as everyday New Yorkers boarded and departed, all the way out to the end of the line at Coney Island, the subway car ceased being merely a means of transportation and became an exuberant party.

The joy of making our own free party instead of paying for over-priced drinks at a club was a lot of fun, but there was a political objective as well: to change people's perspective about their everyday urban experience. What mattered most was not what happened that night on the train, but what happened to people on their morning commute the next day. What once seemed normal: riding a train illuminated by harsh white lights, surrounded by advertisements, and crushed up against people who refuse to acknowledge one another,

would now seem cold, inhuman, and absurd compared to the experience of riding the utopia train.

If one reason to stage utopia is to urge people to ask the question "what if?", another is to urge them to ask "why not?" One of the great powers of art is to shift our perspective: to get us to look at what we've looked at a hundred times over in a new way. By exhibiting a urinal in an art gallery, for example, Marcel Duchamp changed the way we look at everyday items (as well as art). The Futurists, Cubists, and Surrealists showed us multiple ways of seeing reality. In a similar way, depictions of utopia, by taking us out of our world, allow us to then look back upon it with critical eyes. "Alienation," the political playwright Bertolt Brecht argued, "is necessary to all understanding."

GENERATE: UTOPIA SPAWNS IDEAS OF OTHER UTOPIAS.

UTOPIA IS NO-PLACE. It is no-place because what is imagined is simply impossible, or because it is merely staged and performed for a brief time. However, rather than being a critical flaw with utopia, this is its genius. Why create an ideal that can never be reached? Because, as we explained above, it forces us to imagine our own alternatives.

In the Summer of 2014 we were invited to Saint Petersburg, Russia, to run a workshop with a group of artistic activists. The Russians we worked with were highly accomplished in staging spectacular artistic

interventions that garnered a lot of global attention, but they were also self-critical of this practice, and wanted to develop projects that resonated with local people and addressed local issues.

We began with research. With the help of a group of radical social scientists from the university in Saint Petersburg, we surveyed a community in a working-class neighborhood on the outskirts of the city. We

asked people what they liked and disliked about their neighborhood. The residents all spoke of the strength of the local community. But they also complained of deteriorating public spaces in which to meet and socialize with their fellow neighbors. As we probed further, we discovered the residents had a common dream: waterfront access to the beautiful canals that traverse Saint Petersburg and wind through

their neighborhood. In talking with these residents we also experienced an all too familiar sense of fatalism regarding the possibility of things getting any better. To us, this was as an obstacle to overcome.

Using our knowledge of the community, we got to work. Our goal was to revitalize public spaces in the community and to encourage the creation of a vibrant civic society that could make this happen. We planned out an entire creative campaign with multiple objectives. We brainstormed dozens of tactics. We had a grand plan, but with less than a day to enact something, we decided to execute one of the simplest pieces proposed: to build the waterfront beach dreamed of by the people in the neighborhood.

We located a landing by the canal next to a busy street. We brought in beach chairs, palm trees (actually a Russian apple tree but no one seemed to mind), and beach balls. We donned swimsuits, laid out towels, tossed frisbees, and danced to music. Recycling an old Situationist slogan, we hung a banner above us proclaiming "Beneath the Paving Stones the Beach." We passed out flyers to the neighbors, invited local politicians, and for a couple of hours, on the shores of the Griboedova Canal in Saint Petersburg, Russia, we enacted the neighborhood's dream.

It was never our intent to finally realize the local residents' dreams. The real function of our little project was to prompt the community to realize its own dreams. We built a beach to stimulate residents' imaginations about what it might be possible to do — and then we turned off our music, rolled up our towels, packed up our chairs, and left. We created utopia and made sure it was no-place. If there was going to be a real beach, with ongoing maintenance, and actual sand and palm trees, it would have to come from the imaginations and through the organization of the people whose neighborhood this was. What we were doing was not meant to be a definitive solution delivered by outsiders, but simply a model of what could be — an aid to dreaming.

If one way to stimulate public imagination is to realize utopia only to then make it disappear, another tactic is to conjure up utopias so outlandish and absurd that they can never be realized at all.

Lambert once worked on a piece in San Francisco with his friend and fellow artistic activist Packard Jennings that ran with this idea. They interviewed urban planners and transportation experts about their dream projects for the city. Pushing the experts a bit further, wild ideas started to surface. An elected Bay Area Rapid Transit commissioner imagined being able to have a cocktail on the train, and another transportation specialist wondered if something like a zip line would be feasible to move people long distances with no carbon imprint. Even the urban planners who initially only wanted "more trees and bus lines" started to dream more ambitiously—of huge parks and wilderness areas that sprawled across the city. Lambert and Jennings then exaggerated these ideas and illustrated them using six-by-four foot, multi-color posters that were displayed on kiosks on San Francisco's main commercial street.

The posters took the professional planners' most imaginative ideas and pushed them to absurd extremes: a public bar, lending library, and martial arts studio on a BART train; public transit by elephant back; commuting over the bay by zip line; turning a football stadium into a farm (and linebackers into human plows); transforming the whole city of San Francisco into a wildlife refuge. Every one of these proposals was patently impossible. A city could become "greener" with additional public parks and community gardens, but transforming San Francisco into a nature preserve where office workers take their lunch break next to mountain gorillas? That's not going to happen — and that's the point. There was no duplicity in Lambert and Jennings's fantasy. Rather than an attempt to sell people a false bill of goods, it was a dream that invited people to see it as just a dream.

Yet, at the same time, impossible dreams like this open up spaces to imagine new possibilities. Viewing one of these posters on the street, a person might smile at the absurd idea of practicing Tae Kwon Do on the train ride home. But they might also begin to question why public transportation is so uni-functional, and to ask themselves why a public transportation system shouldn't cater to other public desires. They might then wonder why the government is so often in the business of controlling, instead of facilitating, our desires, and start to envision what a better state would look like — and so on, ad infinitum.

This isn't just hypothetical — Lambert and Jennings witnessed their campaign spurring similar thought processes. When they presented the project to the public, on a panel alongside the city planners, citizens in the audience began suggesting their own, equally utopian (if a bit less absurd) proposals. Policy changed too. The head of the Municipal Transit Authority started hosting weekly meetings that pushed the bounds

of what was truly possible for the city. (Alas, there is still no zip-line across the Bay.)

ORIENT: UTOPIA GIVES US A DIRECTION.

This aspect of utopia has more strategic than tactical implications. It's less help in creating a piece, but essential in the bigger work of planning a campaign or making sense of our trajectories as artistic activists. We all know how easy it is to lose our way when working on a longer term project. We get distracted, lost in the details, or bounce from one task to another, and sooner or later we look up and ask ourselves: How did I get here? Do I want to be here? And, most importantly: Where do I want to be? Without a clear sense of direction we will career from one thing to another. It's good to have broad interests and try lots of new things, but if we don't know where we are going we can't bring any sort of order to our actions. Utopia gives us a direction, it orients our compasses. No matter where we are or what we are doing, it gives us a point to look to on the horizon, enabling us to see the different paths available, and to reorient ourselves.

The importance of having a lodestone to orient our direction was brought home to us in 2011 by Occupy Wall Street in New York City. One of the many great innovations of this "ethical spectacle" was Occupy's refusal to issue a list of demands. This allowed for many people with various interests — some of them conflicting — to shape the movement and feel that it was theirs. This is what democracy looks like! However, the downside of this radical plurality was a lack of unified direction, and this left Occupy open to being pulled this way and that. As the police became more aggressive, the focus became battling the police; as homeless people took up residence, time and money was spent servicing their needs. And the continual pressure by authorities for Occupiers to vacate the park meant that the objective was ultimately reduced to merely continuing the occupation in one location.

Occupy became reactive instead of proactive. It is not that Occupy Wall Street lacked a goal. Although the movement was complex and multi-layered, it had a shared ideal of a world based on reciprocity and respect rather than money and greed. But without a clearly articulated utopian vision, consistently and constantly projected onto the horizon, Occupy Wall Street lost its way.

Mobilizing utopian horizons also enables us to measure and check our progress. Just as mile markers only make sense in terms of an end destination, our projects need final goals if we are to know if we are moving forward, sideways, or backward. Does doing Y get us closer to X? We can only know if we have an X coordinate to check against. That said, utopia is a tricky X coordinate as it is constantly receding. Yes, we'll never reach utopia, but using it to guide us at least gives us a better sense of whether we are walking in the right direction.

MOTIVATE: UTOPIA MOVES US, AND OTHERS.

Changing the world is very hard work. As artistic activists, we dive headlong into the ugliness of the world that most people try to escape. We are up against the most powerful forces on the planet. We lose more battles than we win. And the struggle is a long one. To do this work day in and day out we need motivation. We need to constantly remember why we are doing what we are doing. We need, in the words

of the old civil rights song, to "Keep Our Eyes on the Prize." Bogged down in the immediacies of life we often forget this. When we concentrate on immediate objectives and ignore our ultimate goals we are practically guaranteed to break down one day in crisis, screaming out: "What is it all for?!" Utopia is a way to remind ourselves what it's all for.

And not just us. We can't change the world alone, we need others. They will join us, but only if they, too, are inspired by the dream we are working toward. As the author of *The Little Prince*, Antoine de Saint-Exupéry, advised: "If you want to build a ship, don't drum up the men to gather wood, divide the work, and give orders. Instead, teach them to yearn for the vast and endless sea."

We need to make sure that in every piece we create there is a kernel of our utopia. Not only will this glimpse of utopia inspire people, but it ties together the multitude of tactics, actions, and pieces we are creating that may otherwise seem random and unconnected. Utopia provides the thread that others can follow along with us.

For artistic activists, utopia is indispensable. It is a destination that inspires, critiques, generates, directs, and motivates, and one we'll never, ever, reach. But it keeps us moving forward.

Find your own utopia in Exercise 44 in your workbook

Dystopia, or Why We Love Imagining the Apocalypse

UTOPIA HAS AN EVIL TWIN: dystopia. Both are visions of an alternative world, but the worlds imagined are radically different. If utopia is a dream in which everything goes right, dystopia is a nightmare in which everything goes horribly wrong. Utopia is a place we long to visit; dystopia is a place from which we want to flee. They are both powerful tools for artistic activism.

Dystopian scenarios have been employed for millennia to both motivate and pacify people. Take the Bible as an example. For every scene of heavenly promise, where the lion lays down with the lamb,

UTOPIA IS AN IMAGE OF A
INHABIT. IT DRAWS US INTO THE
CAN BE YOURS IF WE MOVE

there is an opposing picture of hell, with fiery lakes of burning sulfur. People are inspired by images of what they desire, but they are also motivated by illustrations of what they fear — perhaps more so.

Because of this, artistic activists employ dystopian imaginings in their work as frequently, if not more frequently, than utopian visions. This is particularly true for artists and activists concerned with the environment. Ecologists are faced with the challenge of making urgent and visible a set of problems that are slow, cumulative, and largely invisible...until it's too late. Employing dystopian scenarios can give environmental degradation a tangible presence, making the invisible horror visible.

And, odd as it seems, people love dystopias. They are a staple of mass media and no summer is complete without several block-buster movies that envision our world invaded by aliens, destroyed by nuclear weapons, controlled by computers, overwhelmed with natural disasters, or dominated by an uber-class of the super-rich. Classic dystopian books like George Orwell's *1984*, Aldous Huxley's *Brave New World,* and Ray Bradbury's *Fahrenheit 451* are taught in grade schools around the world, and newer dystopian novels like Suzanne Collins's

WORLD WE WOULD LIKE TO FUTURE AND SAYS TO US: THIS FORWARD TOGETHER

Hunger Games series are best sellers. Dystopia is popular culture. All the more reason to use dystopias in our work, right?

Maybe not. While both utopia and dystopia conjure up visions of an alternative world, they do not work in the same way. Utopia is an image of a world we would like to inhabit. It draws us into the future and says to us: this can be yours if we move forward together as a society. It is progressive. Dystopia, however, pushes us away from the future by showing us a world in which we would never want to live. Dystopia tells us to stop moving forward so as to avoid reaching this horrible place. As such, the response to dystopia is profoundly *conservative.* In some instances, this conservative impulse might be productive; for example, encouraging conservation of the environment. Dystopias say to us: we need to stop the harmful things we are doing in the present so that we don't bring on the apocalypse.

But then what? Where do we go after we've stopped whatever it is that needs to be stopped? We don't know, because unlike utopias, dystopias do not show us a vision of a better world: there's no model to inspire us and build upon. Nor have we been given any sort of hope that a better world might be possible. In other words: dystopian futures don't give us the space or the impetus to imagine a world better

than the one we live in today. The only world we are encouraged to imagine is far worse, and so real it can seem inevitable. This one-sided presentation leaves people without a sense of agency.

Perversely, we seem to take comfort in contemplating our own destruction. We enjoy watching or reading about how bad things could become. When artists and activists use their talents to create images of our disastrous future, they are doing so with a sincere intent to instigate some sort of social change. They mean well. But we suspect that what they often inspire is a perverse and solitary satisfaction in hopelessness: *disasterbation.*

Yes, dystopias can act as early warnings of the problems that await us if we do not change. But when we use dystopias uncritically in our work we fall into the oldest trap set for activists and artists: assuming that others aren't active because they don't know about or don't understand a given problem. Dystopias are very effective at dramatizing social and natural problems and their dire consequences, translating abstract fears into forms that can be seen and felt. It is often assumed that once people are exposed to the truth, they will rise up and demand change. This belief is attractive to some because it positions us, as activist artists, as enlightened figures and heroic truth tellers. We are, once more, the child in "The Emperor's New Clothes." This is but a fairy tale.

Again, the problem isn't that people don't understand the problems that face us, but that they can't imagine solutions — or, if they can, then how to bring those solutions about. Demonstrating the harsh realities of the past, present, and possible future is important, but it needs to be folded into a larger inspiring vision. As the Marxist literary critic Raymond Williams once wrote, "To be truly radical is to make hope possible, rather than despair convincing."

Write the utopian sequel to your dystopian
nightmare in Exercise 45 in your workbook

Problems on the Way to Utopia

LET'S FORGET ABOUT utopia for a moment and put our feet back firmly on the ground. How do we get anything done? Simple things, like making dinner. Normally, we follow a process something like this: we have an idea of what we want to eat (say enchiladas), find a recipe, buy the ingredients, and make it. While this seems pretty straightforward, even in the simple example of making dinner we used two different approaches to reach our goal. First we imagined the outcome we wanted (delicious enchiladas), and then we thought about the problems we needed to solve in order to reach our goal. Psychologists (and management gurus) call these two processes "outcome thinking" and "problem thinking."

Outcomes and problems are, of course, interconnected. We need to solve problems in order to arrive at a desired outcome. And we need to have a desired outcome in order to know what problems to attack and how to resolve them. Both are necessary, but, in our years of experience, we've found that artists and activists tend to focus more on the problems they face and less on the outcomes they desire. And this can be a *problem*.

There's no shortage of problems that need fixing in our world; to name just a few:

- Environmental devastation
- The widening gap between rich and poor
- White supremacy
- Mass incarceration
- Misogyny
- Sexual bias and discrimination
- Voter suppression
- Right-wing nationalism

In order to change the world for the better, we need to acknowledge these problems. We need to organize a movement to demand an end to carbon emissions, create artwork exposing campaign finances, and plan actions against the police profiling of Black and Brown youth. It is

important that our thinking about such problems, however, does not lead us to solely focusing on obstacles, what to avoid, our past losses and failures — in short, what we *don't* want. When this becomes the focus, all of our creativity and thinking is organized around obstacles, which end up defining our ideas and actions. Rather than imagining ways of making things right, we obsess over what is wrong and attributing blame. Instead of gazing up toward where we want to be, we look down at the places we'd like to leave. This alters our vision of what is possible in powerful ways.

Here's a thought experiment: take one minute and imagine all the ways the world could end within the next year. You might imagine famine, a nuclear accident, an asteroid impacting the earth, oceans rising, a deadly plague sweeping the earth...Now do the opposite: imagine all the ways the world could be saved. If it took a lot longer for you to imagine everything going right than going wrong, you are not alone. Psychologists call this "Negativity Bias." It turns out that we, as a species, have a much easier time recalling negative experiences than positive ones, and a much easier time imagining possible problems than desirable outcomes. This helps to explain why we seem to prefer dystopias to utopias in popular culture. There may even be evolutionary reasons for this pessimism. Our ancestors, who were paranoid, fearful, and suspicious of every rustle of grass, were more likely to survive (and pass on their negativity bias to us). These tendencies may have helped early humans thrive, but they're less helpful for planning artistic approaches to activism today.

One reason that we tend to focus on problems is that they are often straightforward, tangible, and immediate, while outcomes can seem vague and intangible. It doesn't take creativity to notice the obstacles right in front of us, but we need a lot of training, practice, and effort to find ways of overcoming these to arrive at a better outcome. Concentrating on problems, particularly larger structural problems, is further tempting because they are often seem to be created by someone other than ourselves: the politicians, capitalists, racists, and sexists. We are not responsible. Imagining alternative outcomes and

bringing them into being, however, is on us. We are the ones responsible for making change happen, and that burden is a heavy one to shoulder. In contrast, problem thinking is easy.

When teaching students new to art-making, we've found that they're are often adept at thinking of ways they can't do something:

- I don't have time
- I don't have the space
- I don't have the equipment
- I don't have enough money
- This person was supposed to work with me and...
- I couldn't do it because...

Activists can be equally imaginative in their presumed failure:

- We don't have the money, time, or people to do that
- We already tried that once and it didn't work
- The police will stop us
- *They* control the media
- Who are we to act in the name of [fill in the blank]?
- We haven't come to consensus yet

Making art and planning actions is hard, and it's easier to think of excuses. Sometimes there's real validity to those excuses. Often we don't have the resources to do what we'd like and, yes, it may be a good idea to look to the past in order to not repeat the same mistakes. But too many times, "problematizing" is an excuse for doing nothing. Artists and activists who continually look for problems are often avoiding facing up to the fact that they don't really want to do the hard work of bringing about outcomes.

People who focus on problems will often defend their position by arguing that they are only being "realistic," that they are simply focusing on present realities instead of naively dreaming about what might be. (Remember the Swede?) But are they really being honest with themselves? Is our concern with problems always motivated by a desire to solve them? Or do we sometimes amplify the obstacles we

LOOK THROUGH THE TURN, MAKE THE TURN

LOOK AT THE ROCK, HIT THE ROCK

face in order to confirm our personal identity — say, as a rebel with a cause — or our position in an organization whose purpose is defined by these problems? People who insist on focusing on problems are often overly invested in the world as it is. To actually solve those problems would mean calling their political identity or professional position into question. Whether they know it or not, they want to lose. Beware this person. We know him well, not because we've met him many times in our work, but because he resides in all of us.

Most of us do want to win; we want to transform the world. That's why we are artistic activists. To do this, we need to think in terms of outcomes first and foremost, and only to subsequently identify and face the problems we must overcome along the way. This isn't easy, but once we have a picture of what we're trying to achieve in our mind, it enables us to filter the ways in which we see and think, and navigate through the world. It allows us to focus on what is truly important.

This isn't magic. It's not some prosperity gospel, or management advice extolling the "power of positive thinking," or a new revelation of "the secret" of vision manifestation. It's common sense; we use outcome thinking all the time. Let's return to the example of cooking enchiladas for dinner. What began the process? Was it freaking out that we'd run out of tortillas, that the dinner would never come together, and that we would starve? Or was it envisioning a tasty meal? Sure, there are certain things we must do in order to have that dinner, but these are (for many people) minor "problems" to take care of — enjoying eating is what really matters.

We've already mentioned that we both ride motorcycles. Here's an analogy from that experience: imagine you come around a turn and notice a small boulder that has fallen into the road. You're moving

too fast to safely brake before it. Most people's focus is drawn to the obstacle — "Am I going to hit it?" Sure enough, they do, because as any motorcycle safety instructor will tell you, the way to avoid colliding with an obstacle is to focus on the path around it: look through the turn and follow that line. Utopias enable us to look through the turn and focus on what's beyond the obstacle in the road. Dystopian stories scream, "There's a rock right in front of you! You're gonna die!" While utopia demands that we imagine our desired outcomes, dystopia encourages us to think about our problems. And, as we've suggested above, thinking about what can go wrong is just too easy.

As artistic activists our ambitions are grander than making dinner and the stage on which we work is larger than a turn on a country road, but the process is much the same. Yet when we move from the kitchen or the road to the studio or the meeting room, all of a sudden we abandon common sense and immediately begin to dwell on problems rather than outcomes.

Don't misread us: we can't ignore problems. We will encounter many problems in our pursuit of desired outcomes that will need to be identified, addressed, and overcome. But if we identify too much with the problems we face, then those problems come to identify us and influence our goals. We can be activists *against* fascism, or we can be activists working *toward* a world in which cultural difference is celebrated and true democracy is enacted. To be æffective, we need to ask ourselves whether it is the problem or the outcome that is really motivating us.

We can choose to imagine successful outcomes, or alternatively to take past failures and present problems and project these into the future. Projecting our problems forward paints a picture of our failure and the continuation of the status quo, whereas imagining successful outcomes paints a far more desirable picture of victory and change. Which scenario is more empowering, motivating, and attractive to you? It'll likely be the same for those we are trying to bring with us on our journey.

Learn to replace problems with outcomes
in **Exercise 46** in your workbook

Dreampolitik

MARTIN LUTHER KING Jr. began his famous "I Have a Dream" speech on the steps of the Lincoln Memorial in 1963 by describing the many problems faced by African Americans. One hundred years after emancipation, he told the crowd, Blacks are still not free: they are poor and denied the vote, the use of public facilities, and the basic freedoms guaranteed to all citizens by the Constitution of the United States. They are a people "in exile in their own land." "So," he said to his audience, "we've come here to dramatize a shameful condition."

For a world that neither knew nor cared about the plight of African Americans, this revelation of the injustices of segregation and discrimination was critical: a dystopic vision of an America that did not live up to its promises or potential. It was a strategy the civil rights movement had employed for years, stretching back to narratives written by escaped slaves before the Civil War. This was problem thinking, but King didn't stop here. As important as it was to elucidate the daily horrors faced by Blacks in the United States, what was crucial for winning and mobilizing allies was creating a vision of an alternative, a dream.

King's speech went on to paint a vivid picture of a world where the children of former slaves and slave owners would sit together at the table of brotherhood, and where his own children would not be judged by the color of their skin but by the content of their character. Having captured the audience's attention, he described how the state

of Mississippi, now "sweltering with the heat of injustice, will be transformed into an oasis of freedom and justice." The land itself would take new form: "every valley shall be exalted, every hill and mountain shall be laid low. The rough places will be made plain, and the crooked places will be made straight." King concluded by prophesying the future: "One day this nation will rise up and live out the true meaning of its creed: 'We hold these truths to be self-evident, that all men are created equal.'" It was a dream that cleverly appropriated popular Christian values and the founding documents of the United States, such that it was familiar to his religious base and the broader American public.

King is widely remembered for his dream, but he was not some naïve dreamer. He was a realist. He, and the movement that spawned and sustained him, had a sophisticated understanding of how social change happens. The civil rights movement never stopped working on the challenges it faced. It identified, visualized, dramatized, and publicized the horrific reality of white supremacy in the United States: it made the invisible visible. Lawyers filed cases to overturn racist laws, and activists pressured politicians to write new ones that would ensure civil rights for all citizens. But King and other activists of the civil rights movement understood that revealing and resolving problems is not enough to build a movement. In order to organize and orient a campaign, to inspire and motivate people, you need a dream on the horizon.

Making the Impossible Possible

ONE OF OUR FAVORITE, and just plain *fun*, workshop exercises involves participants mapping out their own paths to utopia. We provide a large sheet of paper and have people draw a picture in the lower left-hand corner that illustrates the issue they are working on as it currently exists. If the issue is police violence, for instance, they might draw a picture of Black and Brown kids being stop-and-searched by police, or of a victim of police shooting lying on the ground while politicians look away — our often dystopian reality. In the opposite corner of the paper, they draw a picture that illustrates the world they are working toward: their utopia. It might show prisons that have been turned into schools and community centers, scenes of white cops and Black kids walking arm in arm, or maybe a world that is entirely without crime, criminals, or police. Once these poles have been mapped, we then ask participants to chart three paths, using multiple tactics, to get from the lower left to the upper right side of the paper.

The first path is the "conventional" one. It includes tried-and-true

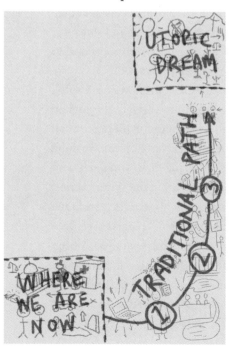

tactics, steps that wouldn't raise the eyebrows of an advocacy organization's executive director, or arts funding bodies. It is the nonrisky, uncontroversial, practical way of getting from here to there. For example, the first step one might take as an artist or activist would be to study the problem. The second step might be to set up an information table, or create online info-graphics, and start educating others. Then one might circulate a petition, make a public presentation, or build a group online in order to demonstrate our support base. After this, one might organize

a rally, demonstration, or exhibition in the hope of getting news coverage. These are real steps working toward real objectives.

The second path is the "utopian" path. This is where the fun begins. We again ask participants to come up with at least three different tactical steps to get them from where they are now to their ideal world — but this time all these interventions can — and should — be impossible. Here, time and money are not concerns, and the physical laws of the universe do not apply. Anything you can dream up, you can do.

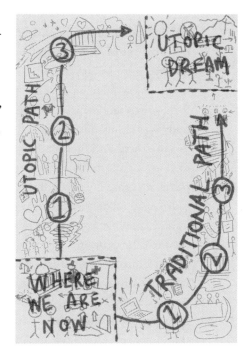

We once worked with a group of activists in Austin, Texas, on a campaign to bring about a more equitable state budget. It was a hard fight: the Texas state legislature was full of deeply conservative politicians who wrapped their business-friendly policies in their born-again Christian faith. When we asked the group to come up with concrete steps toward their utopia, they were stuck on what to do. As seasoned activists, they easily came up with a string of traditional tactics like petitions, legal challenges, electoral strategies, and public actions that would lead them to their ultimate goal of a society that took care of its least fortunate and not just the already wealthy. But when asked to think of utopian tactics, they came up blank.

After a few minutes, two older nuns who were part of the group asked us: "You mean we can do *anything*?" "Yes, anything!" we assured them. "Well," they replied, "if we could do anything then we'd bring back Jesus Christ. He could explain to the public what he really meant by his teachings. And he would show all these right-wing "Christian"

politicians what a state budget would look like if it was based upon his principle of 'the first shall be last and the last shall be first.'" It was absurd, impossible, and the nuns nailed it. Their imaginative leap led to an outpouring of other wild ideas from the rest of the group for utopian tactics: alien abductions, time travel, *Freaky Friday*-style body-switching, and Jedi mind control.

The third and final path is the "creative" path. People are asked to chart a path in the space between their conventional and utopian paths, merging the two. For this creative path, they sketch out three or more original tactics that draw upon the outlandish ideas they came up with, and incorporate the practical steps that are sure to move them forward. By combining the two the impossible is made possible. To depart from our standard ways of thinking, we have to imagine beyond what's possible. But to make our dreams happen, we need to bring our dreams back to reality. When we set out conventional and utopian paths on the same piece of paper, a vacuum emerges between them that draws creative ideas from our minds. It sounds odd, but we've seen it work countless times. When we allow ourselves to imagine the impossible, we're in fact creating the necessary space to imagine how the impossible could be made possible.

To return to the example of the nuns, their dream of resurrecting Jesus Christ to school right-wing Christian politicians was impossible, but it stimulated many creative ideas from the group. The participants realized, for instance, that while they couldn't bring back Jesus of Nazareth, this being Texas they knew plenty of local activists with the common Spanish surname of Jésus.

From this arose the idea of running a campaign for "Jésus for the Governorship of Texas." We'd get an activist friend named Jésus to grow out his hair and beard, perhaps to start wearing flowing white shirts, and to be our candidate. He'd never claim to be *the* Jesus, but this Jésus would participate in candidates' debates and advocate for spending initiatives to help the poor. He would casually sprinkle his speeches with quotations from the Bible, describing a just society as one where "the last shall come first and the first last," and he might

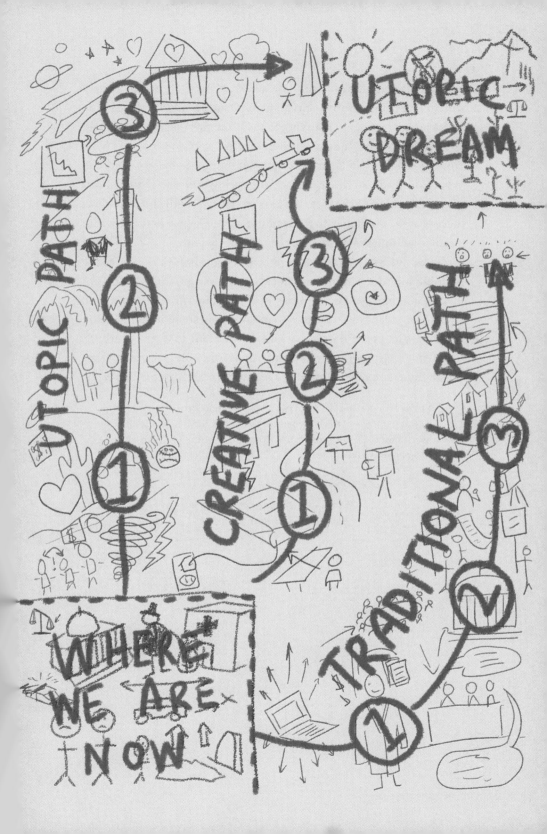

preface his statements with "As Jésus, I believe . . .", or "As Jésus, I will . . ." And conservative Christian politicians would be place in the unenviable position of justifying to Jésus the privileging of rich over poor. We could even "queer" the born-again Christian slogan of "What Would Jesus Do?" by printing campaign bumper stickers that read "What Will Jésus Do *as Governor*?", answering this with a host of progressive spending priorities. It was a brilliant, if mildly blasphemous, merger of the utopian with the traditional, and it spawned an idea for a campaign that the Austin activists could run with.

Æffective artistic activism entails a modulation between the possible and the impossible, between the pragmatic and the utopian. Sometimes you have to rely on what you know will work, and sometimes you have to dream wild dreams. And sometimes those conventional tactics and utopian visions can be made to work beautifully together. Most importantly, utopia gives us something to work toward. The authors and poet, Eduardo Galeano, describes Utopia this way:

> Utopia is on the horizon: I go two steps, she moves two steps away. I walk ten steps, and the horizon runs ten steps ahead. No matter how much I walk, I'll never reach her. What good is Utopia? That's what: it's good for walking.

Map your own paths to utopia in Exercise 47 in your workbook

CHAPTER
10

ACTION!

66 Sentiment without action
is the ruin of the soul.

—EDWARD ABBEY, AUTHOR AND ENVIRONMENTAL ACTIVIST

T HERE ARE MANY books you can find about art, activism, creativity, and combinations thereof. You read them, or at least the first few chapters, maybe find a good quote to use, and then let the book sit on a shelf while you slowly forget it. We hope this isn't one of those books. Over the past ten chapters you've gone through the process our workshop participants complete in becoming more æffective artistic activists. Beyond just theories and concepts, we've provided stories and examples, and workbook exercises to practice the concepts. By now you've filled your sketch and notebooks with your own thoughts, ideas, plans and dreams. You could stop here. But the point of all this training, and all your hard, creative work would be lost. The point of this book is to put your creativity to use in changing the world. And that's only going to happen if you put all these words into *action*. In the words of the Pink Fairies: Do It!

Put your ideas into action by planning out a creative campaign in Exercises 48, 49 and 50 in your workbook

KEYWORDS

Activism: Action to bring about demonstrable social change.

Æffect: A combination of effect and affect. The aim of all artistic activism. Pronounced aye-fect.

Aesthetic: Now often concerned with beauty, but originally meant "relating to perception by the senses."

Affect: Emotional impact. (see Effect)

Agency: The power an individual or group possesses and enacts.

Alt culture: Alternative culture, also called subculture or counterculture. Alt culture is created as a self-conscious alternative to mainstream culture. (see Culture and culture)

Art: A concept creatively embedded in a medium and communicated to an audience. Also defined, and redefined, during inebriated late night conversations among art school students.

Artistic Activism: A hybrid practice combining the expressive qualities of art and the instrumental goals of activism.

Artistic Activist: A person who does the above.

Artistic Activist Process Model: Or AAPM, our design paradigm organized around four stages of the creative process: Research, Sketches, Evaluation, and Production, and four roles an Artistic Activist should play: Observer, Inventor, Critic, Worker Bee.

Audience: Who we are creating our pieces for. Our primary audience comprises the people we want to reach the most; secondary audiences are groups we might possibly reach and should account for; and unintended audiences are those we can't anticipate and who are, therefore, hard to plan for in advance.

Benefit–Cost Analysis: A tool for identifying and comparing the potential benefits and costs of any course of action. Also called "cost–benefit analysis," but we like to lead with the positive.

Brain and Mind: Brain is the biological organ of nervous tissue that sits in our skulls; Mind is our mental capacity to think and feel.

Campaign: The overarching plan to reach a goal; usually includes tactics, objectives, strategy, and goals.

Cognition: Our mental process. How we think.

Confirmation Bias: Bending information or observations to confirm what we already believe.

Counter-hegemonic Culture: Culture created in opposition and as an alternative to the dominant culture of a society. (see Hegemonic Culture)

Creative Habitat: The space, both material and mental, that we carve out for ourselves in order to be creative.

Creative Process: The steps or actions we take when we are creating.

Culture and culture: Culture with a capital C is the creative manifestation or embodiment of a set of ideas or ideals for example, a painting or a pop song. Culture with a small c are lived, everyday practices, for example, language or rituals. Culture is influenced by culture, just as culture is influenced by Culture.

Cultural Mapping: Process of charting out the cultural landscape, as one might create a topographical map to describe a physical landscape.

Cultural Foundations: The stories, symbols, and meanings that form the bedrock of a society.

Demonstration: A political protest, but also to show or model a certain behavior or ideal.

Dystopia: A nightmare image of a society where everything that could possibly go wrong, does. (see Utopia)

Effect: Material impact and outcomes. (see Affect)

Ethics: A set of moral principles to guide behavior.

Ethical Spectacle: A spectacle that reflects a system of values, morals, and ethics. (see Spectacle and Ethics)

Expressive: Concerned with communicating thought or feeling. (see Instrumental)

Figure and Ground: Elements in our visual field: figures are what we focus on, ground is all that is behind that often goes unnoticed.

Five Ps: Five key components of any marketing campaign: Product, Price, Place, Promotion, and Positioning.

Goal: Ideal end result Where we aim, but may never attain. (see Utopia)

Hegemonic Culture: The dominant culture of a society.

High Culture: The type of capital C culture you see in museums or listen to in concert halls. (see Culture and culture)

Ideology: The ideas and ideals of a society of group.

Information Processing Paradigm: Tool used by social marketers to categorize the steps it takes to move people from awareness to action.

Instrumental: Concerned with end result. (see Expressive)

Loss Aversion: Focusing on what we have to lose rather than imagining what we might gain.

Making the Invisible Visible: Using Artistic Activism to highlight a social problem or condition that would otherwise remain hidden. (see Mimetic)

Matlock Method of Political Persuasion (MMPP): Any method of persuasion that relies upon the simple presentation of facts.

Mimetic: To imitate or reflect reality, as in a mirror.

Negativity Bias: Recalling negative experiences more readily than positive ones, and imagining possible problems rather than desirable outcomes.

Objective: Demonstrable, measurable milestones on the road to our goal. Good objectives are SMART: Specific, Measurable, Achievable, Relevant, and Timed.

Piece: Traditionally what an artist creates; their artwork. In this book it is used to refer to what an Artistic Activist creates.

Pop Culture: Popular culture. In much of the world today, this is synonymous with commercial culture. (see Culture and culture)

Prefigurative Politics: Enacting in the present the world we want to bring into being in the future.

Queering Culture: Adopting and adapting mass culture so that it communicates a different message and serves different ends.

The Slump: The inevitable moment in the creative process when a little voice tells you your piece will never succeed, you were a fool to start, and you might as well quit. Don't listen and work through it.

Social Marketing: A field using marketing techniques to change social behavior rather than sell products.

Spectacle: A dream, or nightmare, made manifest visually or as performance. (see Ethical Spectacle)

Strategy: The roadmap for reaching our goal.

Tactic: The basic units of activism. The things we do, the actions we stage, the pieces we create that people see, hear, and experience. Tactics help achieve objectives.

Tactical Myopia: Only looking as far as the action or artwork and not seeing further as to how it fits into a larger plan, strategy, or campaign.

Utopia: An ideal image of a society, often forecast into the future or situated in a distant place. A word made up by Thomas More in 1515 that literally means "no-place." (see Dystopia)

Vernacular: The common, popular language or culture of a group of people.

ACKNOWLEDGEMENTS

A BOOK LIKE THIS does not just come from us as individual authors, it also comes from an environment and community that we've been fortunate to be a part of. Over a decade in the making, we've had a lot of help with *The Art of Activism*, and there have been many teachers along the way. Our comrades-in-artistic activism: Beautiful Trouble, The Center for Story Based Strategy, The Design Studio for Social Intervention, For Freedoms, Ghana Think Tank, Intelligent Mischief, Not an Alternative, Reclaim the Streets, the San Francisco Print Collective, The Yes Men, and Duncombe's old cadres in the Lower East Side Collective. And individuals such as Larry Bogad, Andrew Boyd, Marlène Ramírez-Cancio, Brett Cook, John Jordan, Leslie Kauffman, Nikola Pisarev, Jon Rubin, Nathan Santry, Leónidas Martín Saura, Dread Scott, Cheikh "Keyti" Sene, Keri Smith, David Solnit, and especially Deborah Gonella, who opened the door for Lambert on what an artist could learn from public health communications. Many people read and commented upon early drafts of this book and tested exercises in the workbook, including Ivan Askwith, Taylor Brock, Dipti Desai, Victoria Estok, Steve Flusberg, Silas Harrebye, Michael Mandiberg, Micki McGee, Alissa Milano, Joseph del Pesco, Adam Scarborough, and Ben Shepard. Our frequent South African collaborators, Ishtar Lakhani and Marlise Richter, tried out many of the lessons in this book in their own workshops. George Perlov and Risë Wilson were invaluable in helping us think through issues of æfficacy. Merith Basey of Universities Allied for Essential Medicines along with the hundreds of volunteers for Free the Vaccine for COVID-19 embraced these ideas and tested our exercises in the field. Special thanks to our students at New York University, Purchase College, Hunter College and the School of the Museum of Fine Arts, Boston, who helped us develop and refine these exercises and lessons. A number of organizations supported our artistic activist work these past ten years, including the National Endowment for the Arts, the David Rockefeller Fund, the Rubin Foundation, the Emily and Eugene Grant Faculty Award at Purchase College, and the Professional Development Fund of the

Gallatin School of New York University. *The Art of Activism* was fostered early on by John Johnson and the Harmony Foundation who first put the idea of a book in our minds. A Blade of Grass and Lush Charity Pot's help came at a critical time in the book's development. And the Blue Mountain Center gave us a bucolic summer to work on it. Profuse thanks go out to the folks at Open Society Foundations for seeing the value in artistic activism, creativity, and culture, and investing resources and providing opportunities to work among and learn from new communities, contexts, and issues. Our relationship with OSF began with Patricia Jerido at the Democracy and Power fund, who convinced us we should be doing training workshops in the first place, continued with Brett Davidson of the Public Health Program who brought us around the world, and was picked up by Rashida Bumbray and Lauren Agosta who brought us into OSF's Arts Exchange. Equally essential to our work as creators, trainers and authors is The Center for Artistic Activism, which we co-founded a dozen years ago, our illustrious Board of Advisers and invaluable Board of Directors, and all our staff, interns and volunteers over the years. And, most of all, Rebecca Bray, who came on board as a co-director of the C4AAin 2016 and has helped the organization grow and thrive, and importantly, keep the two of us on track in writing and illustrating this book. *The Art of Activism* would not be the book it is now had it not been for Colin Robinson and the team at O/R who enthusiastically embraced us, Catherine Cumming who painstakingly edited our manuscript, and Andy Outis who beautifully designed its pages and cover. We'd also like to thank the creative (and clandestine) members of The Ministry of the Impossible for walking with us toward Utopia. Our extended families, both biological and not, taught us through example that to live in the world is to change it, and then provided the love and strength for us to live such a life. Most of all we would like to thank the brilliant and passionate artists and activists we've worked with around the world over the past decade. Much of what is best in this book we have learned from you.

INDEX

British Government, 98, 99
British Tea Act, 98
Buddha, the, 88
building blocks, 11

NOTES

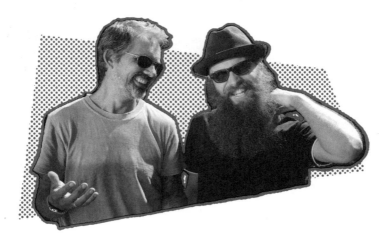

STEVE DUNCOMBE is a lifelong activist, co-founding a community group in New York City recognized for its creative approach to organizing. An award-winning professor at New York University, Duncombe has published six books and countless articles on culture and politics, most notably *Dream or Nightmare: Politics in an Age of Fantasy*.

STEVE LAMBERT is an internationally recognized artist whose public projects have appeared around the world, in four documentary films, over two dozen books, and in Times Square. He has worked alongside the Yes Men and Greenpeace, and is a professor at Purchase College, the State University of New York's public arts college.

THE CENTER FOR ARTISTIC ACTIVISM was co-founded by Steve and Steve out of a desire to learn and share what works. For more than a decade, the Center has trained thousands of activists and artists around the world how to use their creativity to impact power. Working with sex workers in South Africa and Trans-rights organizers in Eastern Europe, dissident artists in Russia and art students in public high schools in New York City, Iraq and Afghanistan War Veterans in Chicago and immigration activists in San Antonio, as well as many others, they've experienced first hand how artistic activism can change the world. The expertise they've gained and lessons they've learned collaborating on real-world campaigns are distilled here, in *The Art of Activism*.